boutique
a '60s cultural *phenomenon*

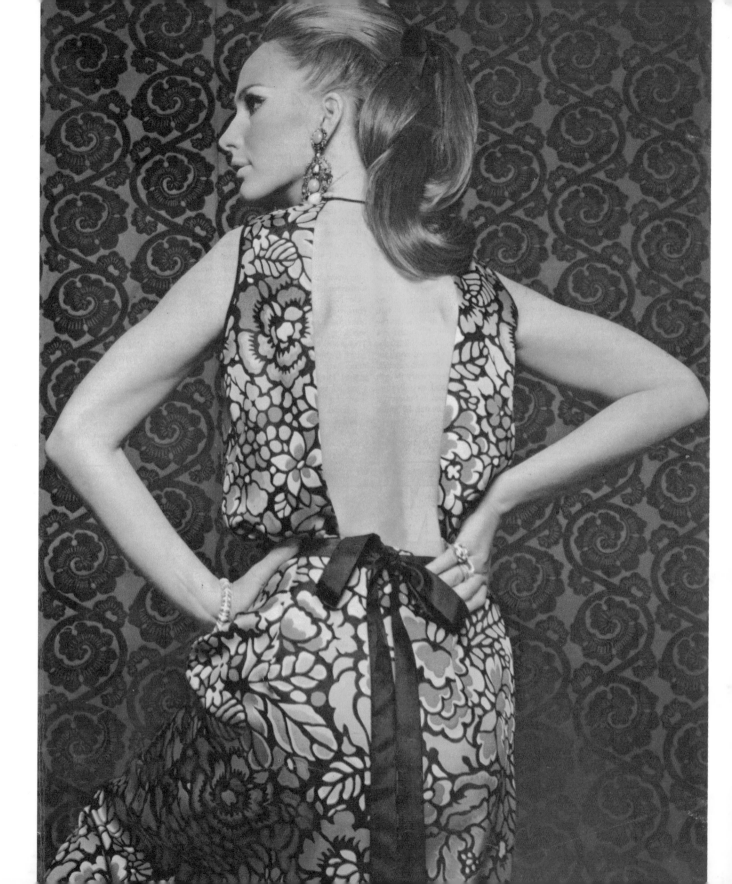

boutique

a '6os cultural phenomenon

MITCHELL BEAZLEY

marnie fogg

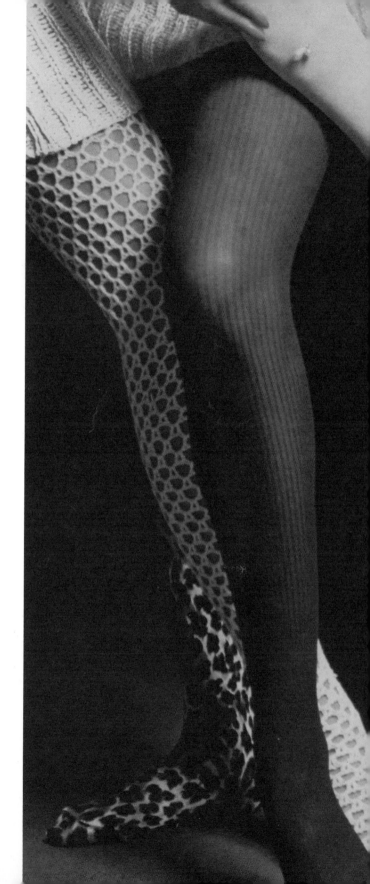

right In the late 1950s the hosiery company Aristoc attempted to attach fully-fashioned stockings to a pair of briefs to make panty hose. By the early sixties "tights", as they came to be known, were made in a tubular form and steamed into shape. Textured and patterned tights provided a new area of interest and 1966 was designated "the year of the leg."

previous spread One of his many designs for London store Liberty by Professor Bernard Neville. "My fashion sense and sense of colour are the two most important things I bring to fabric design."

TO MY DAUGHTER, EMILY

This book has been such a pleasure to write, everyone I have interviewed has been unsparing in their kindness and willingness to help. I am indebted to Marit Allen, Sylvia Ayton, Caroline Baker, Celia Birtwell, Lee Bender, Mike Berkofsky, John Bates, Pat Booth, Rita Britten, Jeff Banks, Janet Campbell, Jo Dingemans, Vanessa Denza, Linda Fletcher, Marion Foale, Barbara Hulanicki, Celia Hammond, Gilbert Hickingbotham, Bobby Hillson, David Hillman, Elsbeth Judd, Barry Lategan, Georgina Linhart, Bob Manning, Sandy Moss, Martin Moss, Gerald McCann, Professor Bernard Neville, Mary Quant, David Skinner, Sir Paul Smith, Mick Snee, Nigel Waymouth, Richard Williams, and James Wedge.

Most particularly I have to thank John Angus for his I.T. and other support, Ian Longdon for his extensive personal archives of the period, Gerald McCann for his delightful company, Nicky for her wonderful book design and Caroline Cox for being my pal.

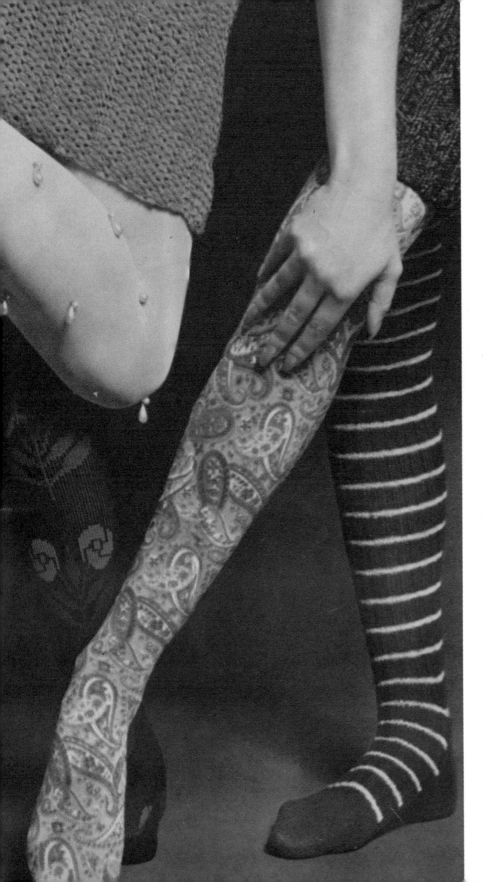

contents

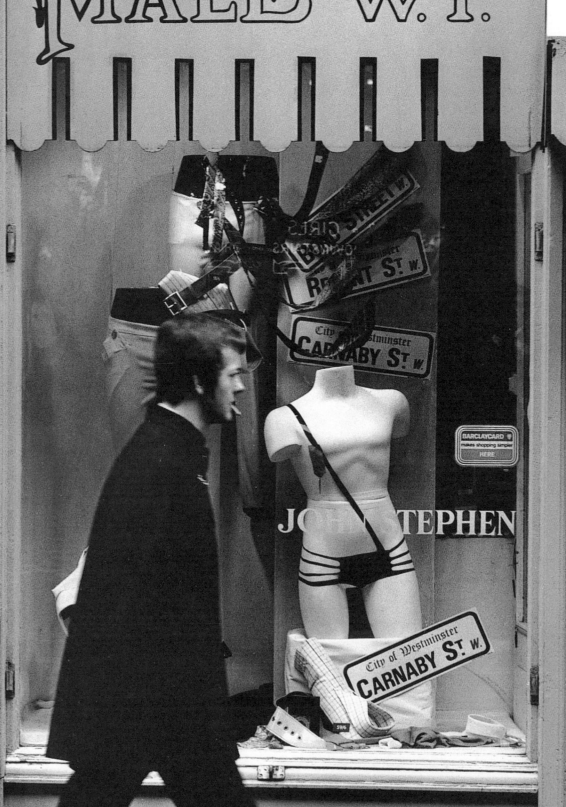

introduction

Mary Quant, Biba, Granny Takes a Trip, Bus Stop – not to mention the phenomenon of Carnaby Street – all conjure up the era of unparalleled freedom, which in the sixties changed the look of fashion and transformed forever the nature of the shopping experience. Boutiques such as these gave voice, form, and location to the youthful desire for independence and personal freedom, and in turn led to an unprecedented awareness of fashion as a vibrant medium of self-expression.

Unlikely as it sounds, the word "boutique" is a corruption of the Greek *apotheke* meaning "something put aside" or storehouse, which then became *apotheca*, the Latin word for shop. *Apotheca* became *botica* in parts of medieval France, and thus boutique. The first mention of the word in the British press was in an article in *The Times* on October 21st 1957, talking about "boutique departments in the big stores designed to fill the gap between custom-made couture clothes and those made by wholesale houses."

In that article, "boutique" is used to describe "a shop within a shop." Parisian couturiers – beginning with Elsa Schiaparelli in 1935 – had used the term in a similar way to indicate the ready-made accessories department appended to their haute couture salon. Through usage the definition was extended in Britain to describe any small independent retailer that neither offered made-to-measure couture fashion nor the wholesale manufactured clothes sold in department stores. However, the implication that boutiques had a fixed place in the hierarchy of fashion manufacturing was soon lost, and the word boutique came to mean something both more specific and at the same time less limiting.

The evolution of the fashion boutique during the sixties changed the nature of shopping in a radical manner entirely coherent with the social upheaval of the times. The device of dividing periods of history into decades is a convenient way of defining the characteristics of an era, and the sixties

previous page Walk on by or get caught window shopping. Male W1 was only one of the numerous boutiques owned by John Stephen during the sixties. He was the catalyst that propelled London's Carnaby Street from a dingy backwater to a thriving retail empire.

right Biba was the first boutique to enter the popular consciousness. The opening of Biba in 1964, and the introduction of its groundbreaking mail-order catalogue in 1968, meant that modern fashion became accessible to all.

are commonly perceived as being a period of drug- and sex-fuelled decadence from which society never recovered, or as an age of social enlightenment that was the welcome start of a more liberal society. Whatever the mythology, it is generally acknowledged that the sixties was a time of historical significance and was nothing less than a period of cultural revolution. The peak of the post-war baby boom in 1947 meant that unparalleled numbers of teenagers reached puberty in 1960. The upheavals they would face in social stratification, in institutional, personal, and familial relationships – at a time of unprecedented affluence – were to mark and define the era. The "teenager" could look forward to an extended adolescence with growing financial independence and diminishing parental control, not least over appearance. I certainly wasn't the only teenager to leave the house with cries of parental shock echoing in my ears, "You're not going out dressed like that."

Shopping, therefore, involved not only the purchasing of clothes and their accessories but became a means of self-expression and identification with the burgeoning sub-cultures of the time. It ceased to be a peripheral activity and became central to the experience of being young, attractive, and cool.

The boutique customer was quite likely to walk out of the shop wearing a purchase, behaviour that would have been unacceptable during visits to the department store. Excursions to these stores were an inherent part of the structured formality of a fifties middle-class childhood and required good behaviour and exemplary manners, easy enough to achieve in the awe-inspiring portals that housed commodities both mysterious and compelling. As a child at the time, I can remember being made to wear white gloves and carry a handbag like a miniature middle-aged woman simply to have afternoon tea in the top-floor restaurant, and I remember my mother's mortification as my dirty hands were revealed when I took off my

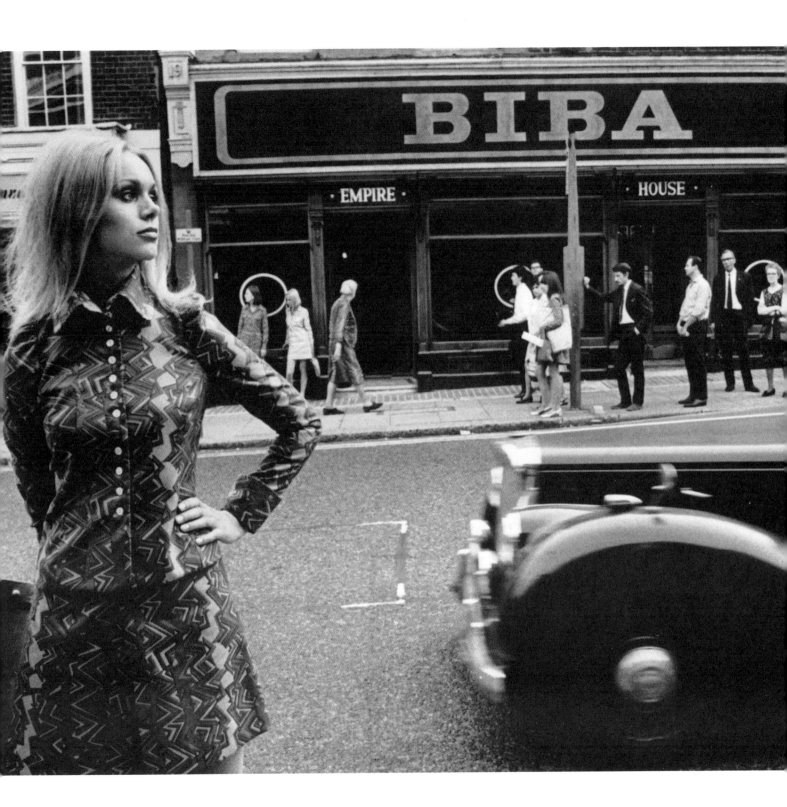

gloves to eat. Cleanliness seemed a small penalty to pay, however, for the thrill of shopping. Simply to be inside the store invited the pleasures of speculation; there was so much merchandise, so artfully displayed.

The architecture of such stores was that of the Victorian institution, built in the grand public style of municipal town halls and libraries, and occupying space in the centre of the town or city. They inspired the same sort of awed respect as town halls, not least because of their size. The invention of new glass-making techniques in the nineteenth century allowed large areas to display some of the commodities available inside to the passer-by, a tantalizing glimpse of the merchandise on offer.

The other mode of fashion shopping available to the middle-class customer came with the expansion of suburban housing during the inter-war years, and the proliferation of small enclaves of shops within walking distance. While some of these shops sold mass-produced items that met suburban needs, and had little to offer in terms of fashionability, those located in the wealthier suburbs became "madam" shops; enterprises usually eponymously named and offering a more personal service than the department stores. The shop assistant would be on familiar terms with her customer, offering suggestions of suitable styles for the special occasions in her customer's life, such as the company dinner, or a wedding.

The child of the fifties was a witness to the leisurely passivity of these experiences, and the ritualizing of shopping as an "event" requiring special clothes and best behaviour. For a thirteen-year-old, shopping with mother became a tiresome chore, driven by need and not by want – a new school uniform, or a winter coat. Irksome considerations of longevity and "never knowingly undersold" came into play when shopping too.

The security of a tightly structured childhood spent in the relatively affluent fifties was a safe place from which to play with notions of independence,

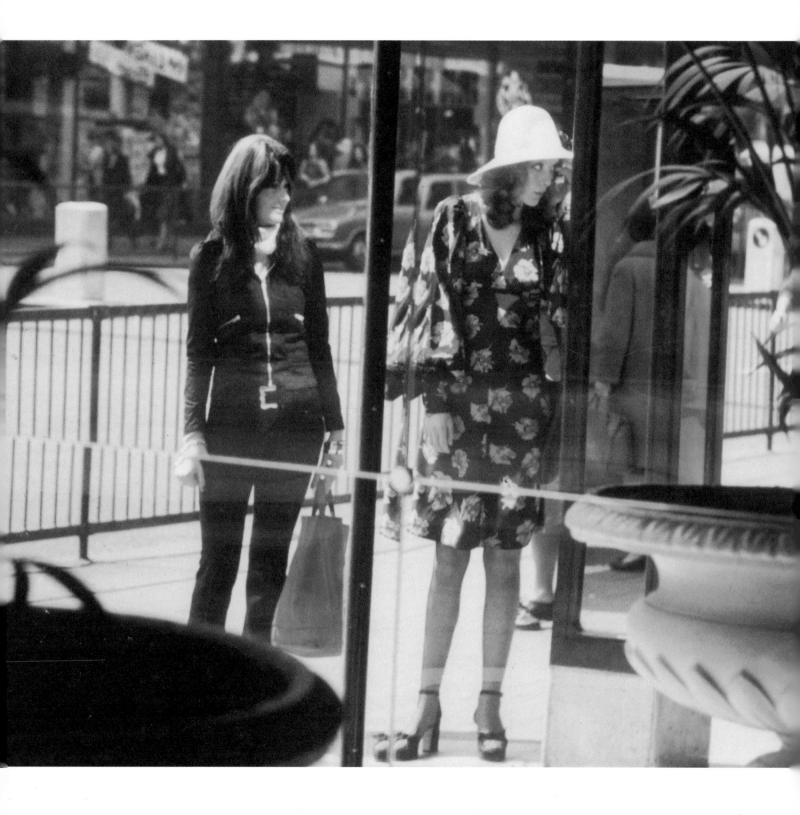

left The interior of Biba
with its curly Victorian
hatstands, jardinières,
and wooden floors set the
style for a million bedsits.
Founder Barbara Hulanicki
remembers, "Potted palms
were now becoming very
expensive, but they were
so much part of Biba that
they were a must."

if not rebellion. The new modes of self-presentation were a reflection of the upheavals taking place in society, and resulted in a many innovations including that of the fashion boutique. The entrepreneurial ethos of the sixties that resulted in teenagers "doing their own thing" meant that young consumers could now become the new producers.

An element of inspired amateurism characterized the setting up of the first boutiques, enthusiasm and a commitment to the profit-making ethic proved to be more than an adequate replacement for experience. There was a common factor, however, that united these new entrepreneurs of the visual arts. One of the results of the Butler Education Act of 1944 was that opportunities had expanded for working-class children to enter further and higher education, and the new students often went to an art college. Mythically wayward, and in receipt of a gratifyingly adequate grant from the local authority, the art student of the sixties forged new ways of solving new problems. Pursuing innovative design processes alongside practitioners in other fields such as ceramics, architecture, and graphics resulted in the cross fertilization of ideas and aspirations.

Graduates would come to find that the designer played a very minor role in the mass-production fashion industry. The tension between creativity and commerce was only evident in resolving how many buttons could be afforded within the constraints of a budget. Traditionally the designer in a manufacturing enterprise would be the wife of the managing director, who would pop into the factory now and again with the latest copy of *Vogue*. When these businesses reluctantly acknowledged their need for a designer, salary and accommodation were, according to Janey Ironside, then professor of fashion at London's Royal College of Art, "still in the sweatshop stage." The design office would be at the end of the cutting table, the factory floor an ill-lit room at the top of a flight of worn stone steps. Those

designers who believed they could change the face of fashion retailing by impressing the buyers of the big multiple stores, such as Littlewoods and C&A, with the sort of designs that they themselves would want to wear, were due to be disappointed.

A designer from those days remembers, "I designed blouses for this small manufacturing company that sold to C&A. I decided to change the basic shape from these hideous square boxes to one that had a higher, tighter armhole. The buyer refused them all. I had to recut the whole range. Most of my time I spent making clothes for the owner's ghastly daughters and fending off the advances of the husband."

Manufacturing usually took place in factories built during the nineteenth century, often with very little change of use during the intervening years. It was an impossible task to change the working practices of decades to satisfy the swiftly changing requirements of a customer base that was neither understood nor appreciated by the buyers in the retail sector. The realization of this was enough impetus for the more maverick designers to start their own manufacturing and retail businesses.

Financial necessity ruled out established retail areas in city centres as potential venues for new businesses, and not only in London. For the young entrepreneur, the high rents and long leases of the provincial high streets were just as economically unfeasible as those in central London, with the result that previously marginal areas were taken over and elevated to fashionable status. Teenagers in the provinces defined their own areas of "cool", starting businesses in unlikely locations, to be followed by similar enterprises.

Boutiques sited in obscure back streets and side alleys had little use of window display. Passing trade was insignificant in the context of word of mouth and the grapevine. Neither did the boutique windows necessarily reflect the commodities inside the shop; occasionally the displays were

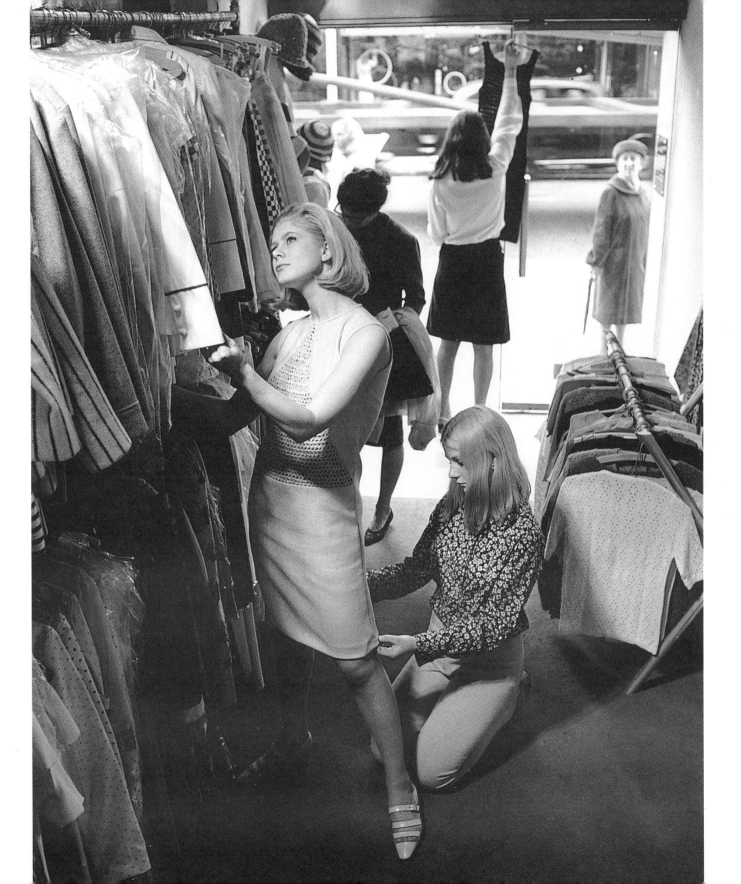

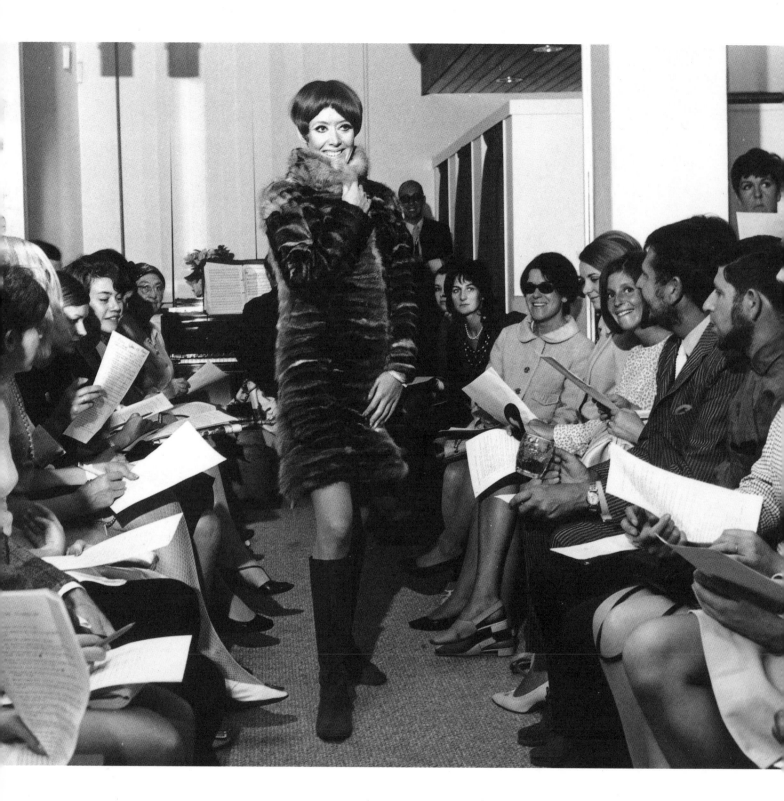

left The first fashion show at the launch party for the new Woodlands 21 shop was an attempt to introduce informality into previously staid and rather ladylike proceedings. The Temperance Seven played jazz throughout and commentary was kept to a minimum.

simply a tease or a provocative gesture. What were passers-by to make of half a 1947 Dodge extending through the shop front of Granny Takes a Trip?

Neither would there be a salesperson to offer advice, to mediate between the customer and the garment. Hierarchies were implicit in the male-owned, female-serviced traditional department store, where status was reinforced by the shop assistant's chic black suit and possibly autocratic manner. "They could be quite terrifying", recalls a customer, "it was one of the few situations when one came across professional women, and they were very certainly very smart and quite intimidating."

These boundaries dissolved as the relationship between the customer and the saleswoman underwent a change. With the absence of a shop counter and the lack of formal staff attire, it was difficult to differentiate between staff and customers. From the 1920s it had invariably been the case that women sold to women, creating a world almost exclusively female. With the development of the boutique women were just as likely as men to own the shopping space, boyfriends were not only "allowed" inside but actively encouraged to participate in the shopping experience with specially designated areas for them to sit and watch the process of purchasing.

The notion of "exclusivity" also underwent a change. The mortification traditionally attributed to women turning up to a social event wearing the same dress as someone else, was replaced by gratification. It indicated evidence of being aware of the latest trends. John Bates famously made a daisy decorated dress in which twenty-five debutantes appeared at the same ball, to their mutual delight.

The new boutique owners not only knew their customers, but were themselves members of the sub-cultures proliferating at this time, and thus part of a vast market. Sharing attitudes, values, and practices with customers was an instrumental factor in the successful development of boutique culture.

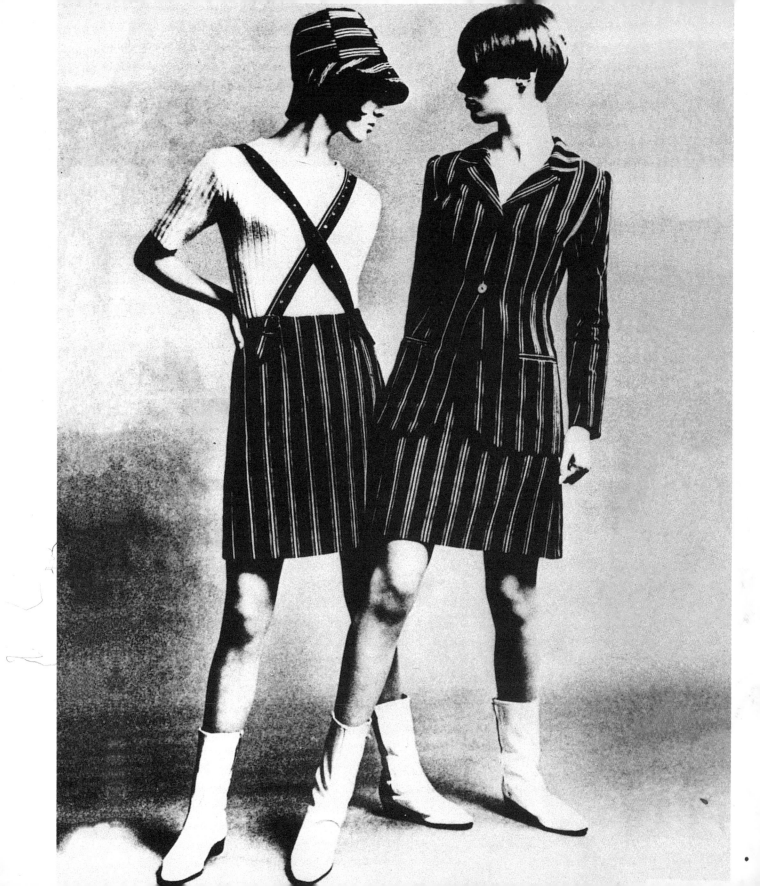

chelsea girl

mary quant and the boutique revolution

MARY QUANT ASKED 22 TOP MODELS: WHAT'S WRONG WITH MAKE

THE BIG MOAN: confusion. No brand with everything you need
or the look of the moment. To highlight bones. Shape faces. Gear eyes,
ps, nails, to now.
THE BIG NEED: speed. Bare essentials for the bare look. Chisel brushes
must.
THE ANSWER: MARY QUANT'S NEW MAKE-UP. It's a no-nonsense
lan: everything you need, nothing you don't for the face
f today. Bones made much of. Contours controlled. Starkers nude
oundation. Face Shapers. Face Lighter. Great play with
yes. Brush Eye Shapers. Liquid Eye Shadow in subtle merging
olours like Grape and Slate that don't jump out at you.
hick thick lashes. Nail colours like Chrome and PVC White
eared to current clothes. Brush Lipsticks boxed with wide
nirrors. Blot-out to neutralise lip colours, give them a fair bare
tart. Unobvious colours. Everything compact, workable,
uick. A free leaflet to give you the Mary Quant make-up
echnique in strip cartoon, step by step. The low-down know-how.
t's the first great post-atomic breakthrough in make-up!

left Mary Quant was first to grasp the transformative power of make-up in completing the "look". In 1966 she launched a cosmetic range alongside her clothes, advertised in Vogue as, "The first post-atomic breakthrough in make-up." She wanted to eliminate confusion and demystify the process of applying make-up.

previous spread The striped pinafore dress and blazer redefined the school uniform for the coquettish teenager. Boots were no longer a utilitarian winter necessity; these calf-length white boots were considered vital to complete the look.

Most entrepreneurial activities that took place in the 1960s had their provenance in the latter years of the previous decade, and the origins of the fashion boutique was no exception. It was 1955 when the trail-blazing boutique Bazaar opened on the King's Road in London's Chelsea, which at the time was a road of small shops selling household provisions to the local community. It opened at an auspicious moment. The stoic resignation to the deprivations of wartime Britain was giving way to stirrings of desire for colour and life and change.

Mary Quant, the influential designer and co-founder of Bazaar, had spent most of the war as an evacuee in Wales, where she practised for her future career by cutting up a bedspread to make a dress. Compromising with her teacher parents, she elected to study for an art teacher's diploma at Goldsmiths College in London, where she met her future husband, Alexander Plunket Greene. In her autobiography she recalls the visual impact he had on the students: "He seemed to have no clothes of his own. He wore his mother's pyjama tops as shirts, generally in that colour known as 'old gold' in shantung. His trousers also came out of his mother's wardrobe. Beautifully cut and sleek-fitting, the zip was at the side and they were in wonderful variations of purple, prune, crimson, and putty. The trouble was that they came to a stop half-way down the calf of the leg so there was always a wide gap of white flesh between the tops of the Chelsea-type boots and the end of the trouser legs."

Plunket Greene lived alone in his mother's house in Chelsea, an area that had long been frequented by the raffish and bohemian section of the upper classes. Mary Quant eagerly participated in the eccentric and larky ambience he created around him, which was such a perfect foil for her pragmatic and sensible approach to life. The two of them met up with Archie McNair who earlier had opened a coffee bar called Fantasy on the King's

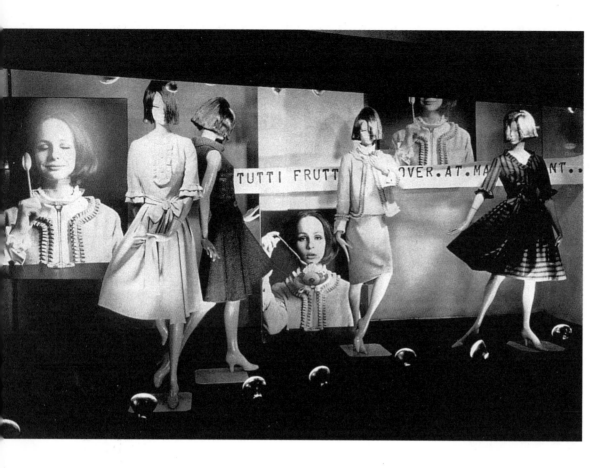

left Mary Quant describes the mannequins in the window of her shop, "I very much wanted to get right away from the standard type of figure used in window dressing… I wanted figures with the contemporary high cheekbones, angular faces, and the most up-to-date hair cuts. I wanted them with long, lean legs rather like Shrimpton's, and made to stand like real life models in gawky poses."

right With this cosmetics advertising campaign, Mary Quant took a step beyond the normal placing of the trademark. Her wordless logo of stylized daisy became instantly recognizable. Another body and graphic combination attributed to Quant was the notorious sculpting of her pubic hair into a heart shape.

Road. Together with the pub Finch's on the nearby Fulham Road, this had become the epicentre of what came to be known as "The Chelsea Set". This group of people were defined by Mary Quant as consisting of "painters, photographers, architects, writers, socialites, actors, con-men, superior tarts, racing drivers, gamblers, and TV producers." They were dissatisfied with the conservative middle-aged nature of the prevailing culture, often referred to as "The Establishment". They sought autonomy from their well-connected families through modes of dress and activities, which included taking up one of the acceptably marginal occupations such as painting, writing, or running a small business.

The desire of the Chelsea Set to dissolve the boundaries between work and play, friends and colleagues, and public and private spaces, goes some way to explaining the origins of Bazaar. Mary Quant describes how the shop came about, "We had endless discussions and eventually it was agreed that if we could find the right premises for a boutique in the King's Road we would open a shop. It was to be a *bouillabaisse* of clothes and accessories . . . sweaters, scarves, shifts, hats, jewellery, and peculiar odds and ends. We would call it Bazaar. I was to be the buyer. Alexander inherited £5,000 on his twenty-first birthday and Archie was prepared to put up £5,000 too."

Although she had spent time in the workrooms of Eric, the milliner, in Brook Street, Mary Quant admits that she knew nothing about the fashion business at this point. She started by adapting Butterick paper patterns and making the day's output of dresses in her bedsitting-room, selling them in the late afternoon to finance the next day's purchase of cloth from Harrods.

Her customers were initially from the same social milieu as herself. The model Twiggy, for example, is emphatic that "Bazaar was for rich girls," and although in 1961 Alexander Plunket-Green opined that "we were interpreting the whole mood of a generation and not just smart art

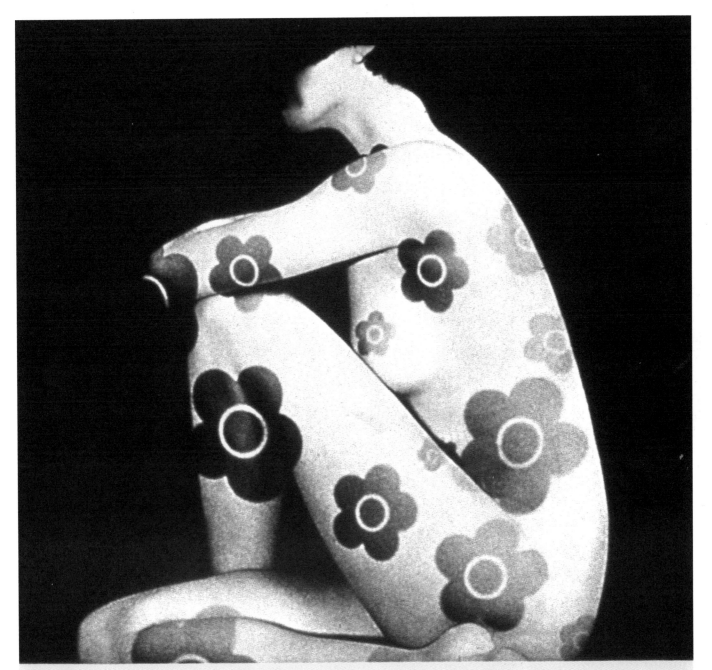

MARY QUANT GIVES YOU THE BARE ESSENTIALS

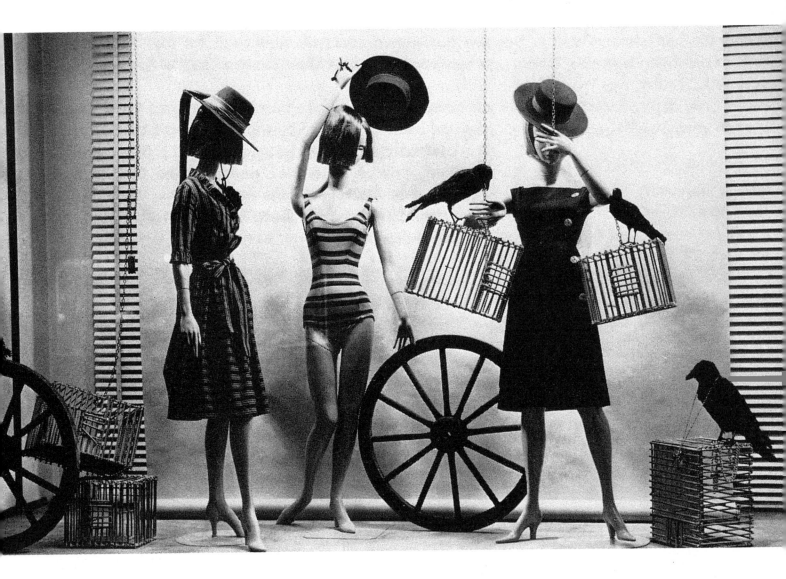

above "We wanted people to stop and look, we wanted to shock people. All the men and women who walk down the King's Road are not necessarily shoppers as they are in Oxford Street. We wanted to entertain people, as well as to sell them things." Mary Quant, 1965.

opposite left Mary Quant's Bazaar – the first boutique – marked the transition of the Kings Road, Chelsea from raffish bohemia to the epicentre of cool.

opposite right Mary Quant and her husband and partner Alexander Plunket Greene dressing the window of their shop Bazaar.

students," Bazaar did not have a working-class customer base. This fact was reflected, for example, in the price of a pinafore dress featured in *Vogue* in 1960: it cost sixteen and a half guineas, which at the time was almost three weeks' wages for a girl working in an office.

The second Bazaar opened on the Brompton Road in Knightsbridge, and was designed by Terence Conran. It was only with the opening of this second boutique that the fashion press began to be really interested. Initially recognition had been confined to the social columns, but Clare Rendlesham – then features editor of "Young Ideas" at *Vogue* magazine – decided to do what she could to promote them. In this she was helped by Alexander Plunket Greene's acute marketing awareness. The journalist Marit Allen, who was to follow Clare Rendlesham as the editor of "Young Ideas", confirms this: "I think the women designers got more publicity, the press projected this 'dolly bird' image, which was encouraged by Alexander. The three of

them formed a triptych of great power. Archie was the business-man, and Alexander was clever and witty and a good publicist. It was his idea to name the clothes for instance."

James Wedge, at that time a milliner who later went on to become a successful retailer and photographer, accompanied Mary Quant and her team on their first selling trip to Paris. He describes Alexander's publicity skills in those early days: "I designed all the hats to go with the collection. At the first show in the morning there were about six people in the audience. No one had heard of us. Alexander got hold of the publicist, Percy Savage, and the afternoon show was full."

Mary Quant's work typified what came to be called "The Chelsea Look", a silhouette that acknowledged the necessity of freedom of movement and lack of formality which was to characterize the era. The clothes shared many of the characteristics of the 1950s art students; a preoccupation with

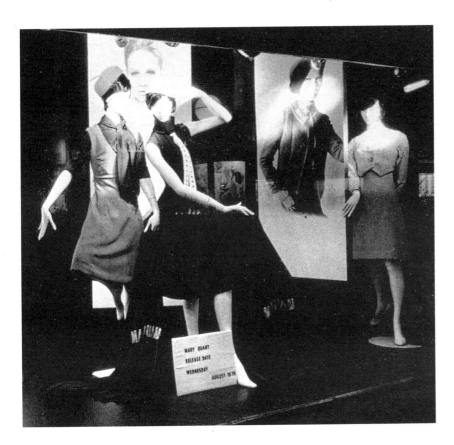

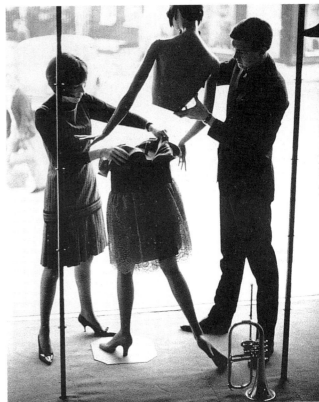

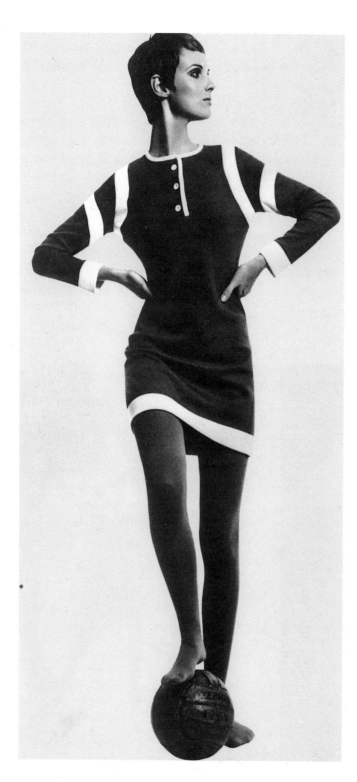

left Mary Quant played with proportion, scaling up children's school and activity outfits, and scaling down menswear for "birds". Here she redefines a man's classic three-button football jersey into a dress to be worn with coloured tights. She described them as "clothes to move and run and dance in."

right The dazzling optical effect of this stark black-and-white matching coat and dress is made still more graphic by the concentric contrast stripe of the hat.

the American "beat" look allied to the sort of garments and fabrics worn by children: skinny pinafore dresses, knee socks, leotards, black stockings, gingham, and flannel.

Mary Quant played with the proportion of classic fashion garments; she scaled up cardigans and made football shirts into dresses. Details and unexpected fabrics transformed the ordinary into the special; the "V"neck of a sweater dropped to waist level, the classic trench coat was designed in wet-look PVC. Quant was the first designer to dismantle the barriers between day and evening wear, no longer was the "occasion dress" the highlight of the catwalk show. "I think clothes should adapt themselves to the moment. Girls in their teens and twenties want clothes they can put on first thing in the morning and feel right in at midnight" she said.

Most striking was her use of colour. She juxtaposed plum with ginger, pale blue and maroon, tobacco brown with purple, at a time when most young women and girls wore pastels. "Pretty" was no longer a compliment, this new look required a new vocabulary to describe the girls dressed by Quant. They were "dollybirds" wearing "kooky, kinky gear".

The designer personally rejected the heavily styled hair of the period and set a trend, together with iconoclastic hairdresser Vidal Sassoon. In his biography he recalls her visiting his salon, "I'm going to cut the hair like you cut material. No fuss. No ornamentation. Just a neat, clean swinging line…"

Mary Quant's influence extended beyond the boundaries of the two Bazaar boutiques when in 1961 Mary Quant Ltd was formed to manufacture the Quant look in quantity. This was extended in 1963 when she became the founder-director of the Mary Quant Ginger Group Wholesale Clothing Design and Manufacture Company. That same year the *Sunday Times* gave her a special award in the first of its International Fashion Awards for "jolting England out of its conventional attitude towards clothes."

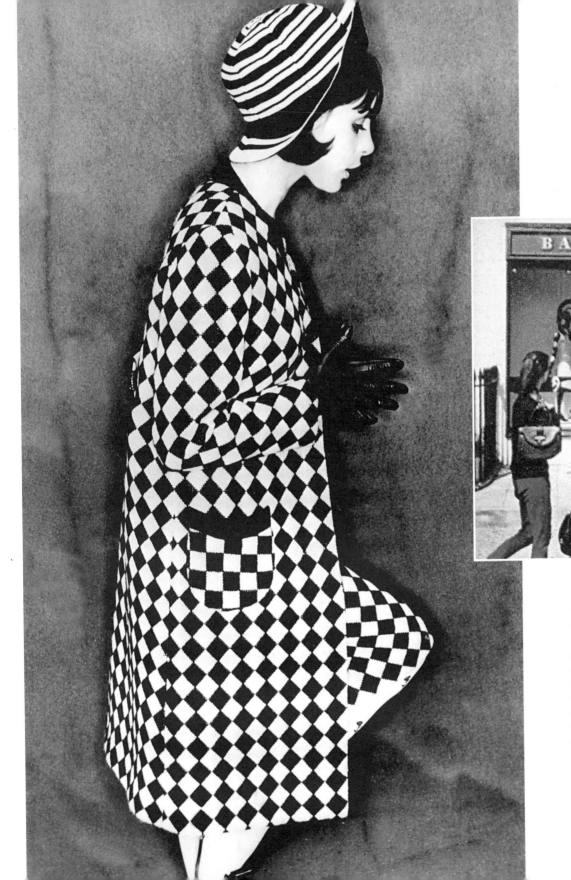

above In 1965 Mary Quant
described her boutique:
"*Bazaar soon became the
focal point of the Kings
Road, particularly on
Saturday afternoons and
in the evenings. The big day
of the week at Bazaar has
always been Saturday. There
are still Saturdays when we
have to keep the door locked
and let one customer in as
another goes out.*"

modern times young ideas

the emergence of the new designers

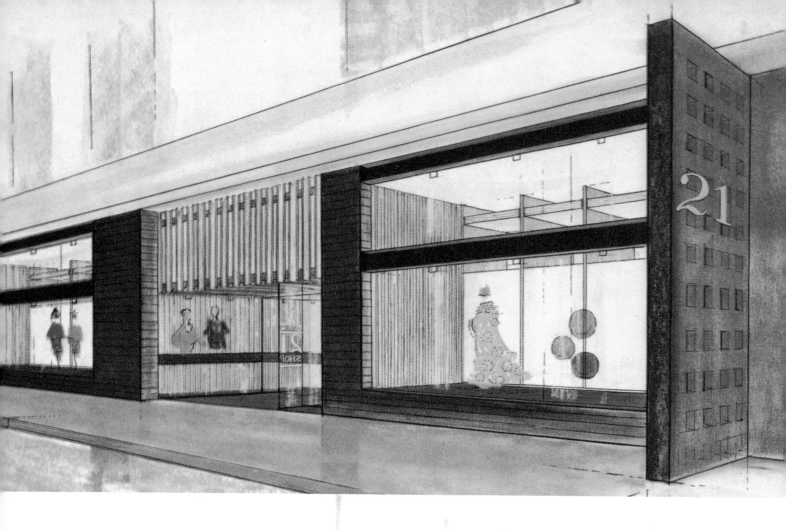

marion Foale and Sally Tuffin were both post-graduate students on the fashion course at the Royal College of Art in London in 1960 when Alexander Plunket Greene gave what proved to be an inspirational talk on his experience of starting up the boutique Bazaar. Janey Ironside, Professor of Fashion at the Royal College of Art (1956–68) writes in her autobiography, "When I first took over the school it was taken for granted that a student leaving would try to get a job in a manufacturing firm. This changed after Sally Tuffin and Marion Foale set up on their own."

Not only had the girls studied together at the Royal College, they had also previously attended Walthamstow Art College, alongside Sylvia Ayton, who went on to open the Fulham Road Clothes Shop with Zandra Rhodes, and James Wedge, owner of the influential boutiques Top Gear and Countdown. This was an exciting period for young designers, and in the *Daily Mirror* Noel

Whitcomb acknowledged the importance of the Royal College of Art in nurturing new creative talent: "It is Britain's university of fashion – a working model of how higher education and industry can go hand in hand for the benefit of all, including the country's export trade. No other country in the world has a state-sponsored fashion nursery like the RCA."

Marion Foale and Sally Tuffin were among the first to graduate from the College and to go on to manufacture and retail under their own label. Marion Foale had been taught dress-making and pattern-cutting skills by her mother, and had honed her craft skills at the Royal College. She says "It was very important that we could actually make the garments; we knew how to do jetted pockets, for instance, and bound buttonholes."

In 1961 the pair found studio premises in Carnaby Street, then a rundown Soho back street lined with warehouses and small neighbourhood shops,

saddlers, and bakers, which gave it something of a village atmosphere. Neither Foale nor Tuffin had the support of a male partner or colleague, so vital to the success of both Mary Quant and Barbara Hulanicki at Biba. Their attempt to infiltrate the overwhelmingly male fashion business resulted in what Marion Foale recalls as "the hilarious response from wholesalers at two 'kooky' girls trying to source fabric and suppliers. We initially bought fabrics from Dickins & Jones and then realized that 'wholesale' existed."

They made the patterns and cut the first samples themselves. They originally sold their clothes to the Woollands 21 shop before opening their own premises in 1962 in Marlborough Court, just off Carnaby Street.

The Woollands 21 shop was becoming well known for showing the work of the new British designers such as Foale and Tuffin, Gerald McCann, and Ossie Clark. Martin Moss, when he took over as managing director in 1961, pioneered the concept of what has now come to be known as "niche

opposite & below Designs for the new Woollands store, which featured in the centenary issue of Queen magazine, 1861–1961. "The 21 shop was an instant success, in spite of the fact that there were very few manufacturers producing the clothes that were swinging enough to live up to the concept of the department," says Martin Moss, who was managing director at the time.

previous spread Photograph taken by boutique owner James Wedge. He says, "The actress Susannah York came in one day with a Nikon and that started me off... Meriel McCooey, fashion editor of The Sunday Times *magazine* was the first to use one of my prints in 1969. I photographed the girl nude, and enlarged the print. Then I cut around the legs, and cut out actual stockings, wrapped them around the legs and rephotographed the image. Then I hand-tinted the colour."

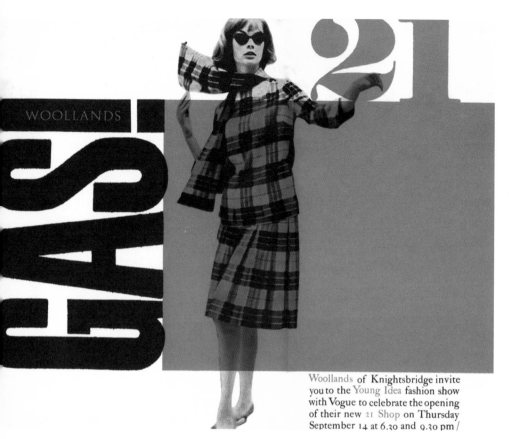

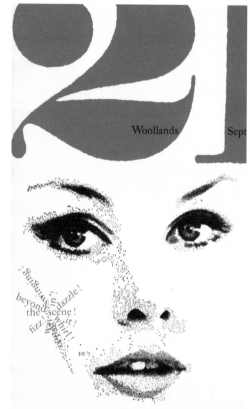

Woollands of Knightsbridge invite
you to the Young Idea fashion show
with Vogue to celebrate the opening
of their new 21 Shop on Thursday
September 14 at 6.30 and 9.30 pm /

marketing". He transformed the Knightsbridge department store, previously a fusty relic from Edwardian days, into a unique retail space. He describes the project: "The most critical of all our new departments was to be the ground-floor shop to appeal to the emerging young fashion customer. We invited the interior design section of the Royal College of Art to undertake this as a students' team project. By coincidence Terence Conran was acting as part-time tutor to the College and he took over the management of this unique challenge. We finally decided on a scheme which provided a central raised 'stage' two steps up, with roundels for garments and displays, and round the perimeter a series of fixtures and fittings using louvered slats."

The most significant aspect of this change in fashion-retail thinking occurred when Moss asked Vanessa Denza, then only twenty-two, to become the fashion buyer for the boutique. She was an iconoclastic figure who redefined this function from that of a passive to an active role. Rather

than choosing merchandise from what was on offer from the manufacturers, she actively pursued previously unknown designers straight from art college and made demands upon their talent and creativity. Georgina Linhart, a young designer from St. Martin's Fashion School, remembers meeting Denza at a party, "She ordered the dress I was wearing, so my husband David and I decided to set up a business. We scrabbled around the floor of our tiny apartment making dress patterns from old newspapers, breaking into our precious 'money-box' savings to buy fabric and then delivering the dresses on our bicycles, praying that the sequins that we had stuck on with UHU glue wouldn't come off."

Vanessa Denza acknowledged and elevated the role of the designer in the fashion industry. Previously, manufacturers had considered that role to be something of an expensive luxury, and had been satisfied to reproduce "diffusion" versions of the Parisian collections that more often than not

opposite page The invitation for the launch of Woollands 21, which was organized by Clare Rendlesham, in 1961. The party coincided with her feature on the boutique in Vogue. Models were photographed alongside celebrities including Kenneth Tynan, George Melly, Stirling Moss, Sean Kenny, Vidal Sassoon, Peter Cook, Wally Fawkes, and Terence Donovan.

left Talented Vanessa Denza had joined Woollands at nineteen and became its fashion buyer at twenty-two.

below The revolution in fashion affected hair styles. Designers Marion Foale and Sally Tuffin wear versions of the famed five-point haircut styled by Christopher Brooker at Vidal Sassoon in 1966. The photograph was taken by David Montgomery.

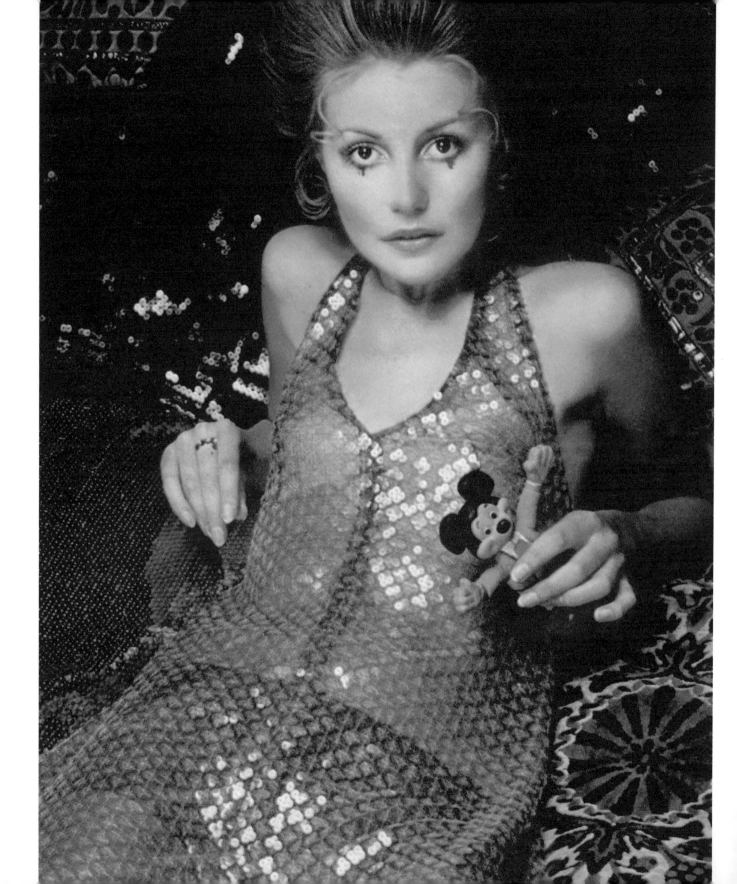

reflected the preferences of the wife of the managing director. Denza also accelerated the speed of change in response to a newly demanding customer, and replaced the slow-moving and monolithic processes then currently practised by the manufacturers by introducing a rapid turnover of stock. Rather than buying a few hundred styles and letting them run for a season, she ran a few dozen styles for a fraction of the time. This meant that her buying had to be absolutely accurate, the swiftness with which styles moved on meant that it was unrealistic to sell left-over stock in the sales. No customer wanted last month's stock let alone clothes from the previous season.

British fashion and culture was becoming the focus of world attention. *Ambassador* magazine wrote in 1963, "At the time of going to press one of our *Ambassador* awards will have been received by Woollands, the Knightsbridge department store, for recreating a young store out of Edwardian respectability and for providing a fashion forum in which British

ready-to-wear has an opportunity to live up to the best from overseas. Martin Moss, the managing director, has brought about what New York's *Women's Wear Daily* described as, "London's One Man Wave of Fashion. What started as a fad five years ago has developed into a very British, very young fashion expression."

Fashion was not the only means of expressing the new attitudes of the young. Marit Allen, editor of "Young Ideas" in *Vogue* recalls; "The flux started in 1963, '64. Things started to hot up, young people were finding a new personal voice; they didn't want to be like their parents. There was a universal movement afoot, that wasn't just about skirt lengths but a new social order. The young didn't want to be part of the existing social structure but wanted to be valued for their own capabilities, enthusiasms, and talent in every possible area. The new designers reflected this. Foale and Tuffin and John Bates came out of nowhere, they had a design concept, which

opposite page, right John Bates had no formal training in fashion design, but in 1960 he started the company Jean Varon and went on to open twenty-eight boutiques in British department stores.

opposite page, left Sixties model Twiggy wears a metallic bodysuit under a transparent organdie mini dress bordered in silver. It was designed by John Bates, renowned for his use of innovative materials.

right & below Such was the striking visual impact of Diana Rigg in The Avengers wearing clothes designed by John Bates, that her image was syndicated throughout the national press. This introduced "the look" to a vast new audience.

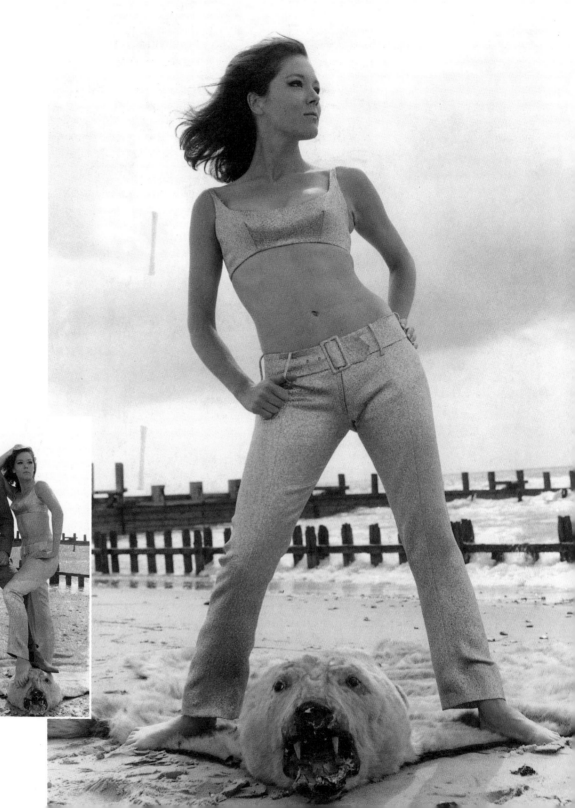

was totally new. They were the most modern. John Bates, in particular, has always been completely unappreciated for his contribution to the innovation and creativity he brought to the London design scene."

With no formal design training, and after a short spell at the War Office, John Bates followed four years at the couture house Gerard Pipard by starting his company, Jean Varon, in 1960. He was the managing director and sole designer and says, "I called it Jean Varon because at the time an English name like John Bates meant nothing, you had to appear to be French. *Jean* is French for John, and Varon because there was no 'V' in the rag trade book. Jean Varon made a good graphic image. The range was in more expensive fabrics and was more labour intensive. The fashion editors connected the John Bates label with clothes that were more avant-garde."

Bates acknowledges that it was tough to begin with. "Without Marit Allen, we would have been nowhere. We owe her a lot. No one wanted to know when we did the collections. Initially I had to do draped chiffon dresses because that was what stores like Fenwicks wanted…. What made all the difference was to get coverage in the editorial of magazines and newspapers. Editorial would mention stockists, so the stores had to agree to stock the garment. That was the only way to get bought by the stores. Sometimes they would only buy the one dress. It was difficult to get Vanessa Denza or Martin Moss to pay attention, as I had not been RCA trained. A couple of collections had to be done before you were considered to be serious, and the buyers would come to see you."

Bates's clothes defined femininity. Cut with the precision of lingerie, the décolletage and high-waisted dresses drew the attention of the buyers and the press. The design for which Bates won the "Dress of the Year" award in 1965 was an indication of his preoccupation with revealing the body beneath the clothes. Marit Allen recalls that he was the first designer to use

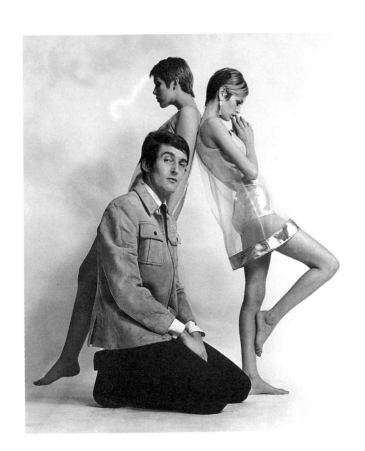

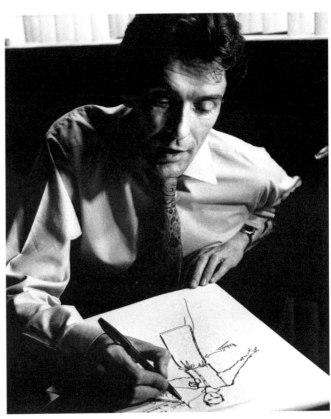

transparent materials and to bare the midriff. By elevating the waistline in his designs the entire proportions of the dress were redefined. It allowed for the importance of the horizontal line of the hips, leading to an emphasis on the midriff and, most importantly, to the raising of the hemline. It was John Bates, rather than Mary Quant or Courrèges, who was responsible for the miniskirt.

A walk through Soho to get some buttons sparked his interest in alternative fabrics, "I saw a dirty old shop with some black oilskin in the window meant to be used for tablecloths. I thought, 'I could do something with that,' and had it made up into a dress. One of the evening papers picked it up with a 'Is this the stupidest dress you could buy?' sort of article. When the model moved, all the seams perforated like postage stamps, so of course we had to solve all sorts of manufacturing problems."

In 1965 Anne Trehearne, ex-editor of *Queen* magazine, asked John Bates to design a new wardrobe for Diana Rigg, the replacement for Honor Blackman in the cult TV show, *The Avengers*. Blackman's trademark look had been the all-in-one leather jumpsuit, but Bates's agenda was to show Rigg as an entirely new sort of heroine: modern, sexy, and provocative. The designs found their perfect showcase in the world of the *Avengers*, with its frantic editing and fast-paced action sequences. John Bates recalls the exciting time: "I had a week to read the script and to design the first outfit. Diana Rigg was not a model, she had quite a masculine shape, with square shoulders, and I fitted the outfit on her. We delivered it and went 'Pheew' because time had been so short. Then on the morning of the shoot they asked, 'Where is Miss Rigg's costume?' The stuntman had worn it, thinking it was his, and had torn it to pieces. I had to make another one overnight."

Bates was also responsible for making the accessories for the show. "I made all the garments, organized watches, furs, shoes, and even had a go at making matching tights."

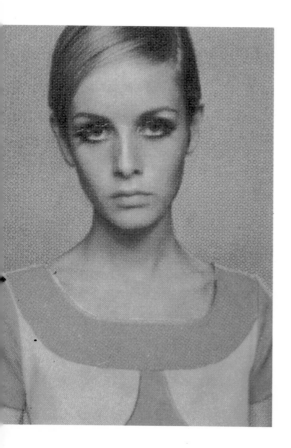

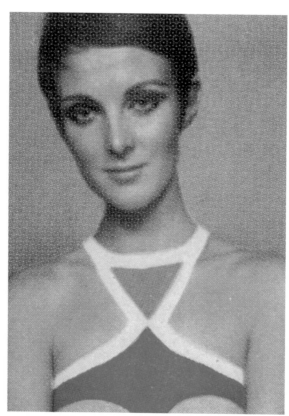

right When designing transparent dresses such as this, John Bates decided that "Rather than using lining material I preferred to make a matching bathing suit. The skirts were so short anyway it was a way for the girls to wear the clothes without showing their underwear when they sat down, and becoming embarrassed."

left & far left Shoulders assumed a new importance in the silhouette of the sixties. Here designer John Bates takes the cut-away armhole to extremes in colour-blocked crêpe. He says, "Patterned crêpes couldn't be bought, so I had to sew the fabric into squares and stripes."

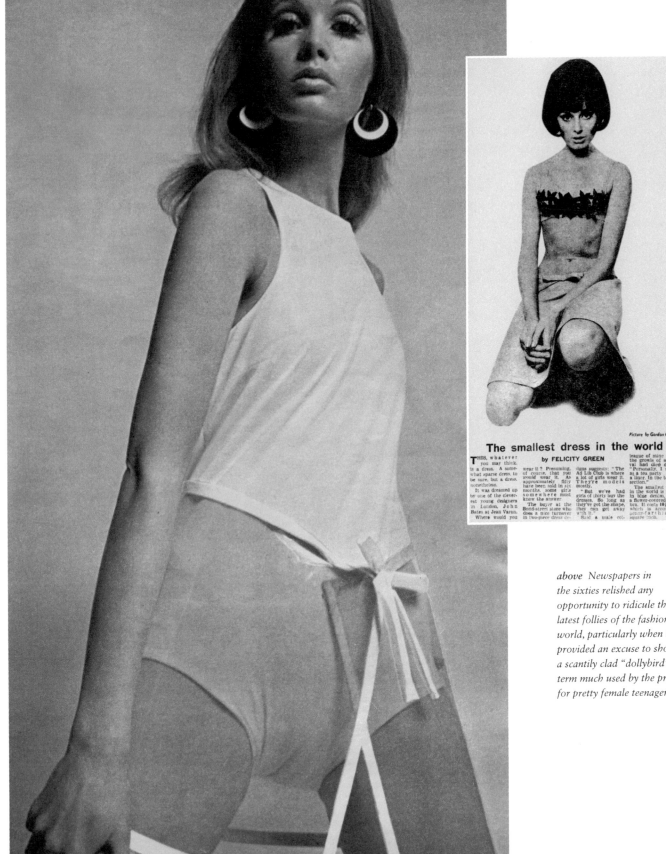

Picture by Gordon Carter

The smallest dress in the world

by FELICITY GREEN

THIS, whatever you may think, is a dress. A somewhat sparse dress, to be sure, but a dress, nonetheless.

It was dreamed up by one of the clever-est young designers in London, John Bates at Jean Varon.

Where would you wear it? Presuming, of course, that you would wear it. As approximately fifty have been sold in six months, some girls somewhere must know the answer.

The buyer at the Bond-street store who does a nice turnover in two-piece dress de-signs suggests: "The Ad Lib Club is where a lot of girls wear it. They're models mostly.

"But we've had girls of thirty buy the dresses. So long as they've got the shape, they can get away with it."

Said a male col-league of mine when the growls of appro-val had died down: "Personally, I see it at a tea party ... or at a liner, in the tourist section."

The smallest dress in the world is made in blue denim, with a flower-covered hal-ter. It costs 10½ gns, which is around a penny-farthing a square inch.

above Newspapers in the sixties relished any opportunity to ridicule the latest follies of the fashion world, particularly when it provided an excuse to show a scantily clad "dollybird', a term much used by the press for pretty female teenagers.

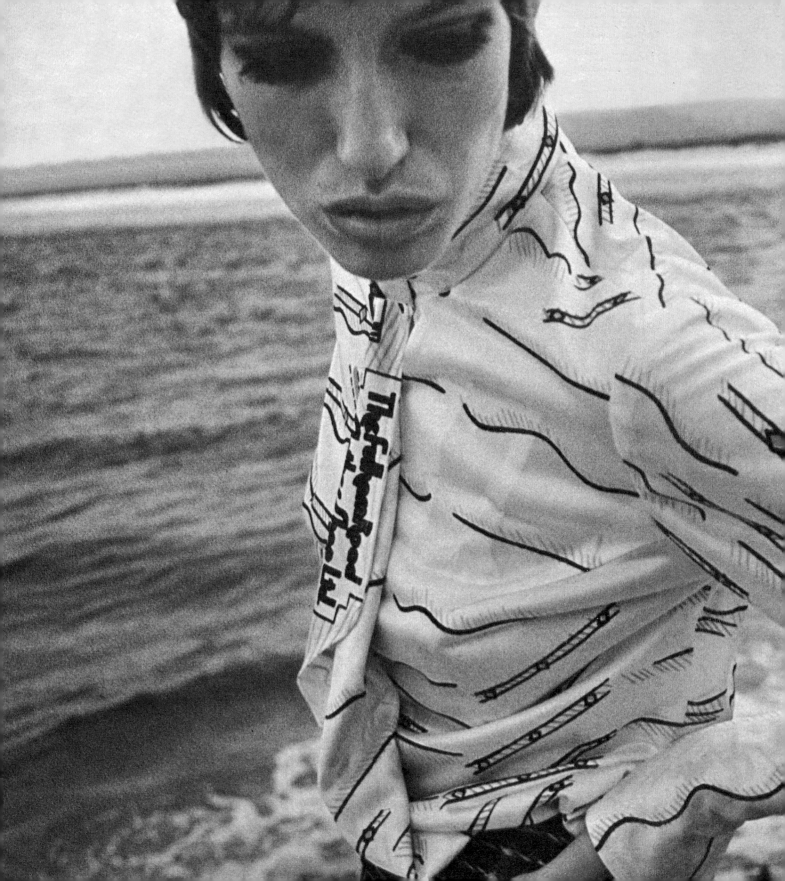

left Janet Street-Porter,
at the time working on the
teenage magazine Petticoat,
models a blouse designed
by Sylvia Ayton using a
print by Zandra Rhodes.
In an early use of the logo,
the tie and the cuffs of the
blouse are printed with the
name`of the two designers'
boutique, The Fulham Road
Clothes Shop.

Bates's clothes appealed to a customer newly acquainted with the novelty of garments designed with their age group in mind, but it was some time before the fashion establishment caught up. *Vogue* was instrumental in conveying the look, but as Marit Allen confirms, "It was difficult ground for Condé Nast. It was bold of them to throw aside conventional wisdom and be prepared to take on the new order. What started in "Young Ideas" was gradually absorbed throughout the rest of the pages as well. Sometimes the clothes I showed had no outlet, such as those by Zandra Rhodes. I introduced her clothes to Fortnum & Mason."

Zandra Rhodes, who had studied textile design at the Royal College of Art, initially collaborated with Sylvia Ayton, a fashion graduate who had also been inspired by the talk by Alexander Plunket Greene. Sylvia recalls: "I had gone through the RCA wearing a black wool crêpe sleeveless shift dress, plus underwired padded bra, stockings, and a girdle. I thought you had to. I was told off for wearing long hair and a mohair jumper on a visit to a London couture house! We were fashion students, not art students. Then gradually we started to design clothes that were different, that were for us to wear. When we left there were very few jobs that we actually wanted to do. No manufacturer could understand us. Too different, too dangerous, too risky.

"Suddenly it was the swinging sixties, it was the most exciting, wonderful and magical time. To be a designer then was fab. We kept our bras but we abandoned our girdles, pulling on pantyhose changed our lives even more than the pill. The sort of clothes I designed definitely didn't go with underwear. It was impossible to buy women's trousers that fitted around the crutch and thigh, they all draped. So I eliminated pleats and most darts, and sexy pants emerged. These were trousers you could not possibly wear over a girdle, suspenders and stockings. The trouser was now a young and sexy and important garment. By wearing it you showed you were different. We

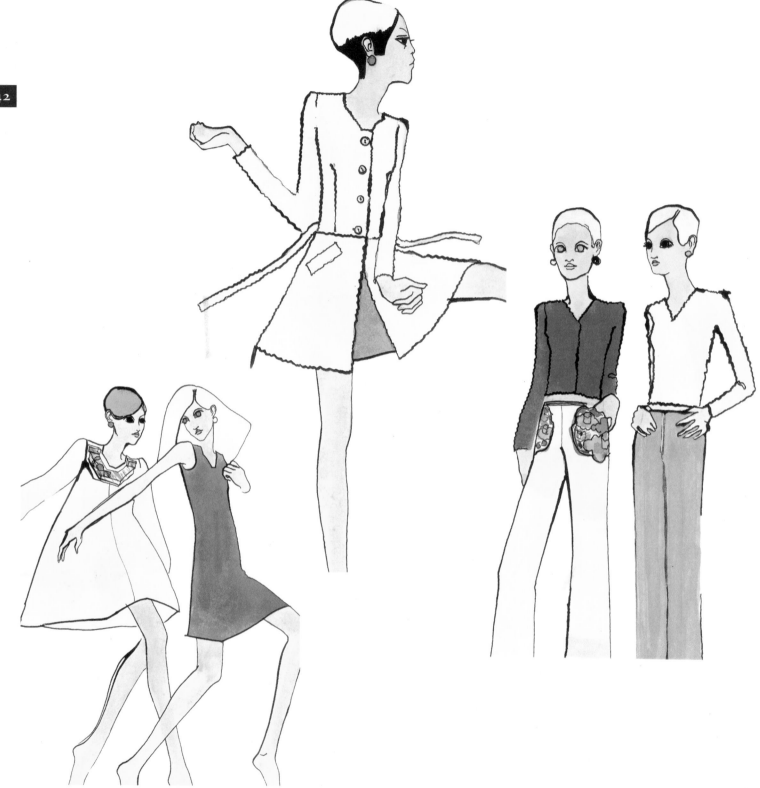

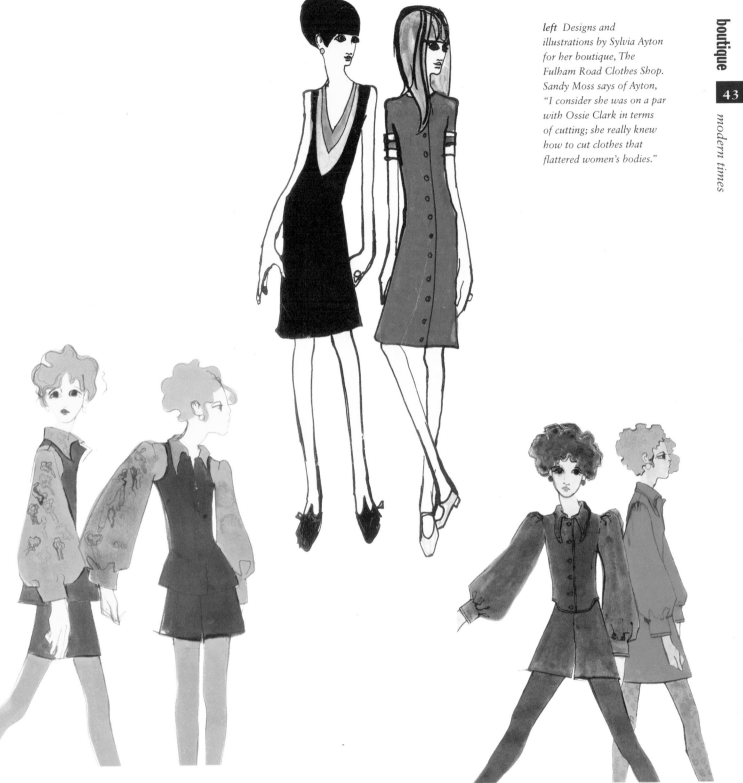

left Designs and illustrations by Sylvia Ayton for her boutique, The Fulham Road Clothes Shop. Sandy Moss says of Ayton, "I consider she was on a par with Ossie Clark in terms of cutting; she really knew how to cut clothes that flattered women's bodies."

definitely rejected couture. In 1965 I was designing for Pauline Fordham's shop Palisades on Ganton Street, and Top Gear and Countdown on the King's Road, owned by James Wedge and Pat Booth."

The King's Road, already the site of the first Bazaar shop and of a boutique owned by Kiki Byrne, also became home to one of the most influential boutiques of the era, Top Gear, which opened in 1965, on the site of what had once been a travel agent. James Wedge, one of the owners, had always known that he wanted a career in fashion and after two years doing national service in the Navy, he went to Walthamstow Art College, before going on to study millinery at the Royal College of Art.

"I was the only student doing millinery. I had a little room all to myself and the tutor, Peter Shepherd, came in one half day a week just for me. Because I was the only student it meant that my hats appeared a lot at the end of year shows. I designed hats for every garment and so I got a lot of press coverage."

From college Wedge went to work for one of the London couturiers, Ronald Patterson, and then made a deal with the London store Liberty. "They paid the rent for a room off Carnaby Street and took first option on the hats I produced." Those they did not want he was allowed to sell. After two years he rented a whole house at 4 Ganton Street. The first floor was the showroom, the second the workroom. The biannual shows were such a success that the press sat on the stairs and had descriptions of the hats called out to them.

Wedge's break into retailing came when Vidal Sassoon, then a radical figure who revolutionized the styling of women's hair, saw one of his hats in *Vogue* worn with the famous geometric haircut. He asked James Wedge if he would open a small boutique in his Bond Street salon.

"Success came to me when I had no idea about the world. I went into Vidal's one day with a bad cold, and he said, 'You don't look well, what you need is a sauna.' I had no idea what a sauna was, I thought it was some kind of drink."

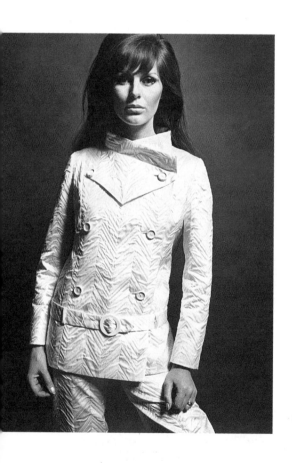

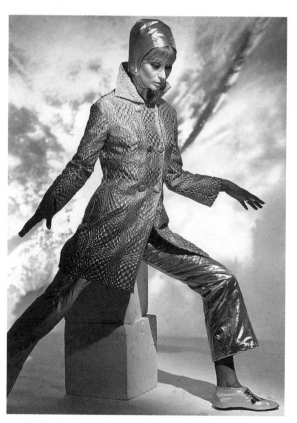

left An advertisement for Lurex, a non-tarnishing metallic yarn, which provided the gold lamé paper taffeta for this "sophisticated relaxer" designed by Georgina Linhart.

far left Prevailing attitudes prohibited trouser suits in most restaurants and hotels. David Skinner's elegant compromise of richly brocaded evening trouser suit sought to give the authority of the evidently expensive to the young cool protagonist.

right Chiffon trousers and spangled top designed by Georgina Linhart. As she describes it, "The bodice was made up of squares of light and dark pink Perspex, all cut by hand."

23 JULY 1966 2s 6d

london life

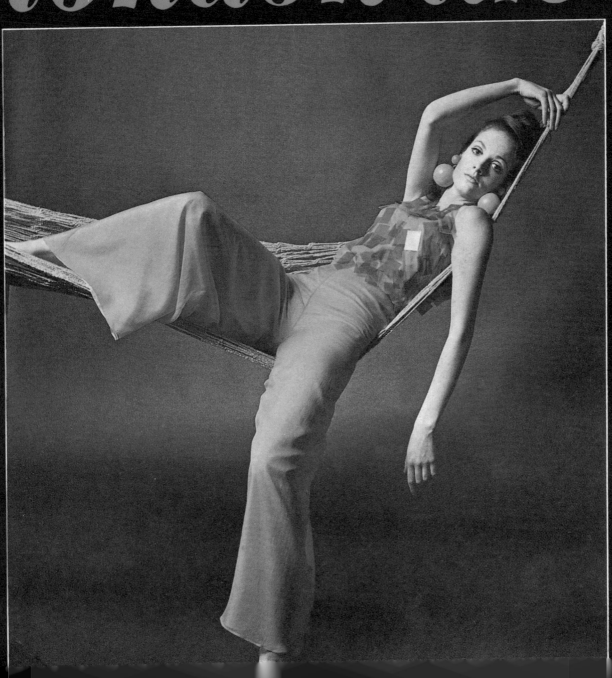

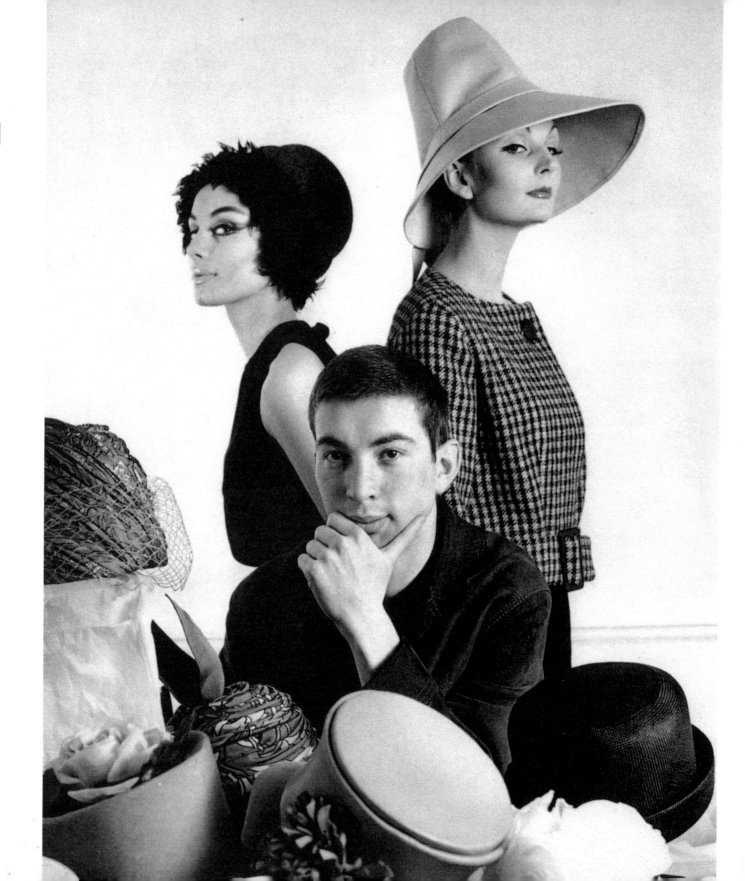

left James Wedge from Shoreditch, London, studied millinery at the Royal College of Art, before becoming a successful hat designer. He then went on to open the boutiques Top Gear and Countdown on London's King's Road with his partner Pat Booth.

right Sixties model Pat Booth. She says, "I decided I wanted to be a model and when I was sixteen I moved to a bedsit in Notting Hill and waitressed all evening so I could take my portfolio around during the day. After a couple of years James and I started Top Gear."

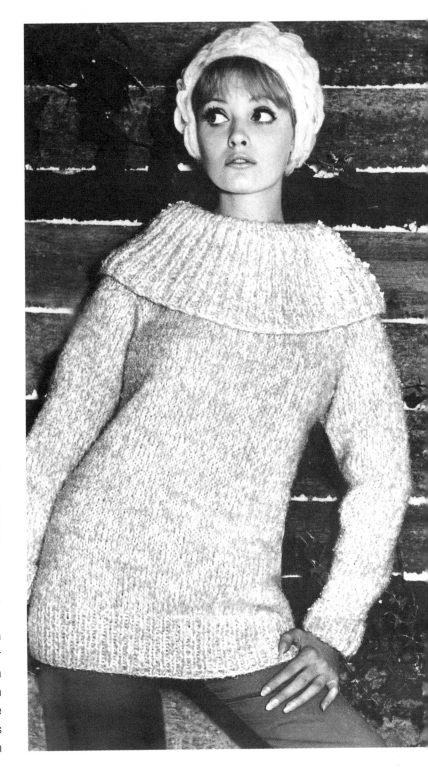

Wedge says he decided to open his own boutique because, "I was trying to sell younger hats, and young people didn't go into the millinery department of the stores, and there was no other outlet." At a fitting for one of his hats he met Pat Booth, a successful young model, who later became a photographer and bestselling author.

She recalls, "I'd made quite a bit of money from modelling, and I was looking around for something to invest in. We opened Top Gear on the same day as Biba opened, but we were much more expensive. At the time there was no one taking the work of young designers. Mary Quant was down the road but she only sold under her own label. It was the first time anyone sold other people's clothes. We sold one-offs from designers such as Foale and Tuffin and Ossie Clark and Moya Bowler shoes. We were showcasing modern British talent." She goes on to say, "It was a tiny tunnel of a shop, and the actor Albert Finney and some mates painted it black."

James Wedge confirms, "Because it was so small I fixed a mirror to one wall and surrounded it with light bulbs. I used scaffolding for dress rails, and the shopping bags were white, with a bull's-eye in the middle. Instantly recognizable. I did bull's-eye earrings and brooches to match."

According to Marit Allen, James Wedge and Pat Booth knew everyone. "They had an enormous amount of social and professional contacts", she recalls.

"The shop was a meeting place every single Saturday," Pat Booth remembers. "For the first time shopping became a social event. Our customers were pop stars and the aristocracy. John Lennon used to sit on the window sill and put 78's on the old record player. Mick Jagger had an account with us for all his girlfriends. When he broke up with them he stopped paying their bills. Albert Finney came in to do the books in the evening. We lost every penny we made in the first year through

shoplifting, but our turnover was so enormous that we could afford to buy the lease of the next-door shop, which we called Countdown."

"When we opened Countdown we had more space," Pat Booth remembers. "We would sell anything that caught our eye, not just clothes. Inflatable furniture to Lord Snowdon. Things I would find on my travels abroad, jewellery. We were the first people to do blue jeans as a fashion statement; they were appliquéd with flowers. I imported them from a company in France, and they sold in their hundreds. We were always trying new things to keep ahead of the game. It was fun, but it was also incredibly hard work."

By the time they were ready to open Countdown, London was burgeoning with new retail outlets. Jeff Banks's Clobber was one of them. He says, "We opened at No. 11, Blackheath Village. Blackheath then was the Hampstead of South London – people like Terence Stamp, Jean Shrimpton, the actress Glenda Jackson, art directors, and photographers lived around there. It didn't matter where you were, people would travel to find you. On the first day we sold out of everything, bar one coat. There were thousands of people outside, the mounted police were trying to control the crowds. Anne Wright and Jenny Quick were our PRs and they got the Beatles and Jean Shrimpton to the opening.

"The shop was tiny and the interior was French bistro meets English country house salon. Bare brick, white-painted walls, wooden floor, iron chandeliers: a really eclectic mix. Clothes were hung in French armoires, and sweaters were folded up in piles on round wooden tables. Clobber was the forerunner of Biba; we had hat stands and jardinières.

"Initially friends supplied the clothes: Ossie Clark, Janice Wainright, Jean Muir of Jane and Jane. We sold Moya Bowler shoes, Sally Jess bags, and Foale & Tuffin knitwear. Everything sold out. We would only allow twenty people in at a time, and would put a red rope across the top of the stairs."

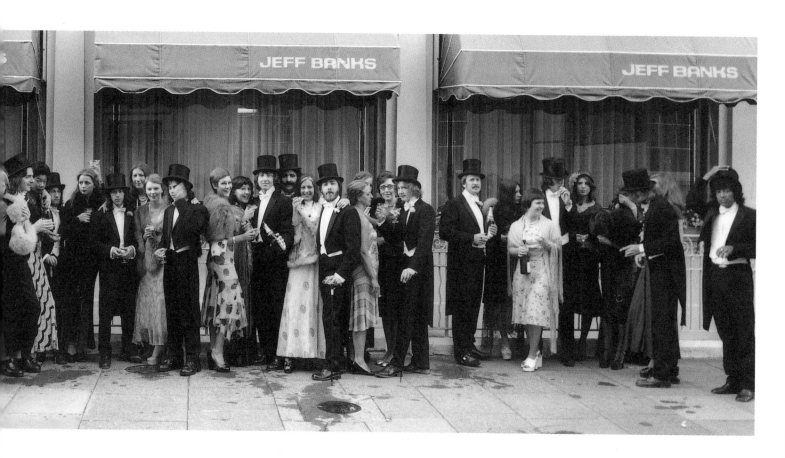

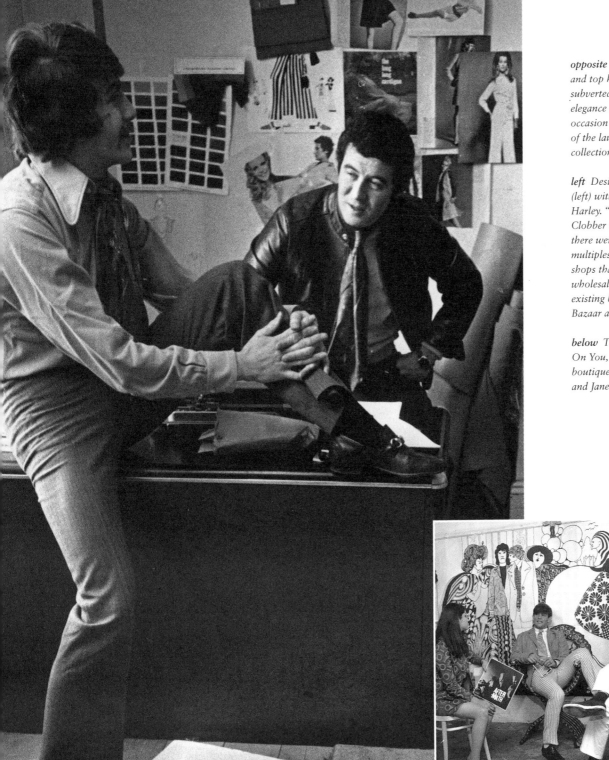

opposite page Long hair and top hats – a look that subverted traditional elegance and formality. The occasion was the celebration of the launch of a new collection by Jeff Banks.

left Designer Jeff Banks (left) with colleague Tony Harley. "When I first started Clobber with Tony in 1964 there were no High Street multiples, just independent shops that bought from wholesalers. The only existing boutiques were Bazaar and Top Gear."

below The interior of Hung On You, the Cale Street boutique owned by Michael and Jane Rainey.

right In the 1950s hosiery company Aristoc first tried to make panty hose. By the early sixties "tights", as they came to be known, were made in a tubular form and steamed into shape. Textured and patterned tights provided a new area of interest and 1966 was designated "the year of the leg."

Banks's move from retailer to designer and manufacturer was prompted by the difficulty in sourcing enough stock to meet the demand. "The day after we opened we were standing in the empty shop and Freda Fairway, who had worked for Hardy Amies and Mary Quant, came into the shop and said, 'Why don't you make your own clothes?' There was nothing she didn't know about making clothes. She stayed with me seventeen years.

"The tiny little shop opened up like the Tardis into giant premises, set around a courtyard, and we had a workroom running with six machinists within the first week of opening the boutique.

"We started making clothes for other boutiques. People travelled from Milan, Paris, and Munich to stock up on Clobber clothes. In 1965 I started to drive around the country to sell the collection to other boutiques. I bought a Rolls Royce because John Lennon had one, and drove up to Liverpool with samples in the back of the car. I sold to Lucinda Byers in Liverpool, and Fenwicks in Newcastle. John Fenwick came to look at the clothes himself. He was an amazing seventy-eight, and prodded at the samples with his walking stick. He said he'd heard about the idea of shops within a shop, and that he wanted to try it in Fenwicks. The models Patti and Jenny Boyd flew up from London for the opening."

The association with celebrity typified the London boutique scene. Actress Vanessa Redgrave and photographer Annette Green backed Sylvia Ayton and Zandra Rhodes in the opening of their new boutique, which was called The Fulham Road Clothes Shop.

The two designers had met while they were both teaching at Ravensbourne College of Art in London. Sylvia Ayton remembers the time: "We decided to work together, her prints with my designs. It was very difficult to get the buyers interested as there were so few outlets, and in 1968 we decided to start our own boutique. We had a wonderful opening party with

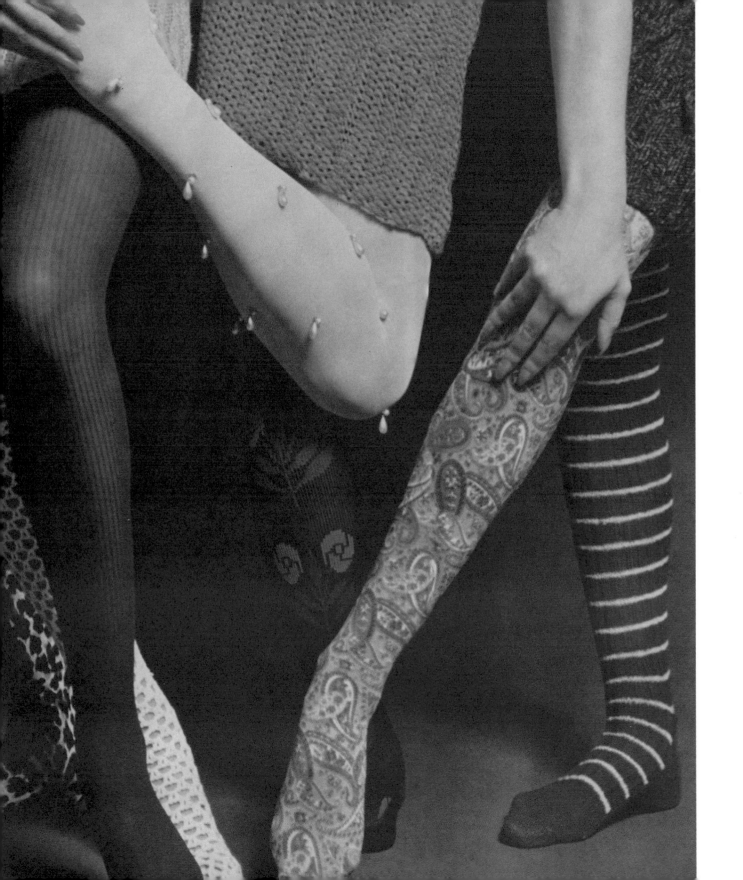

Jo Cocker playing the music. The shop window was neon lights and silver, and the lights flashed if you shouted at it.

"Although our innovations such as tattoo print transfers and paper dresses were commercially successful (the Miss Selfridge buyer asked us how to stop the customers from tearing the hems of the dresses to see if they really were paper), the business side of the enterprise was badly run. We weren't very good at it, we liked designing and drawing too much. People owed us lots of money and we owed people lots of money. The bailiffs came quite often. It was very frightening, they were such huge blokes, and I would hide in the bathroom until they had gone. We had no business sense, and no financial sense. I don't think we ever took a salary from the company. We -always had lots of publicity, but that doesn't always mean much in terms of sales. We wanted to put a poster of Vanessa above the façade, but Chelsea Council turned us down. We had to close the shop. It was very sad."

The capriciousness of the young, the vibrant energy, and the ephemeral nature of fashion were an essential element of the dynamics of the exciting sixties scene in London. *Daily Express* fashion editor Deirdre McSharry summed up the "boutique bonanza". "Over a back bedroom in Bermondsey, in a converted dairy in Chelsea, in Soho cellars, down a dark Dickensian alleyway in the city, the signs appear, 'Top Gear', 'City' ,'You and I', 'Palisades', 'Spice No 1', 'Boys'. The signs are portents – not of night clubs and discotheques, but of the new Saturday night – Monday morning approach to shopping… the boutique.

"The boutique bonanza is the new selling sound, the loud note at the retail level… 1965 fashion's lots-for-less beat. In the past year hundreds of boutiques have opened all over Britain. Lots of them in London…. They are vulgar, brash, loud (literally – they find sales increase in direct ratio to the volume of the record player), and great fun."

opposite page Leopard wild cat fur coat designed by Gerald McCann. There was no resistance to the wearing of endangered animal skins in the sixties – fur was increasingly popular, both real and fake.

right This Liberty Tana lawn smock dress, designed by Gerald McCann in 1965. He described it as "The hottest Dress in the World".

far right Fur ceased to be viewed as a precious commodity and status symbol for the rich older woman. "Once we started to buy fur plates out of China we were able to tailor it as if it were cloth, rather than having to work the skins into shape". Double-breasted fur coat by Gerald McCann for the younger market.

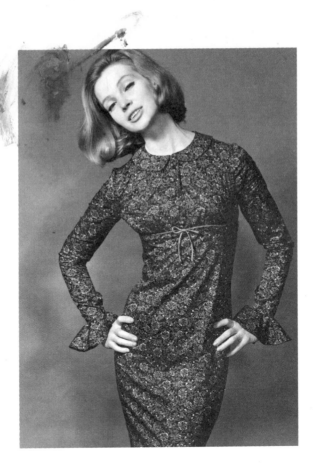

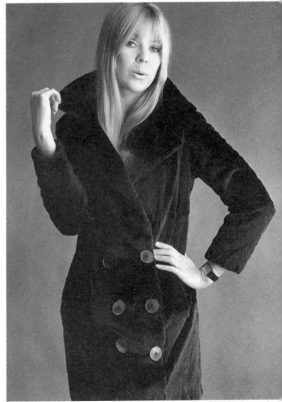

peacock alley

the rise of Carnaby Street and
the shift in masculinity

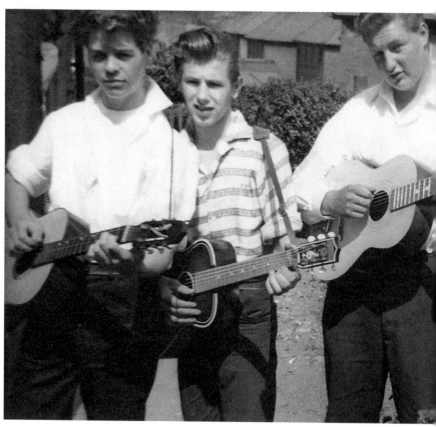

as austerity declined, the dull post-war pavements of Britain evidenced a change as a new youth cult, the teddy boys – flash, colourful, predatory, and every mother's nightmare – arrived on the scene. A teenager from that period recalls: "In our town there were the Young Conservatives, and the teddy boys. Needless to say we preferred hanging around on street corners or in the one and only coffee bar, seeing what the teds got up to. The most shocking thing was throwing a policeman through a shop window. They liked an audience, particularly if it was female."

Shopping has generally been perceived as a female preoccupation. The traditional view is that only women allow themselves to be duped by the vagaries of fashion and to be seduced by the temptations of new clothes, even when these are not appropriate, comfortable, or affordable. However, the teddy boys were to change this view. They were the first group of working-class young men to embrace stylistic self-consciousness and to assert an interest in fashion. Overturning the male middle-class preoccupation with quiet clothes and quiet behaviour, the teddy boys were an example of the increasing interest in male adornment and fashion. They prefigured a new order that was to culminate with the narcissistic and clothes-obsessed mod movement, and later to influence the hippy generation, who went on to push the boundaries of gender with their androgynous hairstyles and clothes.

The origins of the teddy boy look were to be found in a pastiche of the New Edwardians, which was a style that permeated the upper classes of the late forties and early fifties. It was a camp and satirical take on the style of the Edwardian dandy. As the look became appropriated by working-class youth, the details of Edwardian dress – velvet collar and narrow trousers – were superimposed on to the drape coat of the American "zoot" suit, which was essentially a black American style.

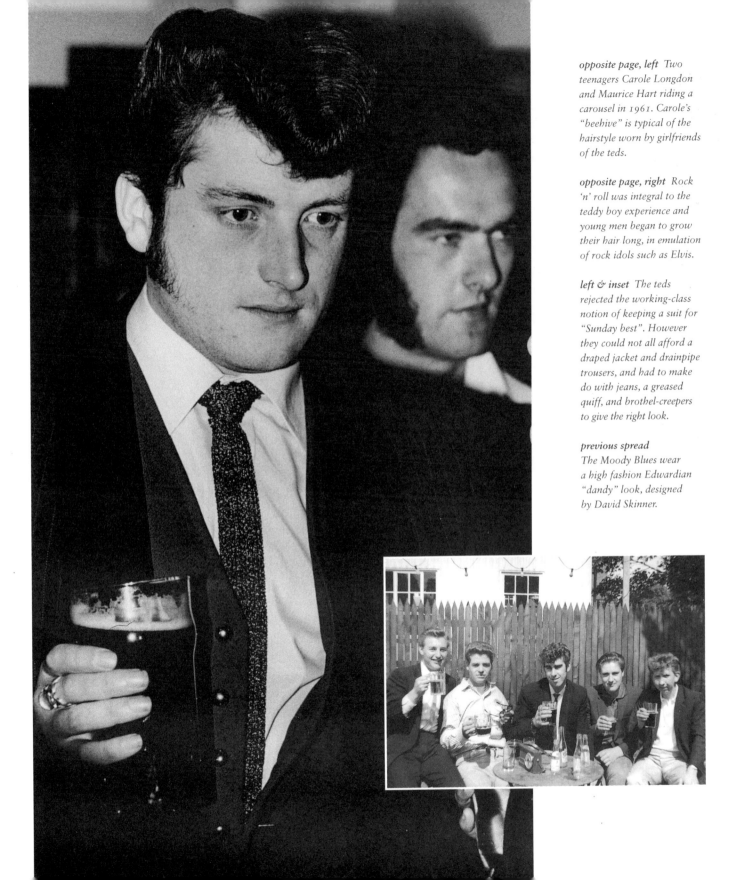

opposite page, left *Two teenagers Carole Longdon and Maurice Hart riding a carousel in 1961. Carole's "beehive" is typical of the hairstyle worn by girlfriends of the teds.*

opposite page, right *Rock 'n' roll was integral to the teddy boy experience and young men began to grow their hair long, in emulation of rock idols such as Elvis.*

left & inset *The teds rejected the working-class notion of keeping a suit for "Sunday best". However they could not all afford a draped jacket and drainpipe trousers, and had to make do with jeans, a greased quiff, and brothel-creepers to give the right look.*

previous spread *The Moody Blues wear a high fashion Edwardian "dandy" look, designed by David Skinner.*

left *People came from abroad to London simply to shop. Carnaby Street and the King's Road became fixed landmarks on the itineraries of young tourists as boutique culture flourished.*

right *The naming of boutiques became virtually a literary genre. Hung On You exploited contemporary vernacular usage, making multi-faceted references to music, to relationships, and to customers.*

Teddy boys initially appeared in the East End of London in 1955. By the time Bill Haley's "Rock Around The Clock" was released they were to be seen in all major cities and suburban towns across Britain.

The most significant feature of this uncompromisingly proletarian and overtly heterosexual group was their hair. Teddy boys had sideburns to well below their ears. The hair was worn long and swept up into a quiff at the front and moulded with hair oil into a neat "duck's arse" shape at the back.

Ray Gosling recalls the hairstyle in his book *Personal Copy*, "In the beginning it was a battle to get your hair done. Most stylists, or barbers as they were called in those days, were men who'd been wounded in the war and they cut short-back-and-sides with conviction – but in one fairly big salon, downtown, a barber called Wally began to specialize in styling teds' hair. Wally the hairstylist. He was in an ordinary barber's shop, Wally was, and on Saturday mornings, the owner used to let him mess about with the

teds. And slowly the shop got taken over and then Wally got an apprentice called Reg, and the two of them used to do teds. Teds made Wally. You used to go in with your hair filthy. You used to have it washed by Reg and rubbed with a towel. Wally then approached you, wearing a different, rather natty, new-style barber's jacket like a dentist. He was a good cutter, serious, and your front quiff he would curl with hot irons. You'd then be finished off in front of a dryer with a hairnet on, feeling silly and cissy. Reg'd come and feel your hair. Wally'd give you a final blow, a last flick and it was beautiful when you went out… We used to plaster it with coconut grease from Boots the chemist: thick grease. I remember a cold day when it was freezing and I couldn't move my hair at all and had to get near a coal boiler to warm it up 'cause the grease had all frozen. Solid coconut grease. When it was hot weather it melted and ran down the back of the neck, spoiling your nice white shirt but we wanted our hair to look greasy, not clean."

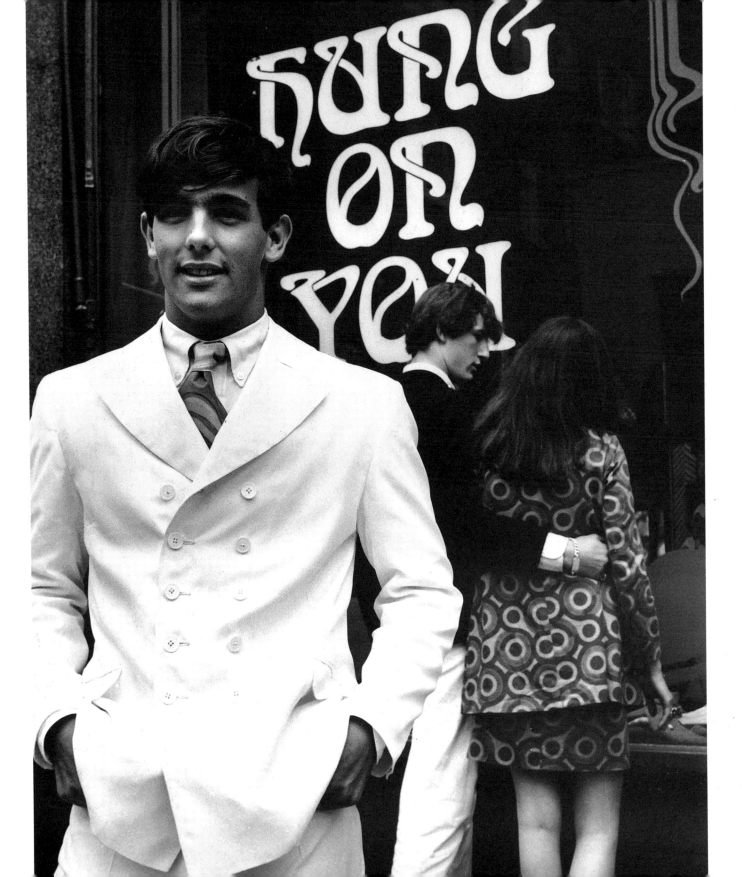

The steel comb that was flicked out of the breast pocket whenever the teenager encountered his reflection or his female audience would have been sharpened along the back to a razor's edge. It was a potent symbol of the juxtaposition of violence and narcissism that was characteristic of the teddy boy movement.

The teddy boys' preoccupation with appearance and their shopping habits were not seen in any way to compromise their masculinity, probably because of the eagerness with which they embraced conflict. It was an expensive look, but for those who could not afford the initial outlay there were credit schemes available.

Gilbert Higginbotham, a gentlemen's outfitter selling the drape jackets and narrow trousers in the suburbs remembers, "We had a scheme by which the boys could put five shillings a week into a club, and pay off the debt that way. It was an expensive business, we did made to measure, and the suit alone would cost about twenty pounds, and that's not counting the money spent on shoes and shirts."

Not every teddy boy could afford the money for the full outfit, which included a drape jacket in peacock blue or maroon with a black velvet collar, a shoestring tie, suede brothel creepers, and a pair of narrow trousers. Most, in the end, were satisfied to get the correct haircut, tight-fitting jeans, and a pair of colourful brothel-creepers, which were later to be replaced by flat-heeled winkle-pickers.

As the fifties came to a close, working-class macho teds were gradually transmuted into leather-clad rockers. They were natural enemies of the clothes-obsessed "mods". The term "mod" came to be used as a wide-ranging adjective to describe anything fashionable. Initially the mods were a small minority cult – a group of youths whose excessive neatness and attention to detail characterized the movement. In 1956, Cecil Gee had

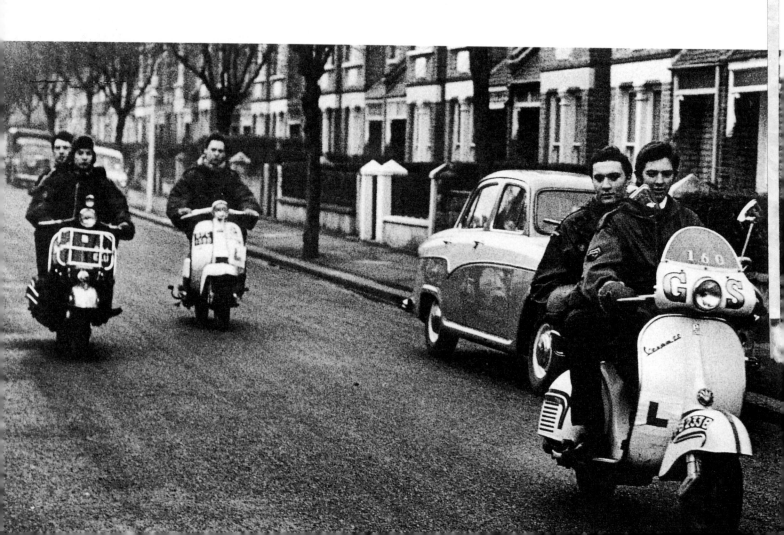

opposite page The summers of '64 and '65 saw the mods congregate in Britain's coastal towns looking for bank holiday confrontations with the rockers, the natural successors to the teds.

above Paul Smith visiting Carnaby Street in 1965 in a shirt made for him by a friend from Liberty's Tana lawn – a small floral print formerly used for children's clothes. His Chelsea boots, made popular by the Beatles, were bought from theatrical shoemaker Anello & Davide.

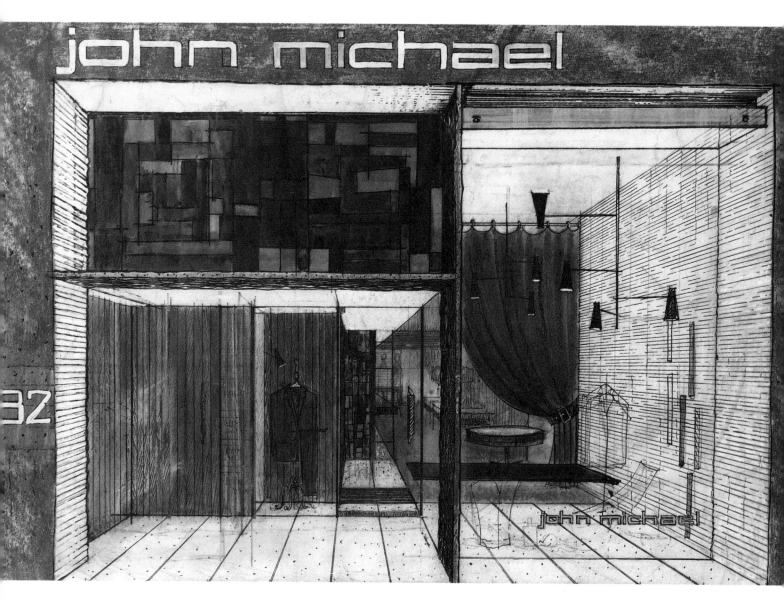

john michael

32

john michael

above Gerald McCann
designed one of John
Michael's eponymous shops.
He said "I designed 'fantasy'
suede curtains, hessian walls,
aubergine paint, and bronze
fittings. My mother made the
billiard table-style lamps as
you couldn't buy them."

opposite page, left Gerald
McCann designed clothes
that were modern versions
of the English country
gentleman style. His jackets
and other lesiure clothes
had a relaxed look that
eschewed formality and
heavily constructed tailoring.

opposite page, right
Drawings by Gerald
McCann for his menswear
collection. The narrow waist
and high armhole of the
jacket and the low rise of
the narrow trousers created
a slim look that was the
essence of youthful dandyism.

introduced his version of the Italian look to his shops, a neat, modern silhouette that was influenced by the tailoring of the Brioni brothers of Rome. The short, boxlike jackets with narrow lapels and the close-fitting trousers in lightweight fabrics were the precursors of mod clothes.

The mods discarded the conventional stereotypes of masculinity and came to understand the transforming nature of clothes and the pleasures of sartorial adornment. The traditional male silhouette of upturned triangle, with wide shoulders and narrow hips, was replaced by that of a narrow-shouldered boy. Neatness replaced flamboyance, but it was an anarchic neatness that signified youth, narcissism, and an indifference to contemporary rules. The mods had rejected the factory wage-slave ethic for work in new enterprises such as advertising and graphic design companies. And, at a time of unparalleled affluence for teenagers, they spent their money on pursuing sartorial perfection.

The suit was subverted from its role as the businessman's uniform into an item of exquisite refinement, where the size and placement of a button and the width of a lapel were subjects of lengthy negotiations with the tailor. Even the large multiples such as Burton's offered an element of choice. A mod at the time, John Angus remembers, "Burton's didn't offer a true bespoke service, I didn't go for fittings, but there were a huge amount of permutations from which to specify an individual style. They would then use the pattern block closest to the customer's specifications, and tweak the system. The suits would have to be cut individually to accommodate the desired length of vent or shape of collar. There would be four or five fabric pattern books on display, with forty to fifty fabrics in each one. A suit would cost around fourteen pounds. I worked night shifts in the bakery while I was at school to pay for my clothes. In those days mods went to London for two things, cheap, long leather coats from the Portobello Road and hashish from Brixton."

far left & below London's Carnaby Street become the epicentre of the mod upheaval and of male fashion. In 1967 it was lined with twenty-five boutiques with names such as His, Mod Male, Domino Male, and Male W1.

left In the sixties the Union Jack flag changed from being a traditional symbol of patriotism to a useful image that rebranded popular culture. It became an ironic, persuasive emblem of "Swinging London".

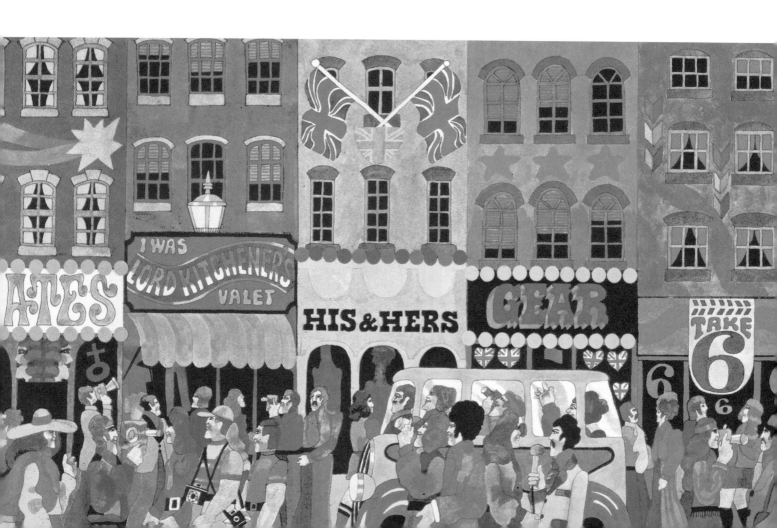

The mod aimed for neat, subtle perfection, and physical grooming played a large part in completing the look. As a group the mods were initially perceived as physically timid, however their obsession with physical appearance caused derision or consternation, particularly among those who felt threatened by the appropriation of traditionally feminine concerns such as interest in clothes and grooming. It was not at all unusual for a girl to claim that her boyfriend was "really pretty". Girls could be mod, too, but it was a diffused version, without any of the male obsessions. As Twiggy confirms, "Being a mod was a serious business. The boys had the best of it. They were like peacocks, strutting around like never before…. And where it all happened was in dance halls on Saturday nights." For the first time popular dance did not involve touching a partner, and the clubs and dance halls had groups of boys and girls arranging themselves at opposite ends of the room at the beginning of the evening.

Those lucky enough to have a mod boyfriend were allowed to participate in grooming activities. "If we were going out I had to put his hair in rollers and do the make-up, nothing too obvious, and then I would get ready, in half the time. I was always waiting for him," remembers one girlfriend.

Schoolboys would try to customize their school uniform in an attempt to adhere to a mod paradigm. Richard Williams recalls the attention to detail, "I went to a fee-paying grammar school, and we used to extract threads from our school ties, thereby increasing the number of stripes. We tried to get away with charcoal V-neck sweaters rather than the regulation medium grey, and with short black raincoats. Clothing regulations were strictly enforced, which made it even more fun."

Essentially an urban movement the mods spread from London to the Midlands and to the south and west of England. Regional uniforms developed, each city having a "Top Mod" who would set the style for the others. There

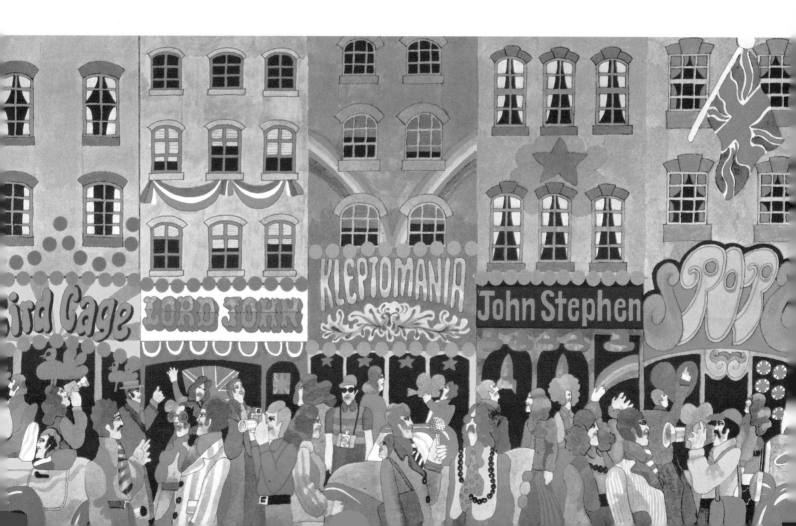

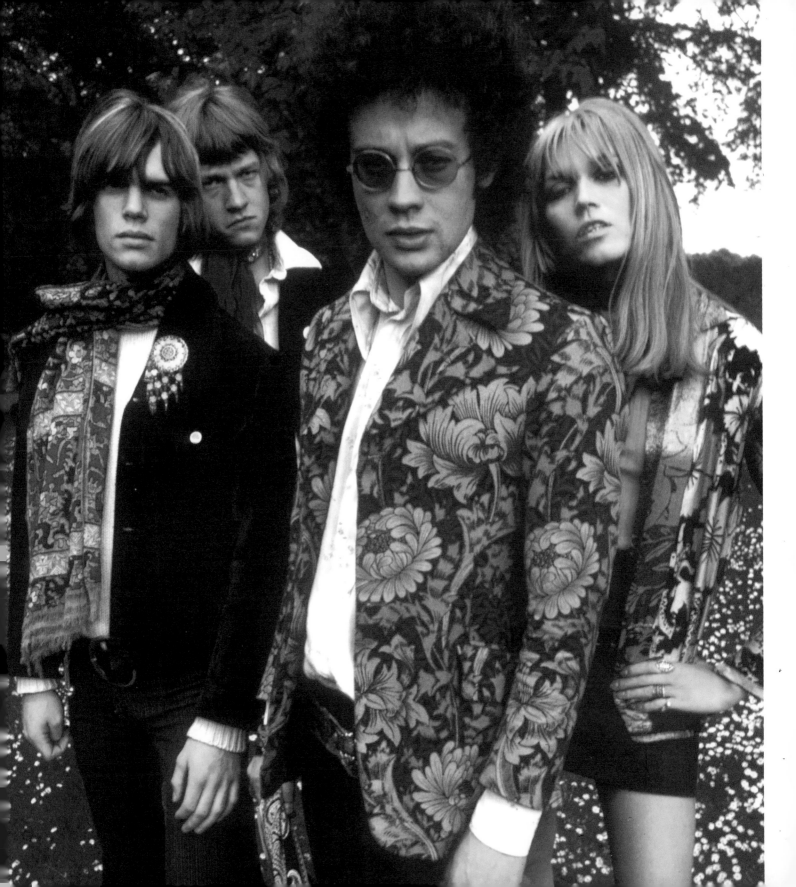

left By 1967 mod style was seguing into hippy. A first move towards androgyny is seen in the use of "feminine" materials, such as silk, and bright colours and patterns for traditionally cut "masculine" garments. The traditional shirt and jacket would eventually disappear; to be replaced by tunics and the ubiquitous T-shirt.

right Dennis Stansfield's dandyish posturing is reinforced by his choice of dog, the saluki. The kipper tie, made popular by retailer Michael Fish, was an easy way to claim stylistic individuality.

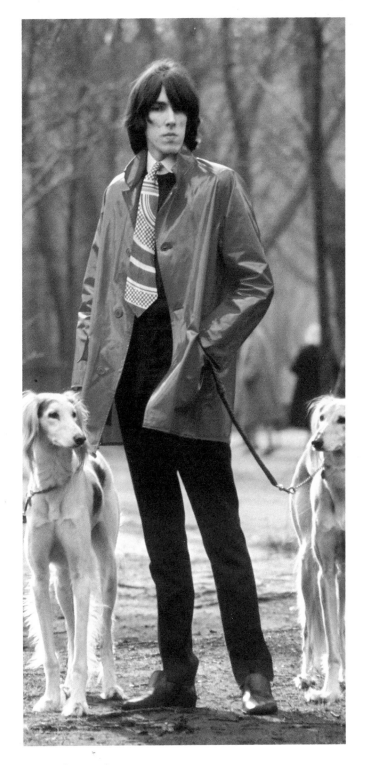

were elements that remained common to all: for example parkas and American military issue anoraks, which were hung about with bits of fur and worn when riding a scooter – the mod choice of transport.

In 1964 John Simons and Jeff Kwitner opened a shop in London's East End selling the American "Ivy League" look that was to permeate mod fashion. The brightly patterned shirts and reefer jackets were so successful that in the following year the pair moved premises to Richmond and opened the Ivy Shop. The location was handy for music venue Eel-pie Island and the mod hang-out, the coffee bar L'Auberge.

The mod look diffused into an approximation of a uniform where the suit still had an importance, but other more outrageous and flamboyant clothes began to replace it. Mods began to travel from all over England to buy this new style of clothes from Carnaby Street in London, where John Stephen was building a retail empire.

John Stephen was the catalyst that changed the nature of men's fashion retailing. He had worked briefly as a salesman in Vince's Man's Shop, opened in 1954 by Bill Green on Newburgh Street. This was considered by Nik Cohn to be the first true boutique in London. "The camp element was undeniable, but Vince's had other qualities. At a time when men's shops were almost all pompous, it was fun, and so were its clothes: lurid and sometimes badly made but, at least, never boring. Green said 'I always put the emphasis on impact, not make. I used materials that had never been used before – lots of velvets and silks, trousers made of bed ticking, and I was the first with pre-faded denims – and I made everything as colourful as I could.'" Selling to an overtly gay clientele, the clothes were nevertheless enormously influential on mainstream fashion, and when John Stephen opened His Clothes, a one-room boutique on a second floor in Beak Street in 1957, he initially sold the same clothes that had proved so successful.

A fire at the Beak Street premises resulted in Stephen relocating around the corner in Carnaby Street, at this time still a Soho backwater of dowdy shop fronts and warehouses. Ten years later it was to be paved over to allow greater access to the multiplicity of boutiques that lined each side.

John Stephen's shops became vibrant emporia with anarchic displays, friendly and casual staff, and an ever-changing stock. They promoted the antithesis of the clothes found at the multiple tailors; colourful, cheap, and fun. The clothes presaged the look of the early psychedelic hippy in some of the styling detail and reflected a preoccupation with historical revivalism and the use of richly textured materials.

The success of the His Clothes shop precipitated an influx of new boutiques on Carnaby Street. By 1966 John Stephen himself owned six, and a booklet called *Gear Guide*, which was published in 1967, named twenty-five altogether. Carnaby Street became an essential venue for the mod who wanted to buy the right clothes, keep up to date with fast-moving trends and wear the right width of collar and correct depth of lapel. Ultimately, however, the excitement generated by the Street imploded: Carnaby Street became a parody of itself, featuring in every "red bus" film made about the era. By 1967 Carnaby Street had become the nadir of male fashion and a place of excess and crass commercialism. It was reduced to being a trap for the tourist eager to participate in what was mistakenly perceived to be "Swinging London".

The response of the traditional male outfitters to the burgeoning market for fancy clothes for men was almost immediate. As manufacturers acknowledged the influence of Carnaby Street the marginal became mainstream. In 1965, Austin Reed filled the gap between flamboyance and traditional menswear by opening the first of the Cue shops, under the guidance of Colin Woodhead. It provided contemporary clothes for the archetypal "bachelor man about town" to buy to the sound of loud music within bright, modern interiors. While not replicating the brashness of the Carnaby Street clothes, there were significant nudges towards a more knowing look: the shop sold hipster trousers with a fourteen-inch- (thirty-five-centimetre-) wide leg, and brightly coloured shirts. By the end of the sixties there were fifty-six Cue outlets throughout the country. A suit would be sold for around thirty pounds, at a time when a young executive would be earning around twenty or thirty pounds a week. Other companies followed Austin Reed's lead. Young Jaeger became the most fashionable of middle-class stores for the smart male executive under the design leadership of Edward Lloyd, and Simpsons of Piccadilly opened Trend in 1965, to be followed by Way In, Harrods' in-house boutique.

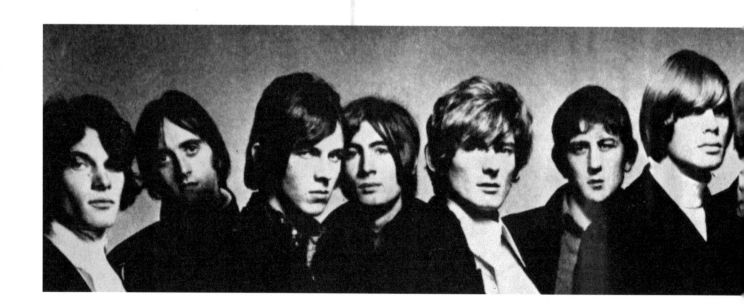

left In 1967 Mark Palmer
opened the English Boy
model agency on the
second floor of the Quorum
boutique. His catalogue
of long-haired, perfectly
groomed dandies was an
attempt to redefine the male
model and usurp the usual
stereotype of rugged and
wholesome masculinity.

above Influential sixties
figure and Men in Vogue
contributor Christopher
Gibbs with Michael Rainey,
(right), "top hippie" and
owner of Hung On You.

Established tailors found that by the end of the sixties most of their custom came from visiting Americans. Rupert Lycett Green capitalized on the desire for clothes with the Beau Brummel excesses of Carnaby Street but made with the traditional Savile Row virtues of quality and fit. Together with tailor and cutter Eric Joy, he opened Blades on Dover Street to serve the needs of the aristocratic dandy set with custom-made suits retailing at around fifty-two pounds. In 1965 traditional shirt-makers Turnbull & Asser recognized the desire for a more flamboyant approach and employed Michael Fish to design for them. In 1966 he opened his own shop, Mr Fish, on Clifford Street. Nik Cohn describes the shop as "a holocaust of see-through voiles, brocades, and spangles, and mini-skirts for men, blinding silks, flower-printed hats… all the surface mannerisms and mouthings of hippy, but none of the intent." However *Vogue* remarked on its attempts to "conciliate modern men's look with a Jermyn Street tradition."

That menswear could be designed and offered up in the market place was reflected in the press coverage of the time. Male-orientated publishing ventures had appeared from the 1950s onwards, but it was only when Tom Wolsey took over the art direction of the staid clothing magazine *Man About Town* in 1961, and managed to turn it into a style bible for the sixties man, that menswear design had its first media outlet. As the magazine changed its title to *About Town* and subsequently *Town*, the combination of pin-ups and provocative features about sex firmly placed the consumption of fashion within the context of heterosexual activity. Rather than promoting the work of designers, as was the case with the magazines aimed at the women's market, fashion editors tended to feature the whole retail concept. Thus the "Men in Vogue" section in the March 1966 issue of *Vogue* featured clothes by Cecil Gee, Cue at Austin Reed, John Michael, and Jaeger. These retail enterprises all served men taken neither with the dirty denim and tie-

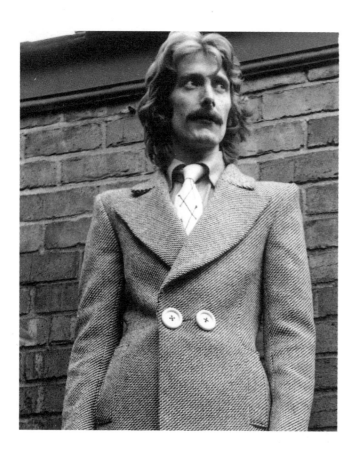

opposite page, left Suits in the early seventies reprised the silhouette of the forties. The lapels and the shoulders widened from a narrow, close-fitting waist, while wide ties and high-collared shirts emphasized the width of the chest. Lapels went on to reach such proportions that they extended beyond the shoulder line.

opposite page, right Designer Tom Gilbey avoided the traditional interlining and padding in his construction of garments for men. The gathered cuffs on this jacket are typical of the feminine details he employed in his reworking of masculine tailoring.

left Tailor Tommy Nutter's signature detailing on a suit worn by Jeff Banks. Previously the province of the older man, hats became an important accessory, as seen in this classic fedora by hatter Herbert Johnson.

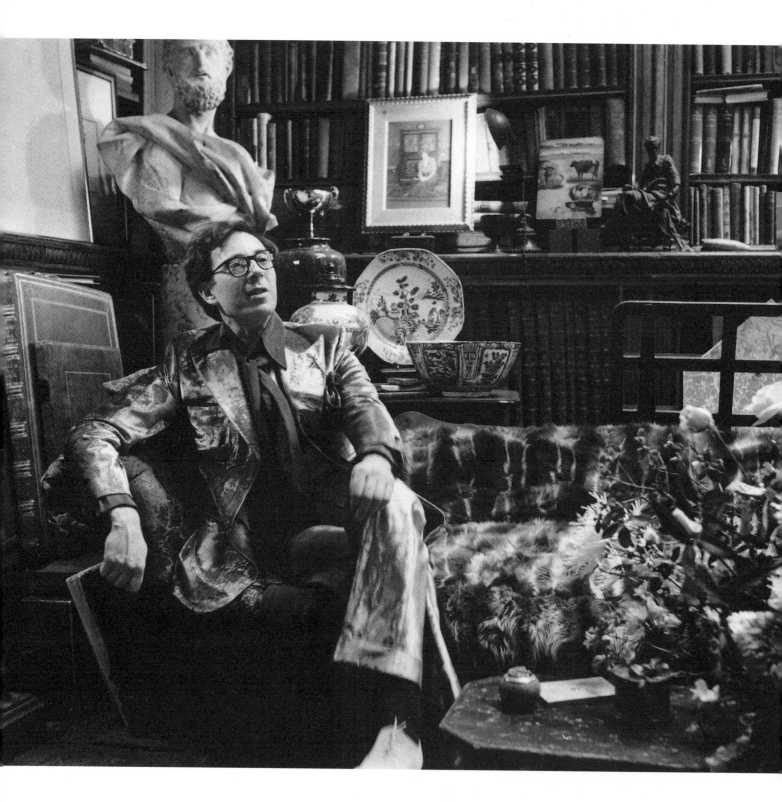

dyed T-shirts of the counter culture nor with the dandified excesses of the King's Road.

Men who were in pursuit of something more remarkable than that which was on offer from the retailers appreciated a new manifestation of sixties cool, the designer tailor, who appropriated the components of the classic man's suit and titivated it into sartorial kitsch. Tommy Nutter took over premises on Savile Row in 1968 and specialized in tailoring to the stars and their girlfriends. For around £140, customers could deck themselves in three-piece suits with wide, bound lapels and pockets in contrasting fabrics.

Designer Tom Gilbey also had an impact on British tailoring. Initially working for John Michael, he opened his own shop in Sackville Street, selling sharply tailored outfits cut close to the body in fabrics that were more traditionally used for womeswear.

The market was further fragmented by the emergence of "fun" clothes from the boutique Mr Freedom opened by Tommy Roberts in 1969. Previously Roberts had tapped into the desire for vintage clothing and ephemera with his boutique Kleptomania on Kingly Street, around the corner from Carnaby Street. He had also bought in manufactured women's wear. A supplier remembers, "We used to do polyester voile Victorian dresses with little puffed sleeves and rows of frills. He could sell as many as we could make, which was about thirty a week." After becoming disillusioned with the hippy trade, Roberts took over the premises of Hung On You on the King's Road and opened Mr Freedom, before moving on to bigger premises in Church Street, Kensington. Here he sold scaled-up children's clothes, multi-coloured striped wool socks, oversized dungarees, and hot pants decorated with ebullient rainbow stripes and appliquéd satin images, such as hearts and stars, for both men and women. He obtained the licence to use the images of Mickey Mouse and Rupert the Bear. Cartoon imagery was a recurrent

visual theme of his, together with an affectionate reappraisal of period Americana that was the antithesis of mid-sixties mainstream modernism. It was kitsch overkill, and as such went on to inspire the excesses of glitter rock exemplified by Elton John and Gary Glitter.

If it's true that the sixties had their provenance in the styles of the twenties and thirties, the seventies were all about the forties. For both men and women the silhouette changed as the shoulders broadened and the waist became increasingly defined. In 1968 John Simons and Jeff Kwitner opened their boutique Squire on Brewer Street in Soho, and went on to open a second shop featuring forties-inspired suits with wider lapels and trouser bottoms and a narrow waist. Under the influence of Richard Young, previously with John Michael Ingram, they sold tight Shetland jumpers and velvet trousers that would come to epitomize the look of the early seventies. To capitalize on this success, the partners opened a further boutique called

Village Gate in 1971 on Old Compton Street, and then yet another on the King's Road in 1973.

As the sixties progressed into the seventies, interest in a particularly British "look" faded, and a European influence began to infiltrate the boutiques. Shops such as Piero di Monzi, Browns of South Molton Street, and Feathers all started featuring continental designers such as Walter Albini, whose clothes for both men and women reflected a preoccupation with pre-war Hollywood icons. Groomed glamour, epitomized by the singer Brian Ferry and his stylish pastiche of a forties crooner, became the prerequisite of fashionable dressing for men. This constant reinterpretation of artistic and historical themes began to usurp the role of the retailer in directing trends. Fashion began to be mediated by stylists, whose visions very often supplanted that of the retailer, in that they drew their influences from many sources.

above Fans of Glamrock
bands wore striped girls'
socks from Bus Stop, calf-
length boxer boots from
Paul Smith, and cropped
trousers from Stirling Cooper.

left Greg Longdon with a
version of the Rod Stewart
mullet haircut. The scoop-
necked T-shirt emphasized
the androgenous look.

opposite page, left Trousers
designed by Anthony Price
for the Stirling Cooper label,
1971. The overt sexuality
of the crotch-displaying
trousers is mitigated by long
hair and use of cosmetics.

opposite page, right Ian
and Greg Longdon and
hairdresser Michael McMahon
in Paris, 1971. The growing
male fashion market included
accessories. The cork-soled,
multi-coloured shoes are by
Dorian of London.

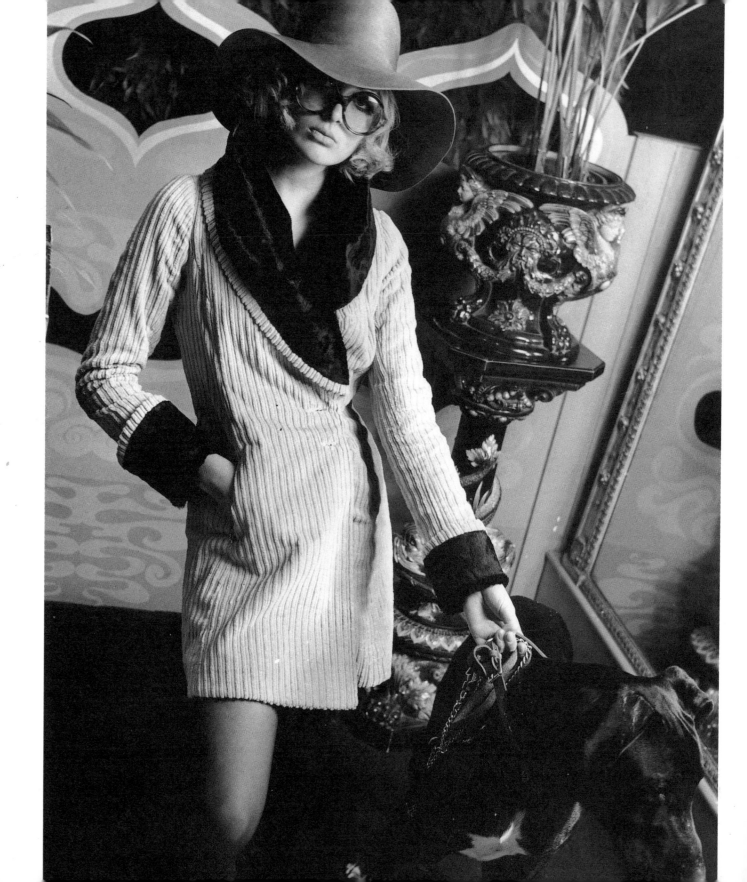

biba was for anyone

the democratization of style

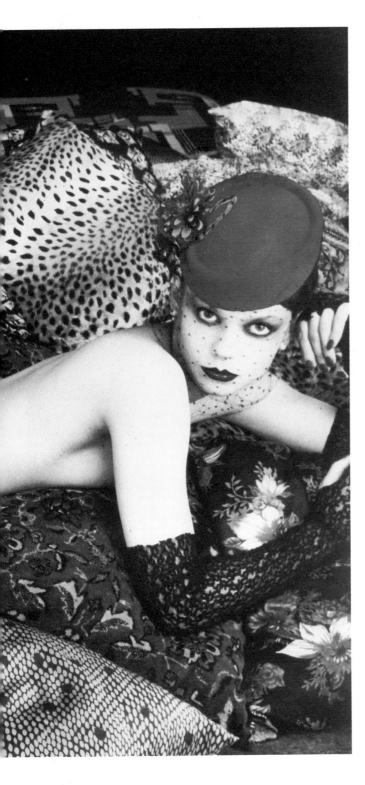

left "Welcome to Biba".
This provocative image
was photographed by one
of Barbara Hulanicki's
favourite photographers,
former retailer James Wedge.

previous page Jo Dingemans
in a bestselling floppy wide-
brimmed hat photographed
by Barbara Hulanicki in the
archetypal Biba interior.

In the early sixties, boutiques were still exclusive in the sense that the clothes were only accessible to the relatively affluent and available to those who could make the journey to London. It was to take the opening of the shop Biba in 1964 to give everyone the opportunity to be "cool". Biba was the first boutique to enter the popular consciousness, and it changed the way the ordinary girl in the street dressed.

The first small shop in Abingdon Road, Kensington, opened by Barbara Hulanicki and her husband Steven Fitz-Simon, and named after her sister, created the experience of instant gratification. Barbara Hulanicki tapped into what she calls "the huge grapevine" in London to produce clothes that every teenager wanted. She remembers, "The market was eager and responsive. I had been illustrating the couture collections for women who lunch, the over-thirties, which was then supposed to be the prime time for women. There was nothing available that I wanted to wear. Kiki Byrne was doing nice things in her shop on the King's Road, and Gerald MacCann, who had a boutique downstairs in Leonard's, had really fabulous clothes. But there was nothing for the street girl."

In 1964, when the shop first opened, teenagers had more money to spend, but not, as yet, enough distinctive things on which to spend it. These new consumers were very often Mods, one of the first youth sub-cultures to be defined in the sixties. Barbara Hulanicki had observed early mod couples queuing in the Strand outside the Lyceum, and had interpreted mod style as one of the first signs of fashion that came from the street and not from the couturiers. Her talent lay in her ability to understand that the snobbish and patronizing attitudes that she herself had discovered to prevail in haute couture while working as an illustrator were about to give way to modes of dress that would not only describe but epitomize the radical shifts taking take place in fashion and in mass culture.

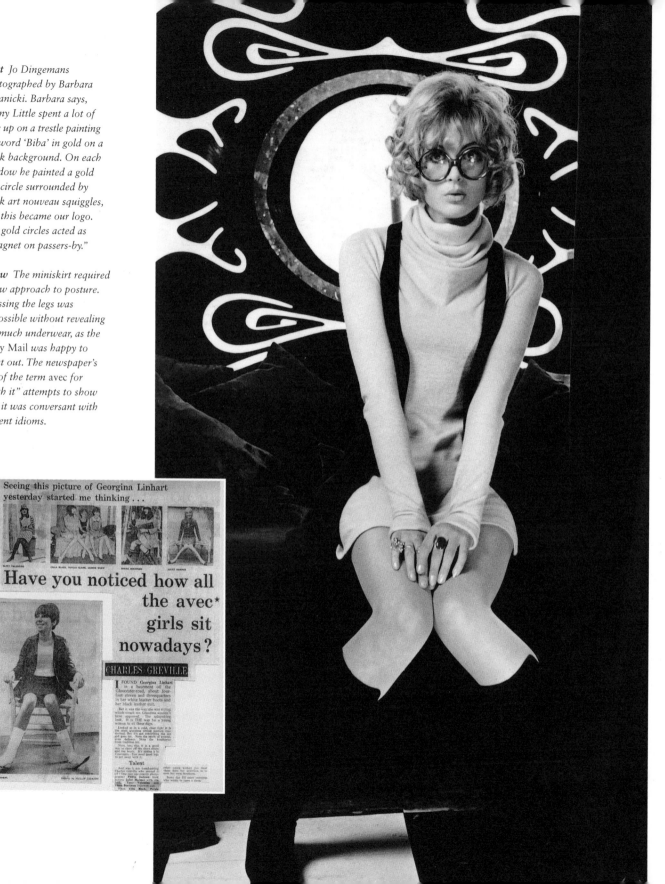

right *Jo Dingemans photographed by Barbara Hulanicki. Barbara says, "Tony Little spent a lot of time up on a trestle painting the word 'Biba' in gold on a black background. On each window he painted a gold leaf circle surrounded by black art nouveau squiggles, and this became our logo. The gold circles acted as a magnet on passers-by."*

below *The miniskirt required a new approach to posture. Crossing the legs was impossible without revealing too much underwear, as the Daily Mail was happy to point out. The newspaper's use of the term avec for "with it" attempts to show that it was conversant with current idioms.*

Seeing this picture of Georgina Linhart yesterday started me thinking . . .

Have you noticed how all the avec★ girls sit nowadays?

CHARLES GREVILLE

far left Olive Sullivan
summed up the various
interior styles of boutiques
in Vogue, 1966. "There are
the rave interiors with the
British flag and pop all over.
The camp interiors that are
as good a joke as any, the
starkers white cell that is
always a certain winner (it
must appeal to something
basic), the art nouveau jobs
that persist ad nauseum.
And out of all of this is
coming something very
exciting and newly British."

left Barbara Hulanicki took
cotton knitted jersey out of
the realms of underwear and
reworked it into best-selling
dresses and T-shirts. This
striped cotton jersey dress
and hat by Biba would retail
for less than two pounds.

Barbara Hulanicki's childhood was spent in Palestine where she says she was "fascinated by shops and market displays". This influenced both the design of the mysterious and private interior of the boutique, with its dark blue walls and low-slung lamps, and the accessible way clothes were displayed for the customer. While Mary Quant had stripped out the front of Markham House to accommodate a wide shop window, and removed iron railings to improve accessibility to her boutique Bazaar, Barbara Hulanicki was attracted to the "marvellously dilapidated" old chemist's shop that remained unchanged from the outside. She never replaced the peeling paint, or lodged her name above the door, intentionally leaving the interior obscured from passers-by. She says, "The shop looked much better without a name. If people wanted to find us, they would."

Hulanicki's cosmopolitan heritage also enabled her to pastiche a very European historical interior and to juxtapose this with all the mystery and allure of an Eastern souk. The shop's interior appropriated the *fin de siècle* excesses of art nouveau at a time when most boutique interiors reflected a preoccupation with the hard-edged modernism exemplified in the brightly lit clean lines of Terence Conran's first Habitat. Biba offered something different. Hulanicki says "My desire was to replicate the feeling of being in a private space, like walking into my sitting-room."

Biba clothes were connected to the interior by their drama, playfulness, and above all, by an extraordinary colour palette of browns, maroon, orchid, amethyst, plum, and "dirty" pastels, which were quite unlike the bright hard-edged colours that were to be seen elsewhere. This range of colours was to have an enormous influence on all aspects of sixties living, from interiors to clothes and cosmetics.

With the decision to produce a mail-order catalogue in 1968, Barbara Hulanicki had the opportunity to take her look directly to the high street

without the intervention of a magazine stylist or a photographer who did not share her vision. At that time existing mail-order catalogues were a way for low-income families to buy goods on extended credit terms. In contrast, the Biba catalogue was an innovation in mail-order shopping. Designed by John McConnell along the lines of the fashion editorials in magazines such as *Nova*, even the shape of the catalogue was original and modern. The slim and elongated shape was intended to fit the width of an average letter-box, and the lettering and colour palette were in the Biba house style.

The innovative photographers engaged by Barbara Hulanicki for the catalogue reinforced the subversive mood of the clothes. The photographs emphasized atmosphere. They conveyed a feeling of decadence in the juxta-position of innocence and knowingness. The clothes were not patterned; the photographs focused on the texture of the fabrics – velvets that reflected the light, crêpe de chine, satin, matt corduroy, lace, and tweed.

David Silverstein photographed the first catalogue, the second and third were by Hans Feurer. Later catalogues were by Helmut Newton and Sarah Moon, who also photographed all the Biba posters. Her images reflected the implicit sensuality of the clothes and placed them within a dream-like, mysterious narrative.

The exaggerated features and big pre-Raphaelite hair together with the extraordinarily innovative cut of the garments changed the essential silhouette, and thus the posture and pose of those who wore Biba clothes. Barbara Hulanicki was adamant about the importance of cut. "The clothes were cut like couture. Cutting was really essential to the look. I was obsessed with armholes and looking thin."

By the time the boutique moved to larger premises in Kensington's Church Street in 1966, Biba was attracting not only a working-class customer base, but the newly famous pop stars and actresses as well as the

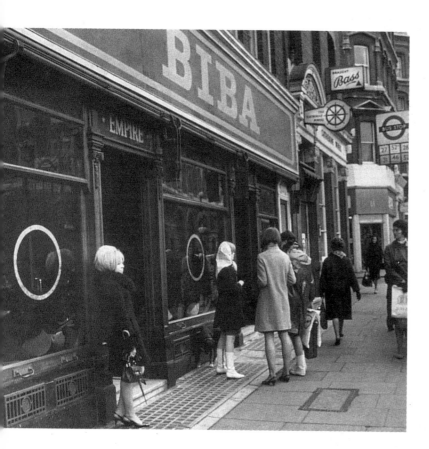

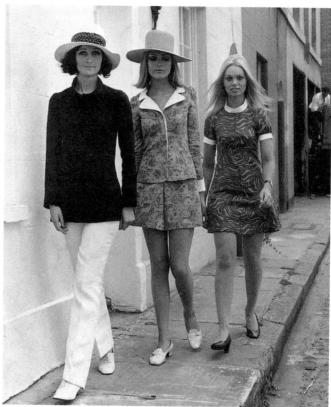

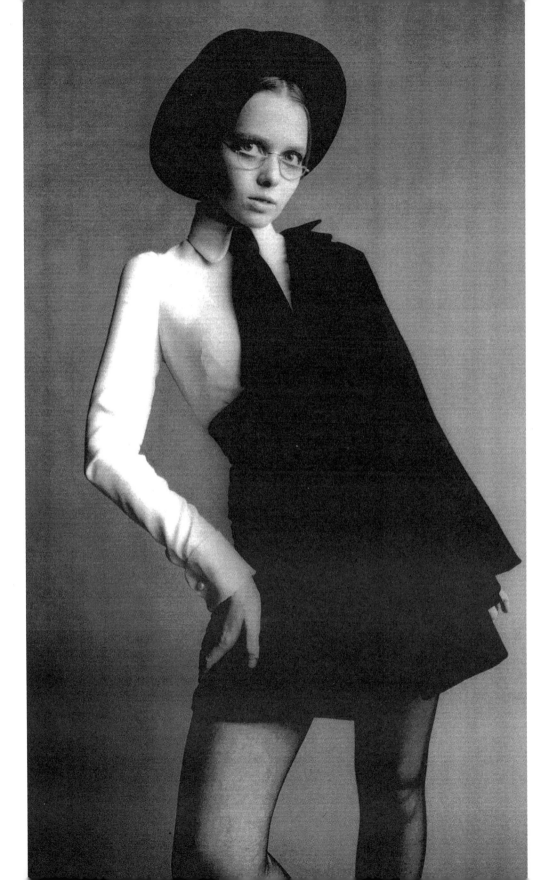

left *Stephanie Farrow, a favourite model of Barbara Hulanicki and sister of actress Mia Farrow. With her long legs, square shoulders, pale skin, and heavily made-up eyes she was the archetypal Biba vamp.*

opposite page, left *The exterior of the second of Barbara Hulanicki's four boutiques. These premises at Church Street, Kensington were ten times the size of the first shop on Abingdon Road.*

opposite page, right *Biba staff Anne Behr, Jo Dingemans, and Eleanor Powell. Barbara Hulanicki said, "The girls were becoming personalities in their own right. CBS made a film about a little country girl who comes to the big city and is transformed into a swinging sixties dolly and ends up dancing in the Ad Lib. They used Elly as the girl."*

left Gingham had always
been associated with
domestic interiors,
particularly with kitchens.
Barbara Hulanicki
appropriated it for summer
and beachwear in these Biba
designs, which are redolent
of children's play clothes.

right An image from the
revolutionary Biba catalogue
of 1968. The stylish
catalogue offered a range of
clothes comparable to that
in the boutique, and thrilled
thousands of teenage girls to
whom London was a distant
and unattainable place.

aristocracy, all united in the desire to achieve "the look". Barbara Hulanicki
recalls, "We must have been the only designers who were copied at twice
the price." Status no longer lay in the price of something, and the clothes
challenged the notion that social identities were based on class.

Hulanicki describes the media attention: "We were never in *Vogue*. *Vogue*
was very snotty about us, we appeared mostly in the Sunday papers and the
young magazines like *Honey*. It made a big difference that people like Cilla
Black and Cathy McGowan were seen to be wearing our clothes. On Friday
nights we would go to the studio to watch "Ready Steady Go!" being filmed.
Would Cathy wear a Biba dress or a Foale & Tuffin?"

The cult show "Ready Steady Go!" helped to spread Biba's popularity.
From 1963 until 1966 it went out live on Friday nights at 6pm, opening with
the slogan, "The Weekend Starts Here" first to the tune of the Sufaris hit
"Wipe Out", and later to Manfred Mann's 5-4-3-2-1. The show featured all
the newly emerging pop stars of the day: The Beatles, The Rolling Stones,
and The Who. Along with Radio Luxembourg DJ Keith Fordyce, Cathy
McGowan presented the show, having been offered the job as a typical
teenager of the time. She rapidly achieved iconic status as "Queen of the
Mods", and her hair and clothes were copied widely by the audience of
teenage girls. A viewer remembers, "I was transfixed with envy, all the girls
were. I used to iron my hair to make it straight like hers. I thought if she can
get close to all these pop stars, then so could I. All I needed was the hair and
a dress from Biba."

Fashion as a sign of self became no longer just about individual garments,
but about body shape, posture, and a different kind of physicality that
conveyed a "total look". This look also encompassed make-up. In 1970 Biba
produced a cosmetic range, the colours complementing the clothes with
innovative brown and maroon lipsticks and dark eye shadows. The

foundations were yellow rather than pink-based, and were influenced by the silent film stars of the thirties. Make-up had previously been sold by superior shop assistants from behind counters. At Biba the cosmetics were displayed in a fantasy boudoir for the teenage to play and experiment. By 1973 Biba make-up was selling in thirty countries. Jo Dingemans, model and manageress of the Kensington High Street store remembers launching the Biba make-up in the Printemps store in Paris. "I was dressed all in blue – blue lips, blue hair, blue stockings, and shoes. The cosmetics all sold out. The false eyelashes were amazing, fine and long, not like the other brands at all."

In 1973 the fourth and final Biba opened in the art deco department store of Derry and Toms. This huge shop on Kensington High Street, designed by Bernard George in 1933, was overhauled to promote a complete lifestyle shopping experience in the lavish surrounds of an eclectic mix of art deco and orientalism, and provided a magical playground for fantasies. As the first tiny Biba had been an invitation to step into a private sitting room, the "big Biba" was styled as a luxurious hotel or cruise ship. Of the available 400,000 square feet (145 square metres) over the six floors, only one-sixth were given over to selling space. The Rainbow Room took up the whole of the fifth floor, with a stage and a 500-seat restaurant, and was named after the art deco ceiling that could be spectacularly lit from within in an endless permutation of changing colour. It became the venue for album launch parties and visiting rock groups such as The New York Dolls.

Barbara Hulanicki had a vision that encompassed a lifestyle where everything was designed to match and complement, from houseware and foodstuffs to furniture and fashion. She was responsible for every creative decision and designed or sourced every single item in the "Big Biba" store. However, the vision became unsustainable in an increasingly fragmented mass market. However, the vision became unsustainable in an increasingly

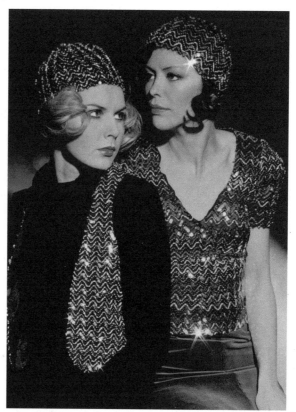

far left A photograph by Barbara Hulanicki of the window of the American department store, Bergdorf Goodman. This Biba display was for their BiGi department for teenage girls, who had their own elevator to avoid more mature shoppers.

left Cinematic glamour reminiscent of the 1920s is suggested in the use of the skullcaps and sequins. The look, however, is restrained by the severe cut of the waistcoat and the typically subdued Biba colours.

below One of Biba's best sellers recalled the seductive glamour of the Hollywood siren of the twenties and thirties. The feather boa invested the simplest outfit with instant allure.

right The leaflet celebrating the opening of the "Big Biba" – five floors of personally chosen merchandise representing Barbara Hulanicki's retailing dream. The store sold everything, from customized tins of baked beans to newspapers and stationery. The fifth floor Rainbow Room became the fashionable venue to eat, congregate, and hear the latest bands.

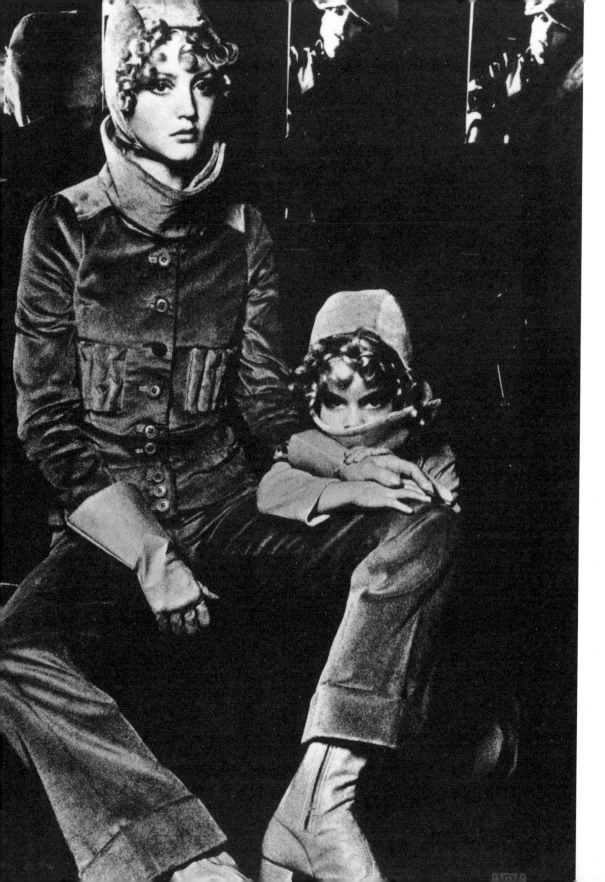

left Biba had a children's department in an outsized doll's house. Barbara Hulanicki designed scaled-down versions of adult clothes, using the same textures and colour palette. Sarah Moon's photograph captures the implicit sensuality of panne velvet for both mother and child.

far right The dream-like quality of this photograph by Barbara Hulanicki adds to the overwhelming impression of milkmaid innocence. The pale, ruffled cotton and straw hat is offset by the loosely tied cuffs and neck, and contrasts with the dark, sultry eye and lip colour.

right Barbara Hulanicki oversaw every aspect of the marketing and promotion of the Biba look. For the launch in the United States, she photographed Jo Dingemans wearing the dresses that were to hang in the window of the New York store Bergdorf Goodman. The images were to be blown up to life-size and positioned behind a set that reprised the "Big Biba" boutique in London.

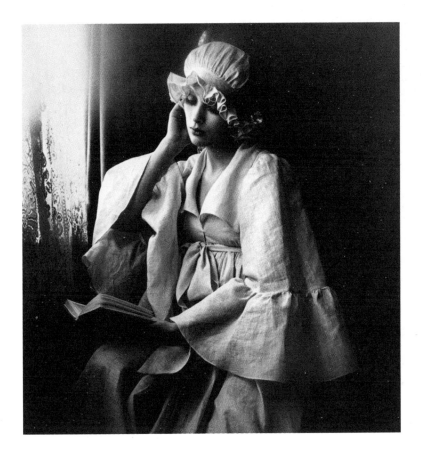

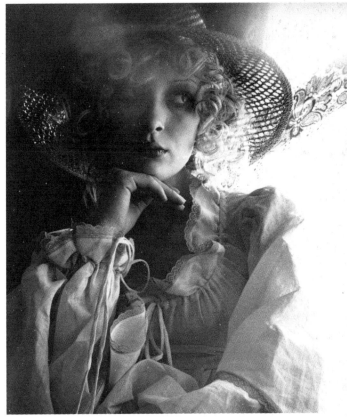

fragmented mass market. A customer base that veered between the idiosyncratic clothes of the counterculture and a high street progressively responsive to customer needs, resulted in independence of choice becoming an increasing option. Together with the emerging friction between the owners, British Land, and Barbara Hulanicki. The Biba experience collapsed under the weight of a number of factors, not least the pilfering of a third of the stock. Celia Hammond, assistant to Barbara Hulanicki during those years, remembers the conflict when British Land tried to introduce strip lighting into the store to cut down on the shoplifting. "Barbara was a formidable woman, she had real presence. She looked fantastic, always smoking a cigarette in a holder, lots of make-up, she walked tall and straight and really commanded respect. She wouldn't compromise over anything. She refused to change the lighting. There was an enormous amount of waste too. There were bales and bales of moss crepe just wasted because they were in last season's colours. You had to admire that uncompromising vision, there was something special about working for her, you were really proud to be part of the Biba experience."

Jo Dingemans, who went on to become fashion editor of *19* magazine, recalls one of Biba's "hippest moments", the phenomenal success of the classic Biba T- shirt, with its skinny torso and tight armholes. "The T-shirts were piled high on the old chemist's counter, 75p and 90p, and we couldn't ring up the tills fast enough." Dingemans says, "I was offered double the price for the last pair of boots: they were really special, of very soft suede, and made in all the most amazing colours. Girls bought a pair in every colour they could get hold of. Every day there were queues for the latest consignment of clothes." While Biba existed, Barbara Hulanicki designed one million styles, not one of which was made more than 500 times. It was a retail phenomenon that touched the lives of a generation of women.

honey

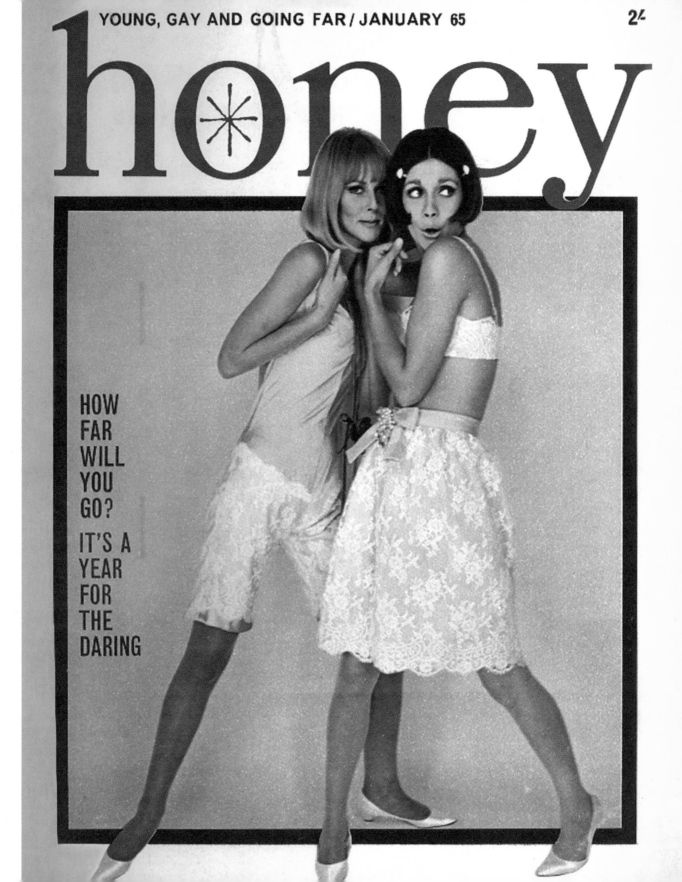

HOW
FAR
WILL
YOU
GO?

IT'S A
YEAR
FOR
THE
DARING

blissful girls
crazy dollies

the new fashion magazines

previous spread Honey appeared in April 1960 and was the first magazine to address the teenage fashion market, and to launch a new concept of femininity – *"young, gay, and going far."* This 1965 cover features designs by John Bates.

opposite page "When you fill your offices with dishy men, blissful girls and a small proportion of crazy dollies, you've got yourself a highly individual set-up catering for highly individual readers." Thus ran the first editorial of 19, launched in 1968.

right A fashion shot from the launch issue of 19. The photograph was taken by Mike Berkofksy.

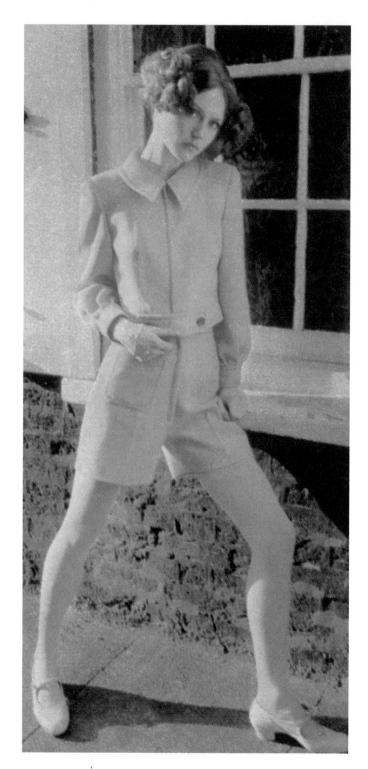

magazines during the sixties shifted the definition of femininity from that of homemaker to that of consumer. Magazines for women had always offered information and advice. With the advent of magazines such as *Honey*, however, the advice was less concerned with household management and more to do with the availability of products. Advertisers came to determine the focus and success of magazines, and market research was used to target readers and profile a customer pattern of spending. Marjorie Ferguson identifies their role in her book *Forever Feminine* (1988): "These periodicals are about more than women and womanly things, they are about femininity itself, as a state, a condition, a craft, and as an art form which comprises a set of practices and beliefs… everyone born female is a candidate for their services and sacraments… here is a very potent formula indeed for steering female attitudes, behaviour, and buying along a particular world-view of the desirable, the possible, and the purchasable."

Honey was in the forefront of niche marketing, and it was launched with the awareness that there was a new audience to be found in the female teenager. Unlike the fashion bible *Vogue*, with its extensive covering of the haute couture collections, *Honey* gave readers fashion images with which they could identify, and which were appropriate for the way they lived their lives. Although it first arrived on the bookstands in April 1960, its unique format did not emerge until Audrey Slaughter took over as editor in 1961. There was some emphasis on self-improvement, with articles on fulfilling hobbies such as painting, and the importance of good elocution, but in general the magazine was light-hearted in its approach to life as a teenage girl. Its pages became a safe place in which to play with notions of independence, and to explore and construct a female self not based on the premise of marriage and motherhood. Girls were offered new ways of

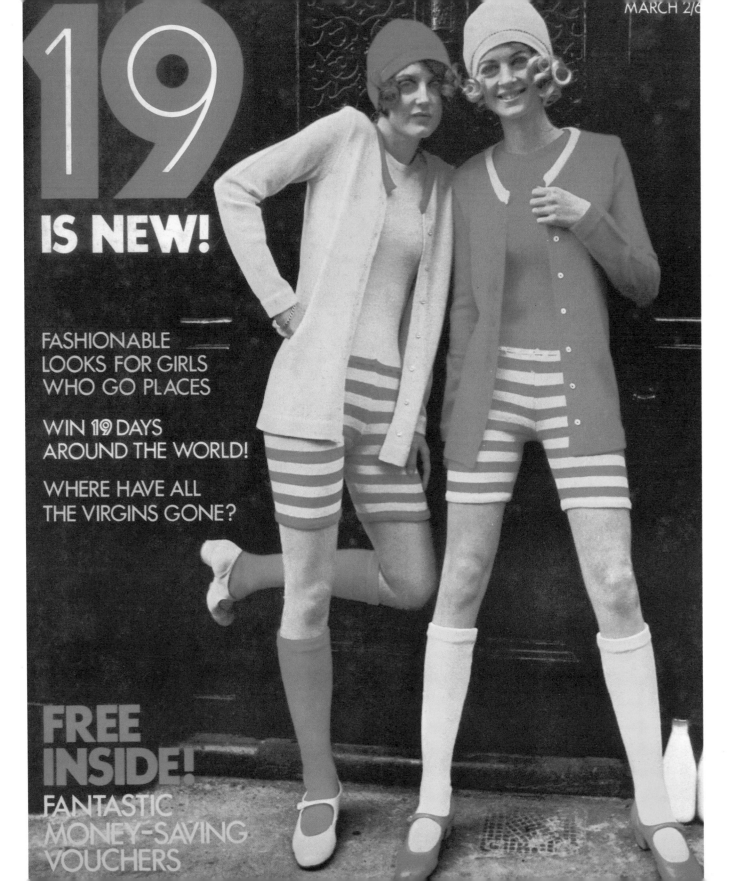

19
IS NEW!

FASHIONABLE
LOOKS FOR GIRLS
WHO GO PLACES

WIN 19 DAYS
AROUND THE WORLD!

WHERE HAVE ALL
THE VIRGINS GONE?

FREE
INSIDE!
FANTASTIC
MONEY-SAVING
VOUCHERS

MARCH 2/6

right Magazines for teenage girls were attuned to the patterns of their everyday lives. These models could be "hanging out" on the way home from school wearing a fashionable version of the school uniform.

opposite page Photographer Mike Berkofksy shot most of the fashion editorial in the launch copy of the magazine 19 including these two models. He was one of the first photographers to show the models in a way with which the readership could identify. He featured the girls in context of their daily social activities and with members of the public in the background.

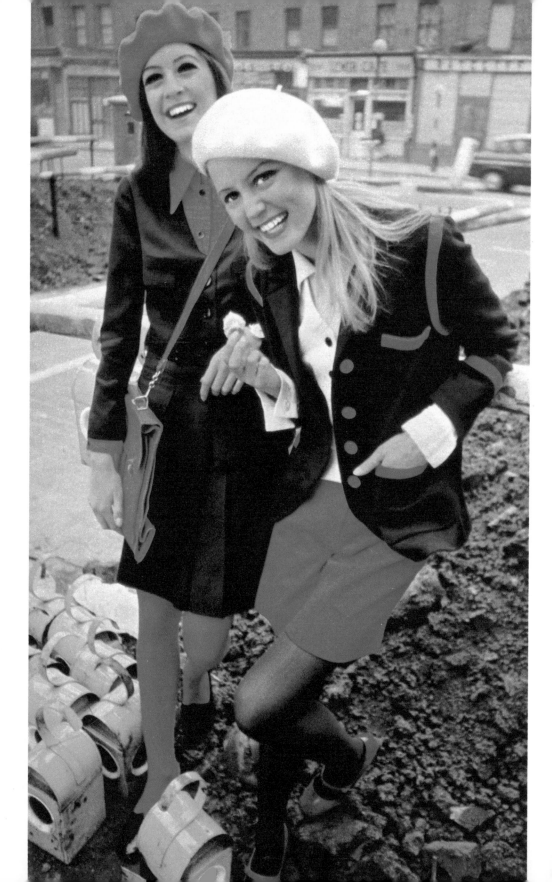

visualizing themselves and were given the knowledge and skills with which to realize their aspirations. It was attuned to the patterns of the everyday life of the average teenager and her preoccupations with boyfriends, fashion and beauty, a career. The magazine was successful in creating a sense of shared values and an intimacy with the readership, and aimed to build up a relationship of trust. Indeed, in 1966 readers could send for a booklet, *Birth Control and the Single Girl*, at a time when the contraceptive pill was only available for those engaged to be married.

A survey at that time confirmed that the typical reader was earning £10 a week, her vital statistics were likely to be 35, 24½, 35½ inches (86, 62, 90 centimetres) and she was interested in clothes and travel. Strategies were developed to encourage reader identification, among them the hiring of a bus staffed with *Honey* personnel to tour the country and offer advice on the *Honey* lifestyle. In addition, *Honey* boutiques and hairdressing salons

opened up in more than one hundred stores, selling clothes and accessories featured in the pages of the magazine.

Pat Baikie was beauty editor from 1963 to 1966, and observed in an interview in the closing issue of the magazine, "*Honey* was the only teen magazine of its kind, for some time there was only *Honey*, so the magazine was in a position of leadership and was extremely influential. The readers absolutely adored *Honey* and they were always being featured in the magazine – interviewed about their jobs, their lives, photographed for fashion and beauty pictures. We really believed it was their magazine, so it was their right to appear in it."

Eve Pollard, who was beauty editor from 1968 to 1969, observed in the same article, "It was such a great time to be involved in the beauty world because there was so much going on. Manufacturers were beginning to cash in on this new younger market with money to spend, and suddenly

there were lots of cheap bright cosmetics around. Daughters stopped wanting to look like their mothers."

In March 1968, the magazine *19* was launched. It was glossier and less cosy than *Honey* and the content placed a greater emphasis on creating a visual impact. It also focused on the readers' single status and cool lifestyle. The first editorial read, "When you fill your offices with dishy men, blissful girls and a small proportion of crazy dollies, you've got yourself a highly individual set-up catering for highly individual readers. And that's what you've got at *19*."

Magazines such as *Petticoat*, *Honey*, *19*, and *Nova* were discovering new ways of representing clothes on their pages. The dominance of haute couture and the power of the fashion designers was soon to become undermined by the alliance that was beginning to emerge between the fashion editor, the art director, and the photographer on these new magazines. This relationship was also fundamental to the way the garment was finally seen on the pages of the magazine. Jo Dingemans, model and manageress at the new boutique Biba, worked with the fashion editor Norma Moriceau on *19*. She recalls this exciting period, saying "Maggie Koumi was the editor, she was then only nineteen herself. She wanted magical pictures that people would want to tear out of the magazine and put on the wall. Norma was a brilliant fashion editor, she had vision. Anyone can look at clothes, but editing them into stories is what really counts. It's about what is right for the readers, not what you like yourself, you have to have an eye for your market. The fashion editor would get together with the art director and choose a photographer, and then the art director would direct the shoot and have final choice of picture. He could make or break the picture by the way it was placed in the magazine, but it was the vision of the fashion editor who really created the images."

left "*Wear them where you dare*" *ran the slogan. Valerie Longdon, a* Honey *reader, wears her peel-off/stick-on "dotties" (large beauty spots) free with the magazine in* 1966.

right: "*We saw the photographer as an artist, and we didn't worry about the clothes being seen,*" *said Caroline Baker, fashion editor of* Nova, *who was responsible for this innovative styling of a Bernard Neville scarf.*

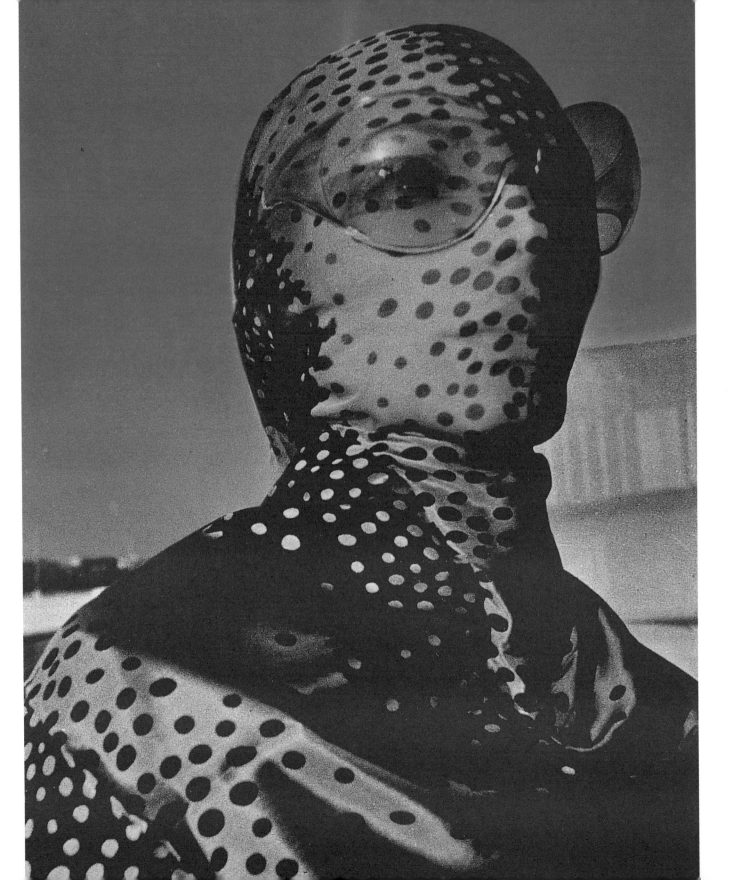

left A photograph by Duffy, taken for Nova *in November 1966. Throughout the sixties fashion photography became increasingly provocative, and seductive, suggestive poses and ideas of femininity, often drawing from soft pornography, were shown in intimate interiors such as the boudoir.*

The photographer Mike Berkofsky was asked to shoot the dummy of *19*. He says "Around that time the young magazine market was increasing, and I made my name as someone who did young relaxed fashion work."

Having been told that he was "not the right sort of chap" to be a photographer, Berkofsky had started his photographic career as a printer for fashion and advertising. "I wanted to be a press photographer when I left school at sixteen in 1960. I was an East End lad, and the careers officer said I was too reserved a personality for the press and got me a job as a trainee darkroom printer for a commercial photographer's in Walthamstow. At this point, fashion was entirely populated with upper-crust society types: aristos, arty homosexuals, and public school types – in fact the entire business was very lah-di-dah. However, Bailey, Donovan, and Duffy had begun to turn the business on its head, and coupled with the sixties momentum it was felt that anybody could do anything. A model who'd heard of my reputation as a printer asked me to do some shots of her. Donovan saw them and started recommending me around town. He gave me his support against the upper-crust mafia. When I met him at a *Sunday Times* magazine party he told me that he'd noticed my stuff and asked me where I came from. When I told him he said, 'Hackney eh? All the cream come from the Hackney Road – if you have any problem with anyone in this business you come to me, I'll sort them out. You've got to duck and dive if you want to get anywhere you know.' I was blown away by that."

As magazine editors, photographers, and art directors started to put their stamp on fashion photography, instead of portraying unreal, sophisticated, and elegant women, magazine fashion pages started to feature lively, sexy girls. The fashion pages of *Honey* and *19* celebrated the ordinariness of the fashion model, while the more upmarket fashion magazines became increasingly sexually explicit.

The sexual nature of the relationship between the photographer and the model was characteristic of 1960s photography. James Wedge recalls how at the time that he was running his successful boutiques Top Gear and Countdown he had become friends with photographer Terence Donovan. He describes feeling envious of Donovan saying., "He used to drive around in a Rolls Royce with a beautiful model at his side and I would think, 'I want some of that.'"

As photographic techniques began to influence artistic developments, clothes became increasingly incidental to the image, and tensions began to emerge between the photographers and the designers. Barbara Hulanicki,the owner of Biba, was careful in her choice of David Silverstein for her first mail-order catalogue. She says, "So many photographers took over and imposed their own ideas of how something should look. I wanted to be the one in charge."

Mike Berkofsky, however, takes a different view. He asserts that, "The photographer's individual style was paramount, and the magazines booked the photographer who fitted the look they wanted."

For those who had no interest in being a "blissful girl or crazy dolly" there was only one magazine that covered fashion in an innovative and groundbreaking way – *Queen* magazine. As defined by Caroline Baker, who was fashion editor at *Nova*, *Queen* "was a very trendy mag with a sense of humour. However, it was run by the 'old schoolboy network' – Eton types."

There was an evident gap in the market for a magazine for women whose interests were neither homemaking or social gossip, and who were interested in the phenomenon of fashion as part of a radical sub-culture. *Nova* filled the gap. David Hillman, who became the magazine's art director, recalls in his book, *Nova - The Style Bible of the 60s and 70s*: "In 1964 the publishers George Newnes called a meeting to discuss a new magazine for

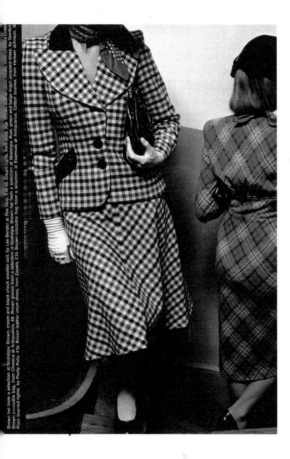

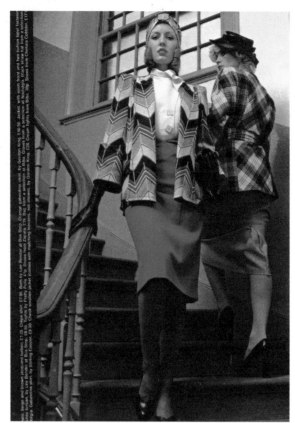

right Nova *magazine was the primer of contemporary mores, designed to appeal to the "thinking woman". Launched in 1965, it was "the quintessential magazine of the sixties era" according to its art director David Hillman.*

left & far left Hans Feurers' *striking photographs of forties-inspired suits by Lee Bender for Bus Stop. Norma Moriceau, editor of 19 sought to produce fashion pages that readers "would want to tear out of the magazine and put on the wall."*

women. The definition was rather imprecise, but it was not to be like other women's magazines. Amongst those present were Harry Fieldhouse and Harri Peccinotti, who were to become respectively the new magazine's first editor and art director. In March 1965, *Nova* was launched. Others were to take up the radical formula that Field-house and Peccinotti created, and develop it, refine it, and make it succeed. But it was these two men who originally assembled the elements that were to distinguish *Nova* as the quintessential magazine of the sixties era."

Dennis Hackett, previously with *Queen*, joined the magazine in 1965 and set up a team with the intention of producing what Caroline Baker recalls as "A sophisticated interesting magazine for women as opposed to a fashion bible or a cooking thing, along the lines of the colour supplements that were coming out at this time." David Hillman was *Nova*'s art director from 1969 until the magazine closed in the middle of the following decade. He and

Harri Peccinotti were responsible for the unique format of the magazine, as Caroline Baker acknowledges. "The art director and the photographer were the most important people on a fashion shoot, I worked with the art director, and we saw the photographer as an artist. We were not at all product-based, we were much more concerned to be visually stimulating, and we certainly didn't worry about the clothes being seen."

Baker's first feature as fashion editor appeared in the autumn of 1967. "Dennis specifically wanted to explore the avenues that the traditional magazines like *Queen* ignored. I was a typical *Nova* reader, I didn't want to dress like Jackie Kennedy. We did not cover the couture or the Parisian collections. I was a feminist, I hated the look of women who dressed formally, with styled hair and perfect make-up. I didn't see why women should have to dress in a certain way to please men. I started to explore second-hand clothes and menswear for women and army surplus clothes. I didn't have

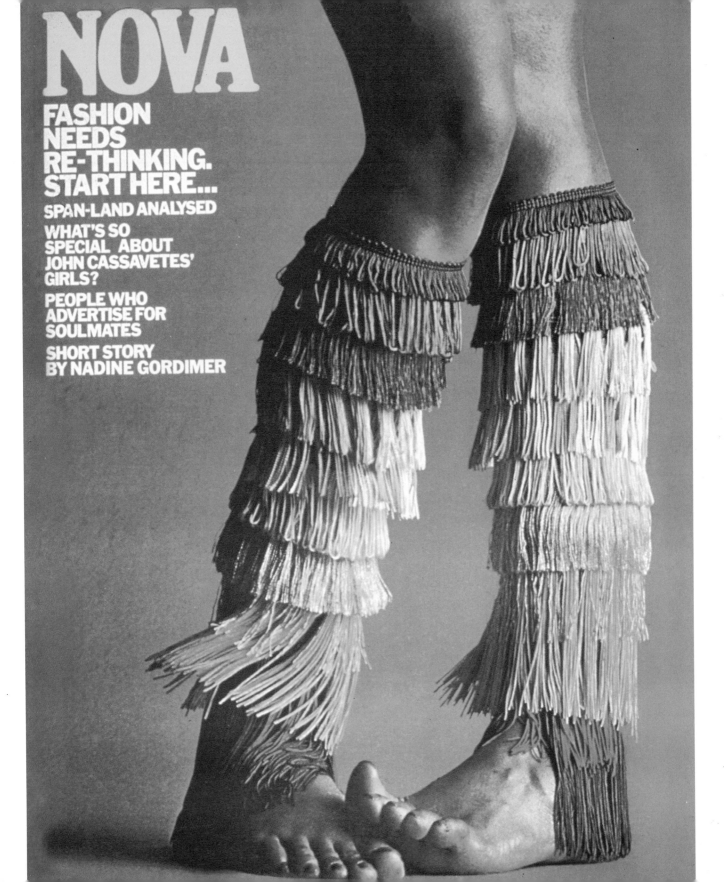

NOVA

FASHION NEEDS RE-THINKING. START HERE...

SPAN-LAND ANALYSED

WHAT'S SO SPECIAL ABOUT JOHN CASSAVETES' GIRLS?

PEOPLE WHO ADVERTISE FOR SOULMATES

SHORT STORY BY NADINE GORDIMER

left Hot pants were a
way of retaining the sexiness
and freedom of the mini,
as skirts dropped to meet
the calf at the end of the
sixties. Knitted shorts by
Lee Bender for Bus Stop,
socks by Mr. Freedom.

much money myself, and the sort of total look that *Vogue* always promoted
was very expensive."

She remembers that it was difficult at that time to convince designers of
the power of publicity. "The fashion industry was much less geared to the
publicity machine. The set-up for borrowing clothes was extremely difficult,
some of the designers were even suspicious of what we were trying to do,
and didn't grasp the publicity angle at all. Boutiques loathed lending clothes
because they felt that they couldn't sell them on. If they had a sample it was
with the manufacturers. I had to visit designers like Foale & Tuffin in their
shops. Apart from Ossie Clark they didn't have fashion shows, and anything
he did went straight to the celebrities. I didn't go to department stores because
they were ghastly. Harrods wouldn't even let you in unless you looked like
the other women who shopped there."

This was one of the reasons why she sourced her images outside of
the fashion establishment. She also featured clothes she liked herself. "I
unleashed leg warmers on the world because I wore them myself. Ballerinas
used them and they kept my legs nice and warm and they were cheap. And
then they end up on Abba!"

One girl buying her first copy of the magazine remembers, "I had gone
into the newsagent for a copy of *Queen,* but he said they had sold out and
why didn't I try this one? I took it back to my room and it was an utter
revelation. Everything about it was compelling, even the shape of it was
different. It was visually stunning, and as a fashion student I appreciated
that. But it was also a brilliant read."

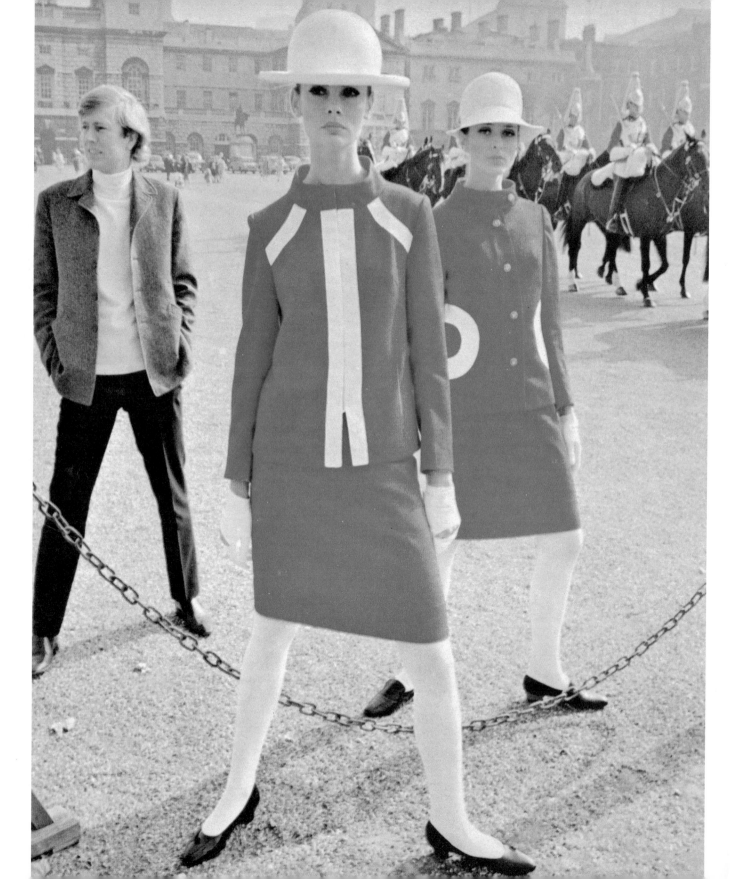

the American fashion industry up until the fifties was enormously influenced by Hollywood. Film stars such as Joan Crawford and Barbara Stanwyk wore powerfully structured designs by Adrian and Edith Head which reflected their commanding screen presence. However, as the fifties drew to an end, the American press had to find new icons to represent the fashion industry. It fell to Eugenia Sheppard of the *New York Herald Tribune* and John Fairchild of *Women's Wear Daily* to create a new kind of celebrity, that of the affluent clothes horse, whose main preoccupation was to showcase her husband's wealth by the extent of her wardrobe.

At this time, only European couture could confer the formality and status that went with a lifestyle of ostentatious entertaining. Once the Second World War was over, Sally Kirkland, who was fashion editor of *Life* magazine and considered to be fashion's most powerful woman, led the move to resurrect the French and Italian fashion industries. The introduction of the jet plane into passenger service in the sixties was responsible for the emergence of the "jet set", who flew to Europe to shop.

The "beautiful people" – the rich wives of the heads of American corporations – who, incidentally were always known by their husbands' Christian and surnames, wanted clothes that advertised and validated their husbands' occupations. Individuals such as Mrs William S. Paley and her daughter Mrs Carter Burden Jnr became the new celebrities. They provided immediate copy for the fashion and society pages in their choice of designer or with their adoption of a particular accessory. They attended the couture shows in Paris but were also loyal to American department stores such as Bergdorf Goodman, Ohrbach, and Henri Bendell, whose buyers visited Paris twice a year to purchase originals from which to produce line-for-line replicas.

As the sixties progressed, however, the shift in fashion away from the exclusive to the accessible began to permeate cultural life. The value of

acquisition was directly challenged by the emergence of a popular culture from across the Atlantic. But while in Britain the democratization of style was intrinsically bound up with the revolution in music, in the US the catalyst was art. Dress manufacturer Larry Aldrich sold his collection of Impressionist and Post-impressionist paintings and commissioned a range of fabrics inspired by his new acquisitions. Work by Anuszkiewicz and Bridget Riley provided a fertile seam of inspiration for designers, which was simple to duplicate for mass production. The work of what *Life* magazine identified in 1963 as the "brash new breed of British designers" began to reach the American press. This was the first indication that the conservative nature of the leaders of the fashion establishment was about to be usurped by the avant-garde, the gamine, the kooky, and above all by the young.

In 1963 J.C. Penney, owner of the biggest chain of stores in the US, decided that to keep up with his competitors he needed to develop a fresher, more modern image. An iconic figure to Americans, his empire had spread from one small shop in a mining town in the Mid West to 1700 franchises throughout the continent. Aware that reliability and worthiness were not enough to attract the post-war customer, Paul Young, the European buyer, was sent abroad in search of suitable new talent to promote in the stores. Alerted to the work of Mary Quant by articles in *Women's Wear Daily* and *Life* magazine, Paul Young viewed work in progress in the London showroom and then signed up Mary Quant to design four collections a year to be manufactured by J.C. Penney and sold throughout their stores.

Mary Quant recalls her astonishment at the extent of the Penney empire, "We asked Paul Young if he had visited all the stores and he said, 'No. Covering one a day, it would take me about six and a half years.'" She also reflected that the editorial publicity generated far higher sales than J.C. Penney had anticipated. "I really believe that when the whole thing had first

far right Sandy Moss in Foale & Tuffin oyster satin, and boutique merchandiser Terry Hooper dancing the frug to the sound of the British group, The Skunks at the launch party of Paraphernalia.

right Sandy Moss, photographed in a black-and-white satin suit by Foale & Tuffin. Moss worked in the United States as a model for Mary Quant before becoming liaison officer and European buyer for New York boutique Paraphernalia.

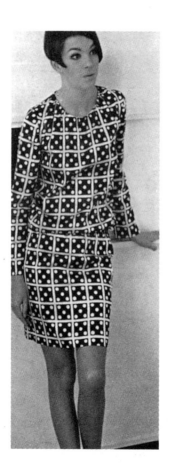

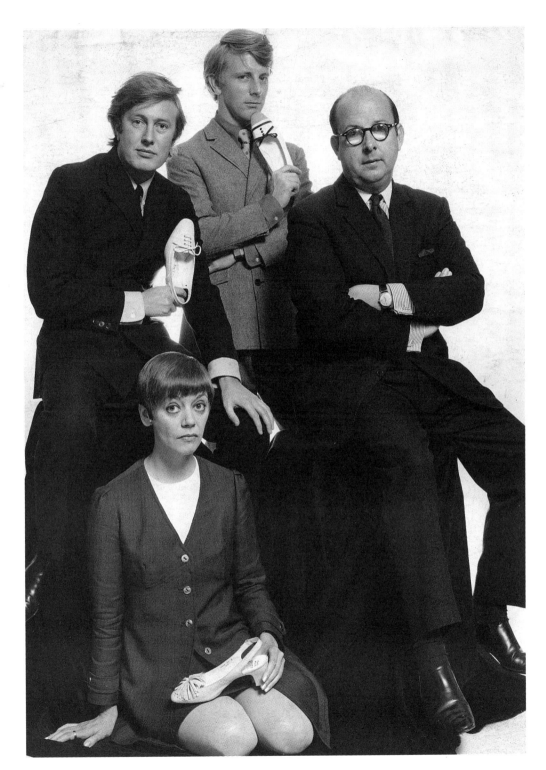

GERALD McCANN

above *Swing ticket by illustrator Jo Eula, 1963. The elevation of designers to celebrity status gained increasing momentum in the sixties. Caricaturing the designer on the swing ticket acknowledges the importance of the personality as well as a making a style statement.*

left *Chairman of the Society of London Fashion Designers and shoe manufacturer Edward Rayne is seated on the right, with British designers Jean Muir, Roger Nelson, and Gerald McCann.*

right The appropriation of op-art motifs, extends to the shoes in this outfit designed by John Bates in 1965. Modelled by Jean Shrimpton, it was destined for an export promotion of British fashion aboard the QE2.

below Paraphernalia on Madison Avenue was opened in 1965 by Paul Young as a flagship shop for Karl Rosen and the Puritan Fashion Corporation.

opposite page, left Successful ready-to-wear designs for the American market by Mary Quant and Foale & Tuffin in 1965. Life magazine commented, "Made even dizzier by the heady air of the New World, the English show an uninhibited disregard for anything that has been established as fashionable."

opposite page, right Life recorded in 1965 that the US ready-to-wear industry imported "kooky, ebullient styles for birds, (cute girls) by young British designers."

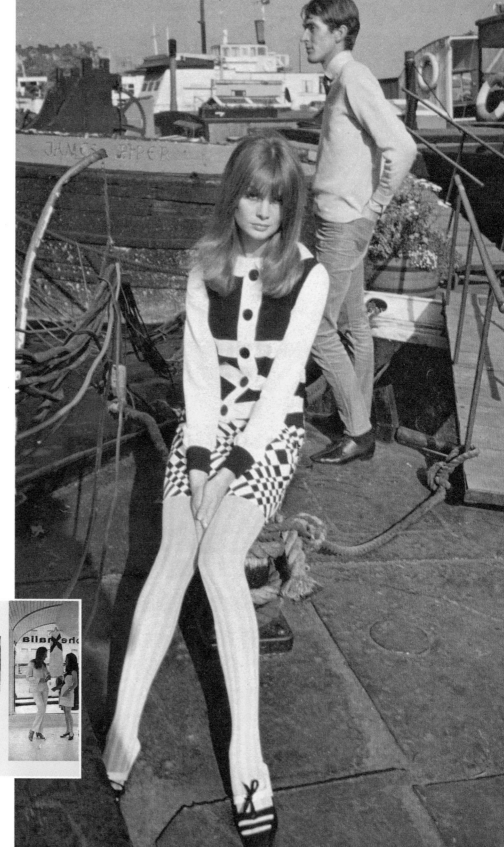

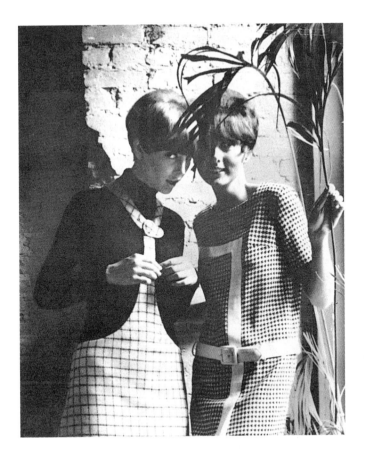

been planned, it had been looked upon to promote the idea in people's minds that Penney's was in fact an up-to-date, with-it kind of store. Actual sales had been regarded as irrelevant. We had not fully understood this. We didn't really appreciate that, in the back of his mind, Paul Young was thinking of us as a one-shot thing. He changed his mind only when he saw the sales figures. For the first time in the history of Penney's, an ambassador's wife shopped in one of their stores. Lady Ormsby-Gore bought one hundred and fifty dollars worth for her daughter. This was splendid."

Paul Young subsequently went to work for Karl Rosen, president and founder of Puritan Fashion Corporation, which was not actually a fashion house but a manufacturer of overalls. His brief was to position Puritan at the forefront of the youth market, and as a result he initiated "Youthquake" a Puritan division, manufacturing clothes by the new British designers. For promotional purposes a short film was made with models cavorting around

the streets of London wearing clothes by Foale & Tuffin and Mary Quant. Another aspect of the deal was the whistle-stop coast-to-coast promotional tours. Sandy Moss, then a model for Mary Quant, recalls the enthusiastic response of American teenagers to the "dancing" fashion shows. "Both the Beatles and the Stones first toured America in 1964. We seemed to follow the Beatles around, the reaction was overwhelming... We did the shows to loud music, flicking our hair around. They had never seen models dancing on the catwalk. There was pantyhose in America, so we could hoist up our skirts, that's really how the mini was born."

For all the initial excitement there proved to be difficulties in selling the garments through the department stores, "Wholesale didn't really work," Sandy Moss remembers. "The clothes were badly made, Puritan didn't make them as well as Penney's, there were compromises made on fabrics, the garments were cut too long, and they were sold in department stores, which

didn't work. The customers were wearing high-heeled shoes and had old-fashioned hair. The main problem was the buyers; each had to divide the orders between four departments: Junior, Junior Miss, Young Matron, and Matron. It was difficult for them to know in which category to place the clothes."

Sandy recalls, "We had all the excitement of being rebels, we deliberately wound up the Americans. In Atlanta we wore see-through tops and short skirts and were ostracized. No one came near us in the room. If you were in a miniskirt, you were refused entry to the restaurants, even in the big cities."

The fashion establishment in the US found it difficult to understand the desirability of a look that was so difficult to categorize. Age still regulated the appearance of women. The fashion editors, many of them middle-aged or old, tended to see the British designers as providing only teenage fashion, and continued to think of real fashion as garments they would wear. In 1966, Geraldine Stutz, president of Henri Bendell, the department store, was asked if the British influence on American fashion was at an end. She replied, "If you mean 'mod' then I do think that that kind of cheap English fashion has had it."

It was becoming increasingly clear that the place to sell the avant-garde was not in the department stores, a fact already acknowledged in Britain and the reason for their flourishing boutique culture. So in 1965 Paul Young opened Paraphernalia on New York's Madison Avenue between 66th and 67th Streets. Sandy Moss recalls her time as the European buyer, "I spent my time scurrying around Europe finding new and interesting things. As well as Mary Quant, the store sold Foale & Tuffin, Emmanuelle Khan, Georgina Linhart, Zandra Rhodes and Sylvia Ayton, Ossie Clark, and the hats of James Wedge. I must have been one of the first people to cross the Atlantic so much. The Algonquin was where we all stayed, the whole British contingent." The interior of Paraphernalia embodied the metallic glitter of the space age. The boutique was designed by architect Ulrich Franzen as a series of raised

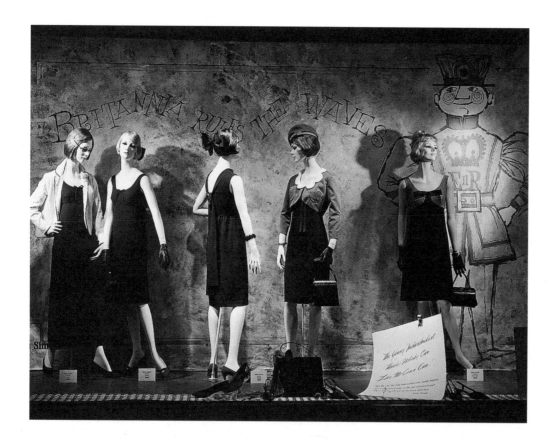

left Beefeaters, Bobbies, and Britannia – the New York department store Lord & Taylor's display promoting the designs of Gerald McCann. The slogan ran, "The Young Individualist Thinks Nobody Can Like McCann Can!"

right Members of the team involved in the export of British fashion to America. Mr Digby-Morton stands at the back viewing model Jean Shrimpton wearing a trouser suit by Reldan/Digby-Morton. The plaid coat is by Burberry and company chairman W.S. Peacock is seated at the front.

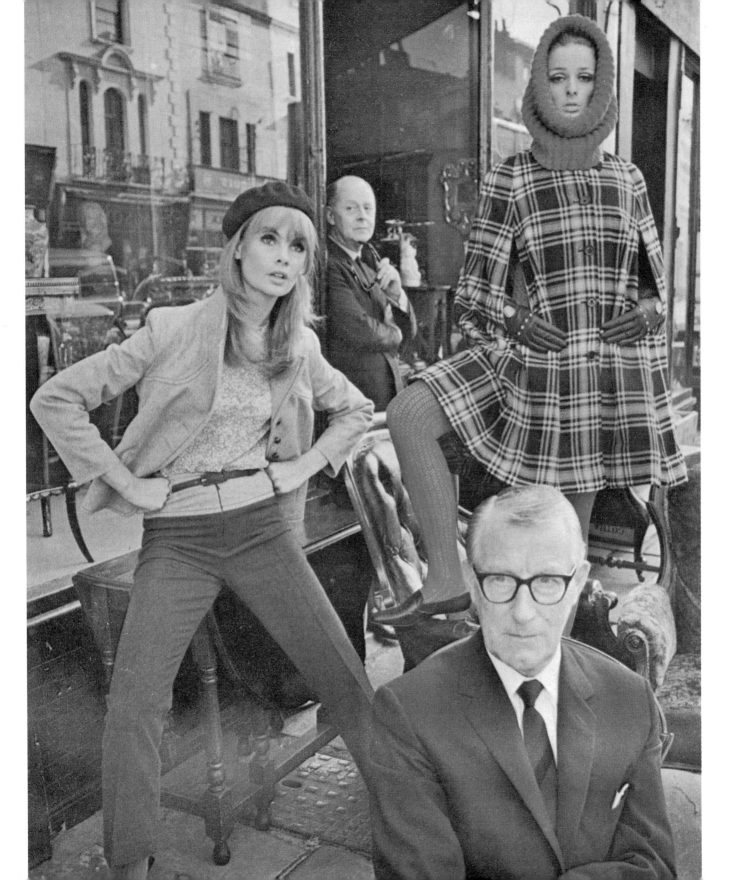

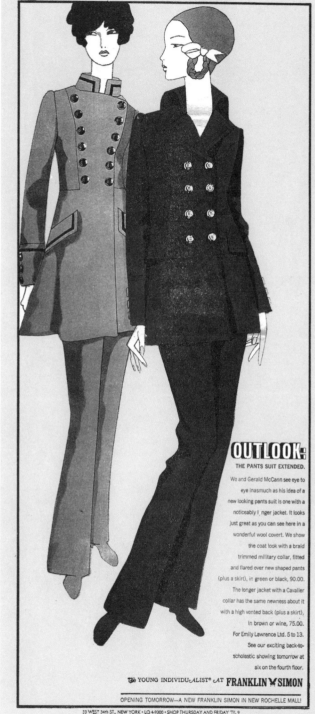

OUTLOOK:
THE PANTS SUIT EXTENDED.

We and Gerald McCann see eye to
eye inasmuch as his idea of a
new looking pants suit is one with a
noticeably longer jacket. It looks
just great as you can see here in a
wonderful wool covert. We show
the coat look with a braid
trimmed military collar, fitted
and flared over new shaped pants
(plus a skirt), in green or black, 90.00.
The longer jacket with a Cavalier
collar has the same newness about it
with a high vented back (plus a skirt),
in brown or wine, 75.00.
For Emily Lawrence Ltd. 5 to 13.
See our exciting back-to-
scholastic showing tomorrow at
six on the fourth floor.

Ṫ̇ṡ YOUNG INDIVIDUᴄALIST® AT FRANKLIN ⋈ SIMON

OPENING TOMORROW—A NEW FRANKLIN SIMON IN NEW ROCHELLE MALL!

23 WEST 34th ST., NEW YORK • LO 4-9300 • SHOP THURSDAY AND FRIDAY TIL 9
ALSO AT ALL OUR SUPERB SUBURBAN STORES

far left *Americans were*
particularly responsive to the
disciplined, tailored cut of
designer Gerald McCann.
He said, "This was the first
trouser suit with the longer
jacket to be retailed in the
American stores."

left *A summer coat dress,*
a seasonal variation of the
redingote by Gerald McCann.

right *Coats by Gerald*
McCann. The extended
jacket could be worn
with either a matching
skirt, pants, or on its
own. The Beatles' cartoon
"Yellow Submarine" was
the inspiration for the
graphic style.

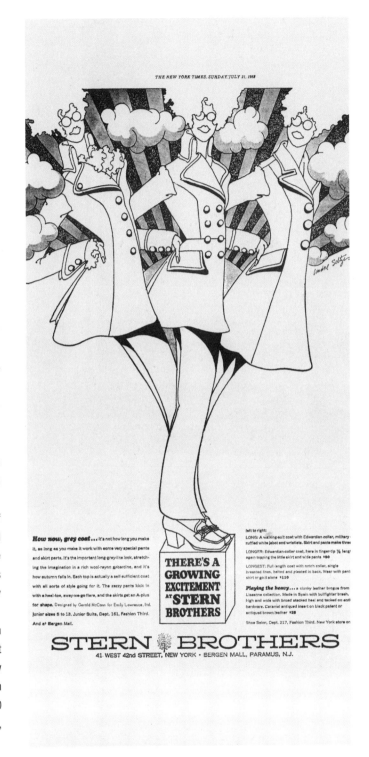

dais on which live models gyrated to music. There was no overt selling, the
display was confined to live models, and the merchandise was unobtrusive.
Far more important was the space; innovative tractor seats later exhibited
in the Whitney museum provided the perfect venue for the urban leisure
activity of "hanging out". Paul Young hired Susan Burden as director of
public relations, an astute move which assured the continued support of
America's first family, the Kennedys. Joan Kennedy had been her college
room-mate, and Jackie Kennedy was photographed for the cover of *Life*
magazine wearing a Betsey Johnson silk shirt from Paraphernalia in 1967.

Betsey Johnson was seen as the home-grown talent that could usurp the
British stranglehold on the avant-garde. Her work had been spotted by Paul
Young when he was visiting *Mademoiselle* magazine in search of new talent.
She was enormously influenced by Biba, whose shop she had visited while
on a trip to London. She says "That was it, for me, Biba, Mary Quant, it was
so inspiring. London told me to be fashion designer."

Dressing-up became performance art as the materials and structure of
Johnson's garments were subject to endless variations. She utilized found
materials such as plastic, paper, aluminium foil, and vinyl, which added to the
transitory nature of the clothes. She produced a clear plastic dress that was
sold with a kit of coloured plastic squiggles for the wearer to attach as they
pleased. Edie Sedgwick, the Warhol superstar, was her fitting model.

Fuelled by the impetus of Betsey Johnson's talent, Paraphernalia went on
to franchise branches all over the US, first in New York and then throughout
the country. As the company grew, however, Sandy Moss became increasingly
disenchanted, "The buying got very complicated. I didn't know what women
wanted to wear in Texas, so I left and came back to live in England." In 1970
Betsey Johnson, too, became disillusioned with the franchising operation,
and left the business to sell under her own label.

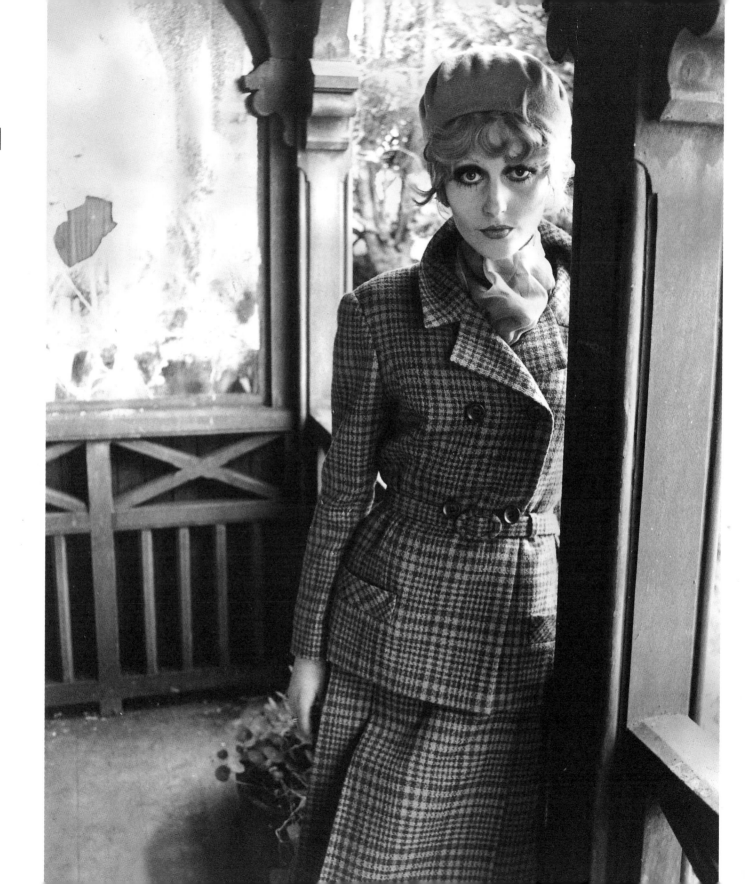

youthquake stateside

stateside

the undermining of junior miss

right *The proportions and style of the millinery animate the simple modernity of this red georgette shift dress designed by Gerald McCann. The styling succeeds in conveying a distinctive American feel to what was inherently a British look.*

opposite page, left *Red wool suit by Jeffery and Harold Wallis, one of the outfits featured in* Life *magazine promoting the work of young British designers.*

opposite page, right *Ankle-length double-breasted red greatcoat designed by Tuffin & Foale to be worn by British actress Susannah York in the 1966 film* Kaleidoscope. *The eponymous heroine owns a boutique in Hampstead and designs, "kinky clothes for baby-faced Chelsea girls who like to show off their pretty little knees."*

previous spread *Here come the Redcoats, selling British design to America. Designer Roger Nelson and two models wearing his designs photographed in front of a uniquely British scene, in Horse Guards Parade, Whitehall.*

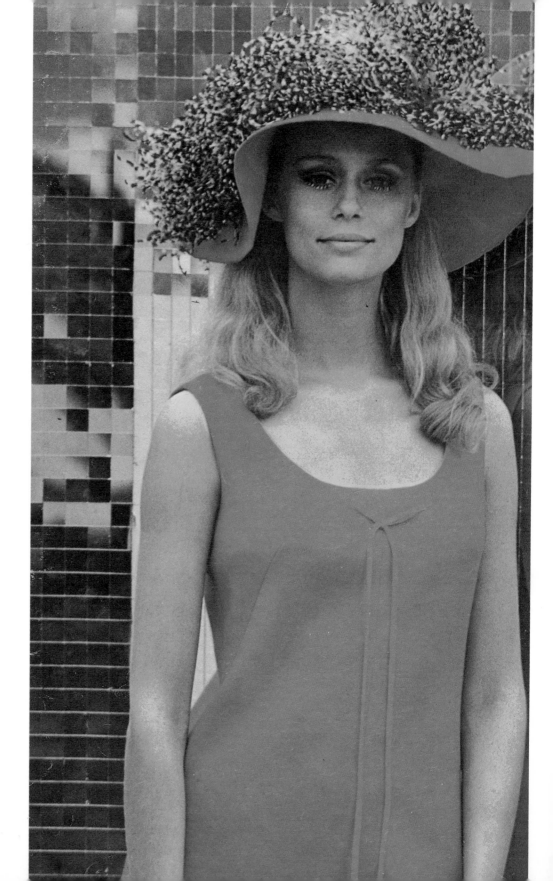

Meanwhile, the Society of London Fashion Designers with the support of the Board of Trade had instigated several different schemes that were designed to promote British fashion outside of the United Kingdom. In 1964 a number of fashion designers led by the Society's chairman Edward Rayne and accompanied by a team of models decided that they would take part in a ten-day fashion festival that was happening in Las Vegas. The following year the cruise ship the *QE2* sailed to the United States, presenting four spring fashion shows on board the ship to the North American buyers, which was worth a million pounds in sales. The visit garnered immense publicity in press and TV coverage, and helped to familiarize American buyers with the "London look".

In 1967 Lord Mountbatten opened a "Best of Britain" exhibition in the New York department store Macy's. Gerald McCann was one of the designers featured in the exhibition, when he arrived at the store later in the morning, his clothes were nowhere to be seen: all two hundred of his "Napoleonic" suits had sold out completely.

Gerald McCann had trained at the Royal College of Art when Madge Garland had been head of fashion, and he went on to join the atelier of London couturier Harry B. Popper. In 1963 McCann opened up a boutique in Raphael and Leonard's House of Beauty in London's Upper Grosvenor Street, as well as starting up a wholesale business that was the biggest supplier to the Woollands 21 shop. McCann went on to consolidate a reputation in the US for modern elegant clothes that sold across that continent. His greatest success was his tailoring: the clean, contemporary lines had a particular resonance with the American public. In spite of his British nationality and his propensity for "spending every night of 1964 in Elaine's," McCann went on to be named as one of the top ten American designers, and was even one of the few English designers to manufacture in the US under his own label.

left The fusion of traditional qualities of material and construction with modern detailing and cut were key aspects of the designs by David Skinner for the international couture house Matita.

right Reefer style jacket by David Skinner for Matita. Within the constraints of couture tradition, young designers injected contemporary elements into their ranges for ready-to-wear clients.

far right In balancing the avant-garde with the traditions of couture, the styling of this outfit by David Skinner harnesses the conservative country house connection to enhance the acceptability of this look.

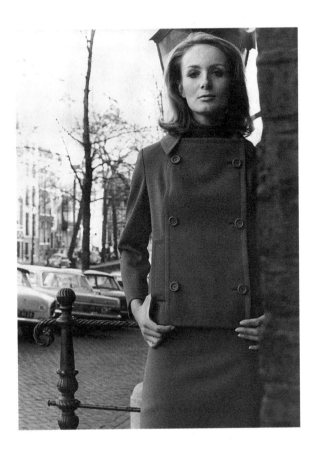

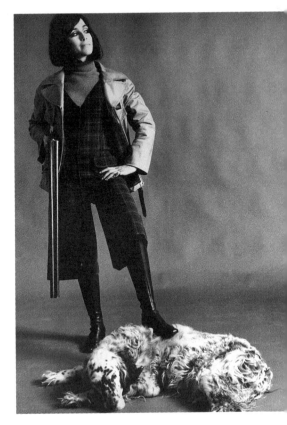

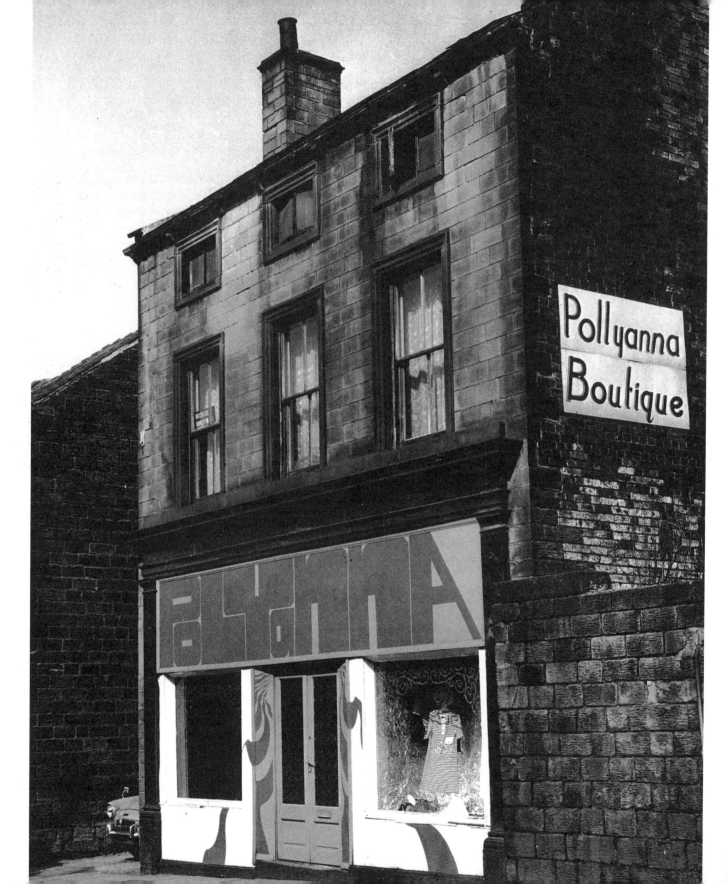

i'm in with the in crowd

boutique culture in the regions

left Thousands of young girls ironed their hair to straighten it in slavish imitation of style icon and television presenter Cathy McGowan. Barbara Hulanicki would wait with bated breath for the weekly showing of "Ready, Steady, Go" to see if she would be wearing one of her dresses, or of her rival, Foale & Tuffin.

previous spread This unprepossessing building with its hand-written fascia was the original site of the internationally renowned Pollyanna Boutique, which was opened by Rita Britten in Barnsley.

the stereotypical view of the British northerner is of someone who is hard-working, honest, careful with money, and plain-speaking – albeit somewhat lacking in finesse. It contrasts with the perception of southerners, who are fast-moving, sophisticated, and spendthrifts. George Melly, writing a pastiche of "Swinging London" in the screenplay *Smashing Time* in 1967 recounted the story of two girls who came to London from an unspecified place in the North in search of Carnaby Street. It was a light-hearted "double-decker" film made to capitalize on London's reputation as a "swinging" city, but it nevertheless pinpointed the prejudices towards people from what were then called the "provinces". One of the girls, Brenda, finds a job in a boutique ("Brenda? I've never known anyone called Brenda before"), but is hopelessly out of place, demanding that the customers buy something before they get a free cup of coffee. She is told by the owner, the Honourable Charlotte, "If one's chums have to buy something every time they come in, one's chums won't come at all."

Nevertheless, the advancement and development of the youth sub-culture was not confined to London. Art colleges in major provincial cities had a significant part to play. For example in Nottingham art students, natural allies of the West Indian population, frequented the shabeens, and for the first time white middle-class teenagers had access to black music and cannabis. Alongside the jazz clubs and the Union bar of the university, Nottingham's students appropriated certain pubs, coffee bars, and nightclubs in the city for their own. Dress was rooted in the scruffy anti-establishment uniform of jeans and duffle coats, or for the "chicks", black stockings and dirndl skirts in a nod to the Paris Left Bank.

Overlapping this sub-culture was the emergence of the "mods". In Nottingham this term was a description of style rather than a sociological definition. It included office workers, factory girls, students from the design

right The staff of the Birdcage in Nottingham in 1966: Ian Longdon, Paul Smith, and Valerie Longdon. They are wearing graphic T-shirts, a new phenomenon sold through mail-order by the satirical magazine Private Eye. The shirts were designed by Nottingham art student, Dave Humby.

Opposite page, left Fashion in 1964. Charity shop finds, furs, and family remnants from previous eras were used to construct an individual identity outside the confines of the boutique system.

Opposite page, right Three Mods and a Mini. Valerie and Carol Longdon and a friend in front of the car that epitomized the era. Designed by Alec Issigonis and launched in 1959, and with the introduction of the Mini Cooper in 1961 the mini went on to become Britain's best-selling car.

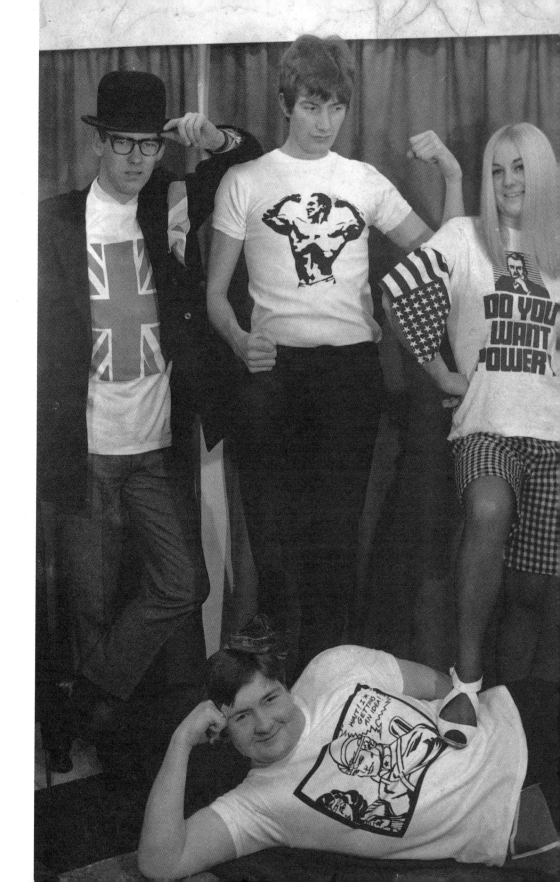

disciplines, and boys in advertising and marketing. However, there was nowhere in Nottingham that sold the sort of mod clothes that approximated to what was seen on the screen and in magazines such as *Honey*. George Melly reflects in his book *Revolt Into Style* (1971) that whereas in the fifties fashions took an incredible time to spread, "TV programmes such as 'Ready Steady Go!' made pop work on a truly national scale. It plugged in direct to the centre of the scene and only a week later transmitted information as to clothes, dances, gestures, even slang to the whole British teenage Isles."

The boys travelled to London's Carnaby Street for their clothes, the girls had to make do with home dressmaking and C&A. So it was not surprising that new entrepreneurial activities began to emerge in Nottingham, significantly in the clubs and pubs of the city. Ian Longdon, an illustrator for an advertising firm by day, and Paul Smith, then working in a warehouse as a "gofer", both started selling handmade floral ties in a Nottingham night club. They both went on to be associated with the most successful boutique in Nottingham.

Nottingham was too small to compete with Manchester or Birmingham for the title of England's "second city". However, in the sixties, there were more boutiques opening up in Nottingham than in either of those cities, almost certainly as a result of Nottingham's tradition of textile and garment production. Whole areas of the city were then devoted to the manufacture of clothes, most particularly the Lace Market,which had been built to house the lace industry. Now, as well as accommodating the few remaining lace manufacturers, it was also home to companies specializing in the production of cheap mass-produced clothes, and wholesale warehouses selling to the retail trade. The obvious opportunities evident in the fashion industry led to healthy recruitment levels in the fashion department of the local art college, and the majority of its graduates went on to open boutiques.

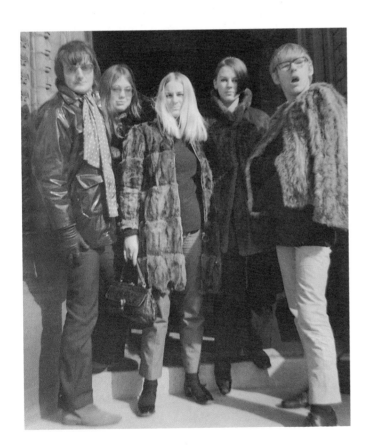

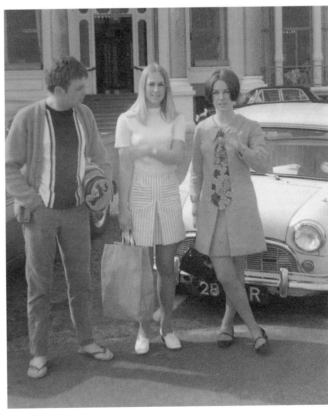

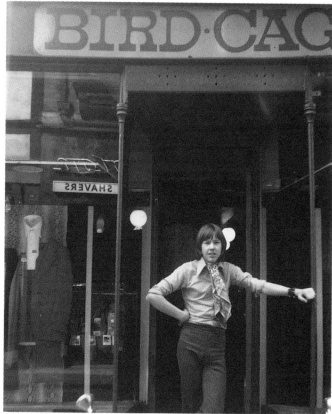

Janet Campbell opened the most successful of these boutiques, the Birdcage. On leaving college she spent a few months in London "smocking posh frocks for a shop in Sloane Street" while formulating ideas about her own shop. She came back to Nottingham and gave herself a week to find a property, and with the help of her friend Paul Smith discovered an old tailor's shop at the end of Bridlesmith Gate, paying twenty pounds a week for a six-month lease. She says "I knew that I didn't want to be where anyone else was, definitely. I knew it had to be a little road somewhere, to be different. In a city, on a road that was interesting, different, and affordable.

"Lots of people knew who I was, and they would pass the shop when I was doing it up and would laugh and say, 'I'm sure she'll go bust,' but in fact it was the big companies in the Lace Market that went bust because they couldn't see what was happening. The Birdcage was instantly successful. The day I opened, Paul had done the window and it looked fantastic. People stood outside frightened to come in. Literally three rows of people. And it was so impressive. Paul went out and joked and made them laugh. He said to them, 'Come in, it's all right.' And they did. And from then on it never stopped."

New designs came onto the rails constantly, and by 5 o'clock on a Saturday evening the shop would be cleared of stock. Some customers would travel to London once Biba opened, but the majority needed the constant fix of a new dress every Saturday to wear at one of the new clubs opening up in the cellars of the Lace Market or on the narrow street itself.

"I'm in with the in crowd," sang Dobie Gray in 1965, "I go where the in crowd go." The Birdcage was certainly one of those places. Janet Campbell remembers, "It was a meeting place. Instead of having someone behind the counter saying, 'Good morning, may I help you?' it was, 'Did you go to the club last night?' None of us had any formal training in retailing, or worked in a shop before, so nobody knew the 'right' way to do it, anyway. I employed

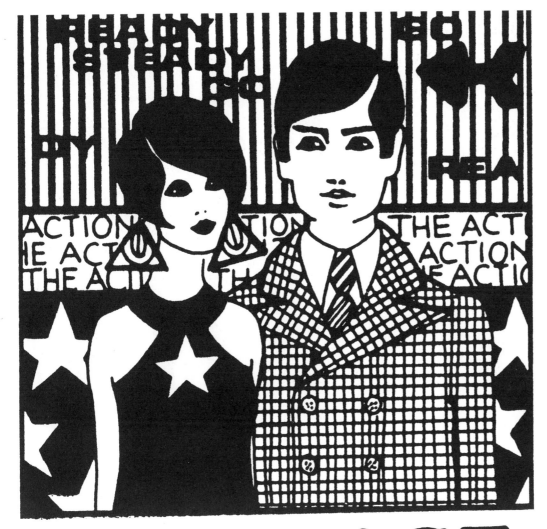

BIRDCAGE
★★★★★★ *BOUTIQUE* ★★★★★★
FOR GUYS & DOLLS!
24 BRIDLESMITH GATE
Tel: NOTTINGHAM 53490

right The Birdcage sold garments designed and made by several people under their own label. Ian Longdon not only manufactured clothes for the shop; he also designed the publicity and packaging. He constantly updated the style of the presentation of the merchandise from the early mod look to the art deco style that was to emerge at the end of the decade.

opposite page, right The Birdcage double frontage, Bridlesmith Gate, Nottingham. The original Edwardian traditional tailor's shop façade was inexpensively reworked in maroon and gold to suggest a trendy boutique.

opposite page, left Art imitates life and life imitates back. Ian Longdon posing with a body cast created for one of the renowned window displays of the Birdcage boutique.

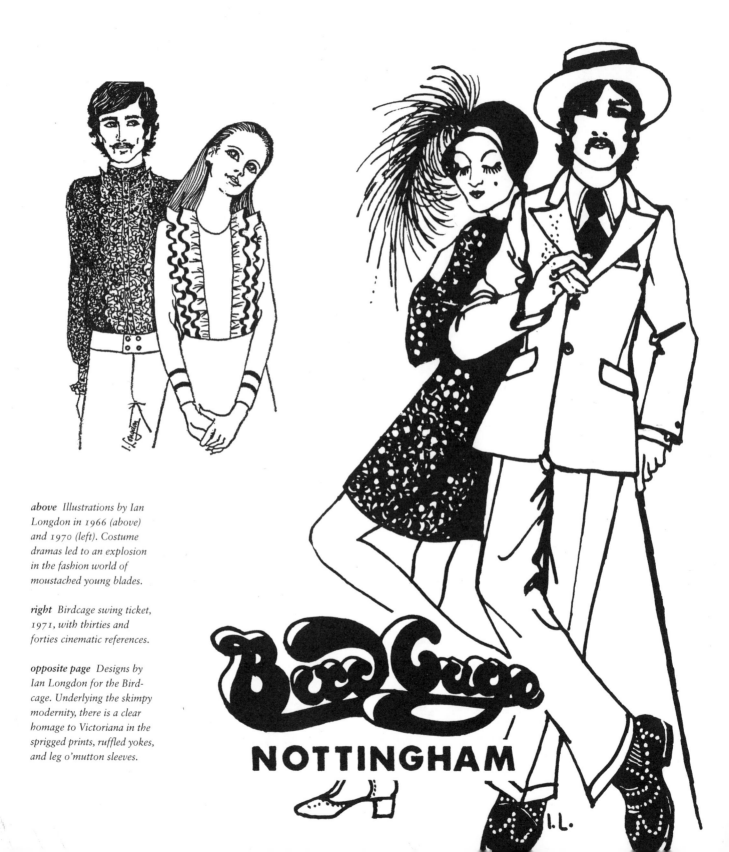

above Illustrations by Ian Longdon in 1966 (above) and 1970 (left). Costume dramas led to an explosion in the fashion world of moustached young blades.

right Birdcage swing ticket, 1971, with thirties and forties cinematic references.

opposite page Designs by Ian Longdon for the Bird-cage. Underlying the skimpy modernity, there is a clear homage to Victoriana in the sprigged prints, ruffled yokes, and leg o'mutton sleeves.

NOTTINGHAM

a girl called Valerie because she'd got the right sort of hair. Our clothing was very democratic. Rich or poor, everyone came in. Girls who worked in banks, students, office girls – and rich girls, too. Completely classless."

The defining characteristic of the customer was youth. The clothes did not conceal imperfections, they were cut to reveal and did not go beyond a size twelve. "I was walking around the city on a hot day," recalls a customer, "and all I wore was a pair of tiny knickers and a very short turquoise dress with cutaway armholes. After the restrictions of a school uniform it was amazing to feel the breeze on my bare skin. No bra, no petticoat, no stockings or tights. My mother was horrified, she had been measured for a corset when she was fifteen even though she was as thin as a rake."

However, although the popular media profoundly influenced the style of teenagers, the older generation was essentially more hidebound. Older people were less tolerant of the vagaries of fashion, and sought to place

clothes in a "moral" context. What was acceptable and even commonplace on the streets of London was perceived as outstandingly provocative in the regions. In addition, "fashionable" boys faced even more criticism than fashionable girls. Homosexuality was still a criminal offence and any indication of sartorial enthusiasm was considered deeply suspect and compromising of masculinity. Teenagers still lived at home in the sixties, unless away at university, and passing a driving test was not an automatic rite of passage at seventeen. The majority of teenage boys exposed themselves to ridicule if not physical violence as they ran the gauntlet of a journey on public transport through the towns and suburbs on their way to a night out in the city.

In 1966, a year after opening, Janet Campbell decided it made sense to move the machinists from the first floor of the building to make way for a menswear department, and asked Paul Smith to run it. He soon built up a

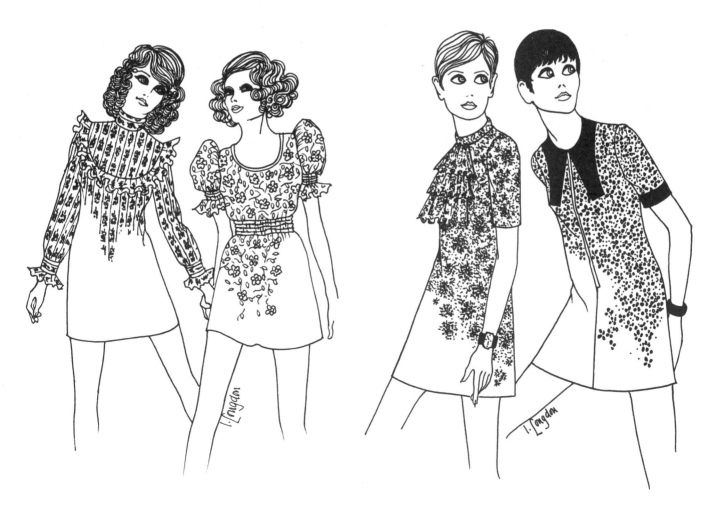

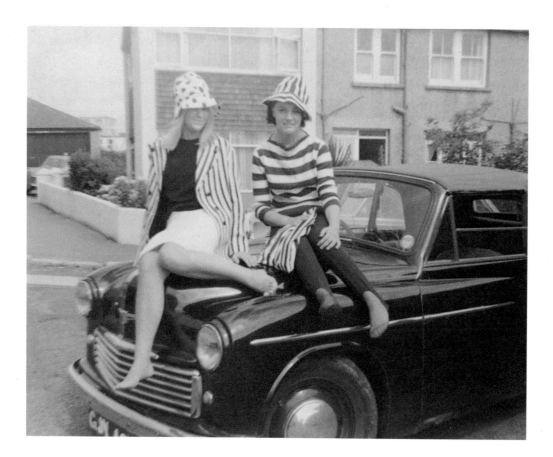

left Surfers' Paradise – the romance and the reality – back street Newquay, Cornwall. Every girl and boy mod dreamed of living the life of a surfing beach bum. Here beach retailers pose in fashion samples.

right Sir Paul Smith, at the beginning of his career as a retail entrepreneur, posing in his first tiny boutique in Byard Lane, Nottingham 1971. The development of a globally recognized brand and the dedication of a vast acreage of retail space throughout the world to his products underline his distinguished achievement.

customer base which spread out across the Midlands, sourcing labels that were previously unknown outside London such as Mr Freedom, Chelsea Cobbler, and Mulberry.

Richard Williams, then a journalist for the local paper, who went on to become a writer for *The Guardian*, remembers being measured at the boutique for a double-breasted, chalk-stripe RAF-blue suit, made to order, which cost twenty-five guineas. "I'd describe myself less as a customer and more as an inhabitant. The Birdcage was enormously important to me. I went in there on Saturdays and would often call in on weekdays, sometimes on my way to and from covering juvenile court. I had a very clear idea of its value. The choice of music in the shop was also important, and if I was spending an hour or two there I tried to have some say in it. The other good thing was that the women's shop was downstairs, so there was a good chance of bumping into girls."

In 1970 Paul Smith made the decision to leave the Birdcage and start up on his own in a twelve-foot- (three-metre-) square room down a corridor at the back of a tailor's shop. He says "I would go to a tailor in Bridlesmith Gate who did alterations, Douglas Hill. He let me use the back room as a shop, together with a very damp basement. I left the Birdcage on a Friday and two weeks later opened up. My brother and Dad helped me to decorate; white paint directly onto brick, spotlights, big mirror on the wall facing the door. It was free for three months, fifty pence a week rent after that.

"At the Birdcage I'd been selling what was available in Carnaby Street, but I wanted to dig deeper. I was a pioneer, I had things that nobody else had. Modern classics you couldn't get anywhere else – 501s from New York, Anello & Davide boots, cashmere and Shetlands, and unbelievably tight, flared velvet trousers. Our bestsellers at that time were the multi-coloured Shetland sweaters with the satin appliqué on the front.

opposite page, left Lee Bender describes Bus Stop's early days: "The first shop we opened was as a showcase for our manufacturing business. It was originally an old-fashioned grocery shop, Cullen's Grocery Store, and we changed it very little. We opened next to Biba on Kensington Church Street in 1969. We chose the name 'Bus Stop' because it was so identifiably British; and red because it was the colour of telephone kiosks, pillar boxes, and London buses."

opposite page, right Lee Bender says "Bus Stop was the first boutique to open branches outside of the capital city, and to sell the same merchandise in each store. It was an instant success, and eventually we had twelve stores altogether throughout the UK."

left Forties-inspired wide-legged trousers designed by Lee Bender for Bus Stop. The vibrant, oversized check parodies the tweed suit of the English country gentleman.

"I knew that if I opened all week I wouldn't make enough money to survive because the goods I was selling were essentially self-indulgent and not what many people wanted. But if I started selling clothes that I didn't like, but lots of people did want, then the job would have changed me. My solution was to work all week doing nasty jobs for money and then open the shop on Friday and Saturday: my two days of purity. I made thirty-five pounds on the first day. I usually took around thirty pounds on the Friday and fifty to seventy pounds on Saturdays. Two days a week for four years.

"Eventually, customers just found me and that was the start of Paul Smith. I called the boutique Paul Smith because I was a familiar name to existing customers, and it was also a reaction against the trend for silly names that were around at the time, such as Carrot on Wheels, etc.

Paul was helped by his partner Pauline Denyer, a contemporary of Marion Foale and Sally Tuffin at the Royal College of Art. He says "Pauline bought fabrics from Pontins to make suede coats and patchwork shirts. I had to borrow a buttonholing machine. It's a terrifying experience using one of those."

Even in that cramped room, with stock hanging on the walls and clothes, shoes, and boots in piles on the floor, Paul found space for the art and artefacts for which he had such a private enthusiasm and such a commercial eye. He opened up the "very damp" basement as the "Pushpin Gallery", exhibiting limited edition lithographs by Warhol and Hockney.

Paul Smith not so much pre-empted the strategy of "lifestyle marketing" as acted on an intuitive understanding of the customer and more importantly, of the product. He gave people goods they didn't know they wanted, a strategy which is directly opposed to the present ethos of using focus groups to research customer needs. Paul Smith says, "What's missing today is individuality. Having a boutique, or being a designer means you can have an idea in your head that you can turn into a reality. Now it's all marketing led."

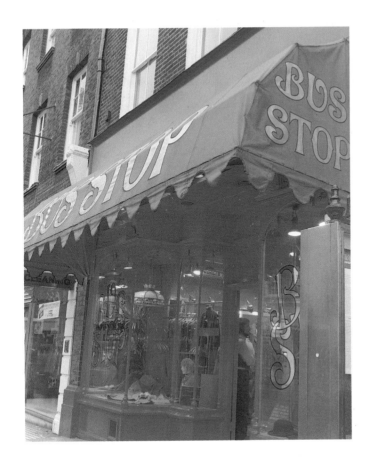

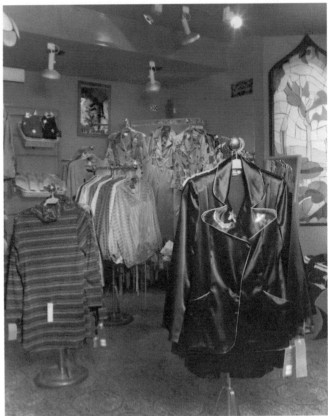

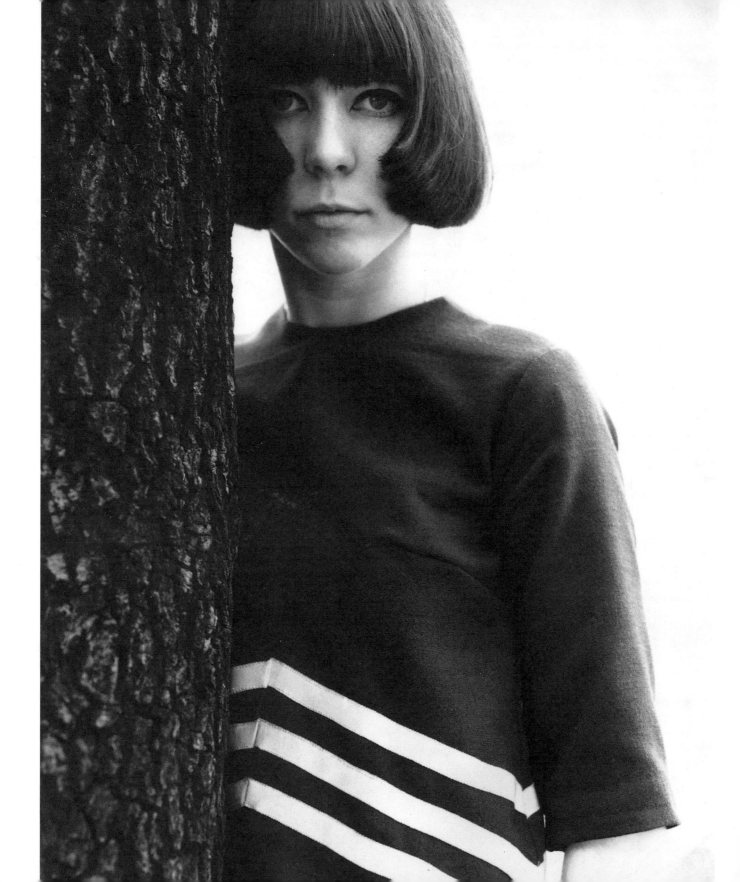

diy fashion

home dressmaking

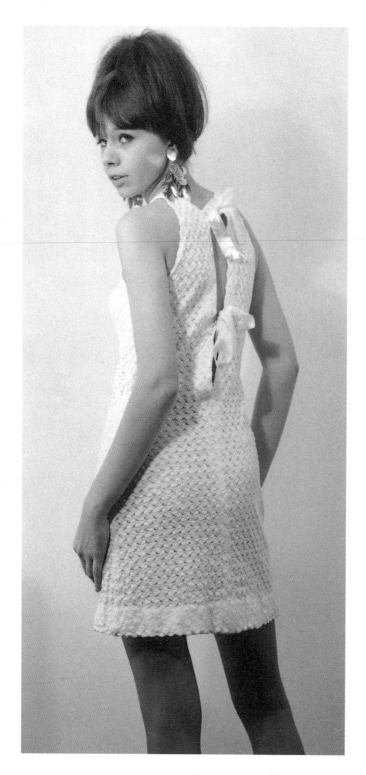

previous spread Quality was less important than the right look. Art student Jane Holder says, "When I made this dress I just lay the fabric on the floor and cut into it without a paper pattern."

left For teenagers, home dressmaking was the only way to provide clothes for an eventful social life.

right Sandy Moss, a model, wearing a dress she made herself. "I copied this Roger Nelson suit from Vogue. In 1962 there were no designer patterns so I made my own. It was in black wool bouclé with a shot blue and green Thai silk collar."

ome dressmaking was commonplace in the sixties, as was engaging a family dressmaker to make up the family's clothes. Middle-class families had access to a "little woman" who made up garments for the family with varying degrees of skill, from the amateur who did a bit of sewing, to the highly skilled personal dressmaker prepared to embark on tailoring projects.

Although cheaper, mass-produced clothes became available after the Second World War, there continued to be a significant interest in home dressmaking. Sewing in the home had had an element of "make do and mend," but in addition home dressmaking came to be seen as an alternative to boutique shopping. The principal reason for a teenage girl to make her own clothes was the desire to wear what she could not purchase, either for reasons of economy or through lack of access to boutiques stocking the current trends. Twiggy details the importance of the dressmaking process, "By the time I was thirteen I was making my own clothes… Breaktimes at school would be spent discussing what we were going to wear that weekend. Some of us pooled our money in order to buy *Vogue* patterns which, although expensive, could be easily adapted if you knew how. And I knew how. In those days I could buy a yard of cotton for two shillings and eleven pence (fourteen pence). Whereas the new invention, tights, were incredibly expensive and a real luxury."

As a teenager "ran up" something to wear for the evening, however, value for money was the last thing on her mind. She wanted the latest "look", and sewing was a means to an end. For Abigail Bailey, an art student, sewing her own clothes was the only option. "I can remember spending a couple of hours on a Saturday afternoon making something to wear to the club that night. I was hopeless at sewing but the shape was so simple, what pattern makers call 'fit and flare'. The bust dart was closed and then opened into the

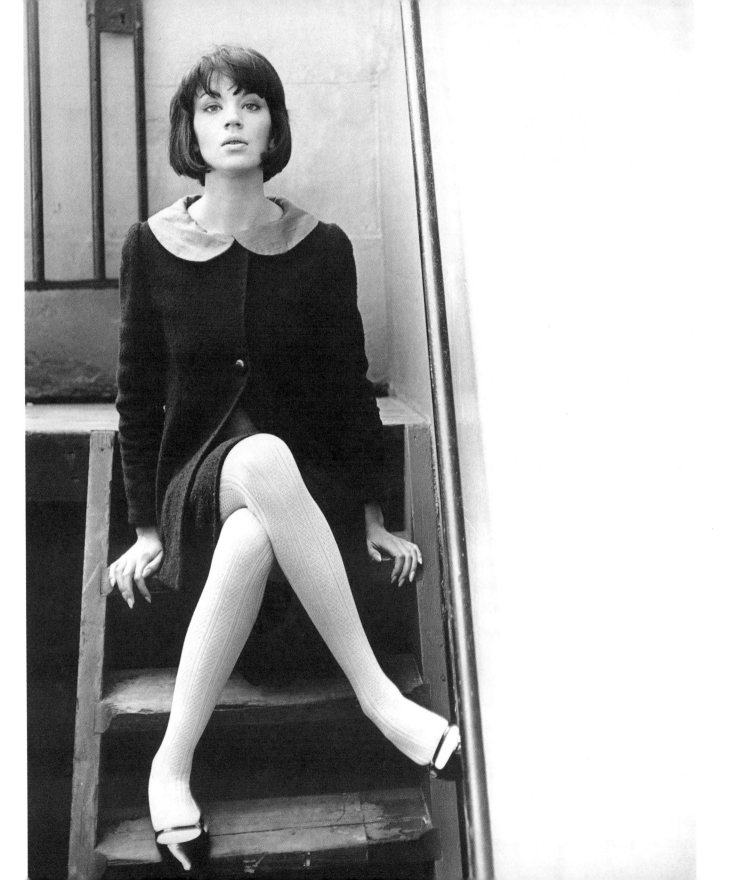

The bicycle problem: Diana Quick (right) and
Vivien Rothwell by Hell's Passage in Oxford.

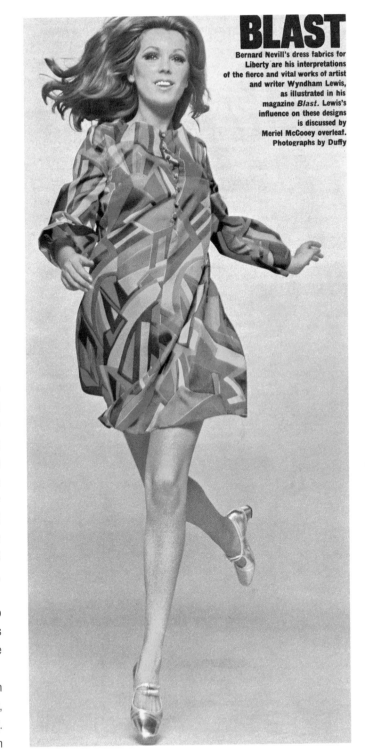

left Oxford students asked by journalist Gillian Edwards about their attitude to clothes expressed their love of fashion. Future actress Diana Quick in red sou'wester and friend Vivien Rothwell wearing a dress designed and made herself.

right Bernard Neville was design director of the London store, Liberty. His "Tango" range of fashion prints, photographed here by Duffy in 1967, along with his Jazz print (see overleaf) were used by Jean Muir in the UK and by Bill Blass in the US (in spite of Diana Vreeland's remark that they were, "too intellectual").

BLAST

Bernard Nevill's dress fabrics for Liberty are his interpretations of the fierce and vital works of artist and writer Wyndham Lewis, as illustrated in his magazine *Blast*. Lewis's influence on these designs is discussed by Meriel McCooey overleaf. Photographs by Duffy

hem of the dress which gave a tiny top with a flirty skirt. Two hours' work, tops, and a new dress for the price of a one and a half yards of fabric."

Maureen Carter, a student teacher, improvised further, "I came home one day with a piece of material from the market. I couldn't afford the two shillings and sixpence for the paper pattern, and my father said, 'You don't need to buy a pattern, we'll make one.' We put wallpaper on the floor and I lay down on it and he drew round me to get the shape. During the war he'd been a sheet-metal worker, so he was used to taking measurements."

Dressmaking and cooking were domestic arts considered necessary to reinforce family values. Even the more academic grammar schools included such skills on the curriculum. Linda Fletcher, in her final year at secondary school had to complete three items: a school dress, a pillowcase with shadow stitching for a trousseau, and a child's dress with smocking. She took pleasure from sewing as a leisure activity, and as her practical experience increased so did the variety of the designs she could execute. "My mother had always had a sewing machine, my grandmother had been a professional dressmaker. I made my evening dress for the graduate ball – I copied it from Cilla Black on TV. Thin straps, with a high waist and straight to the floor. I covered the bodice with sequins. I used to adapt the paper patterns, too, making three or four different versions from the one pattern."

Linda was earning £650 a year at this time as a university secretary, so a dress from the local boutique would have cost around half a week's wages. Home dressmaking was the only means by which she could have a substantial and changing wardrobe for her typically active social life.

For the teenager who did not have the ability or desire to customize her own patterns, paper patterns provided inexpensive access to the latest fashions, and the less structured styles of the sixties made sewing less daunting. Manufacturers even began to run "Very easy" or "Simple" ranges. The main

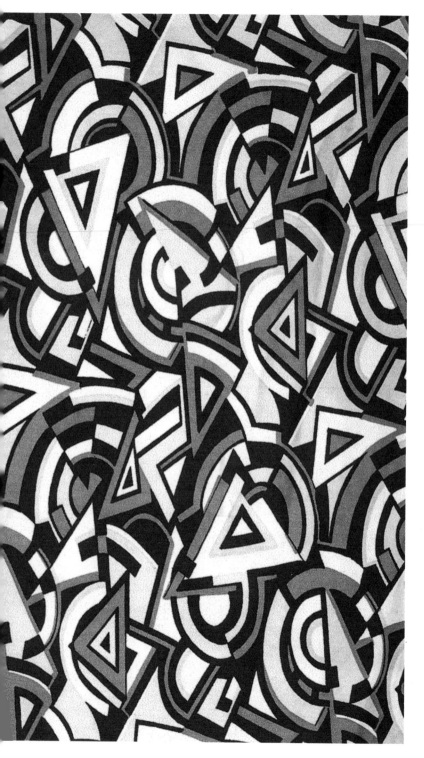

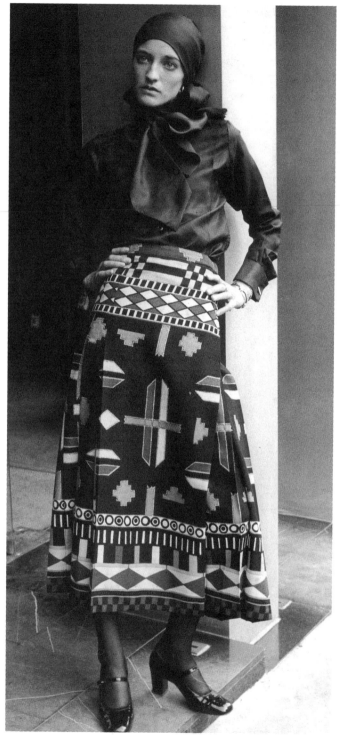

far left The abstract theme of Bernard Neville's "Tango" collection was inspired by the illustrations in Blast *magazine, the* manifesto of the Vorticist movement, which first appeared in 1914.

left Yves Saint Laurent is credited with marketing the first maxi-skirt to appear on the catwalk He used the print "Macedonia" by Bernard Neville. The fabric was also available to buy by the yard from Fenwicks department store.

right Such was the popularity of dressmaking, in 1967 the BBC ran a series introducing the skills and techniques required to make a succession of outfits, under the instruction of well-known designers, including Gerald McCann.

 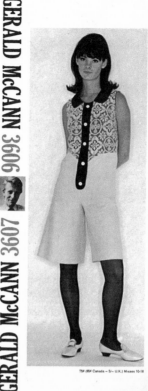

companies producing paper patterns were McCall's, Simplicity, and Butterick. The latter acquired Vogue in 1961, while still marketing the labels separately. McCall's had licensed the designs of many of the French couturiers as far back as the twenties, and this led the way for other manufacturers to do the same, particularly Vogue, which occasionally featured garments made from patterns in mainstream fashion features.

Occasionally a talent for dressmaking fuelled entrepreneurial activities. Ian Longdon began to design clothes for his sisters and initially, his mother, the family dressmaker, made them up. "I started sewing because my mother couldn't keep up. My sisters went to Newquay in Cornwall for the summer, and they sold what they had taken with them. I posted them more and more garments. I used variations of a Butterick pattern, or made the pattern myself. Eventually I rented a room in the Birdcage, and sold my designs through the shop, as well other outlets in Derby and Grantham. By that time I was just

doing the pattern cutting, and the garments were made by a machinist. I missed the activity, though, I liked sewing."

Strong colour and pattern were introduced into fashion fabrics halfway through the sixties as the crisp lines and geometric shapes mutated into a softer and more fluid silhouette. This made home dressmaking easier. Fit and finish were less important than colour, pattern, and texture, which all went to blur the outline of an ill-fitting frock. The hippy movement introduced the notion of customizing existing garments with fringing, beads, feathers, and patches, and this was a look that could be pulled together by mixing home dressmaking with the odd ethnic find or second-hand item.

At one point Butterick sold 70,000 copies of a Mary Quant design and this dissemination of designer styles aided the democratization of fashion. The *Observer* magazine estimated that there were 345,000 dressmakers at this time, and recorded that the Simplicity book *Guide to Home Dressmaking*

sold half a million copies. Patterns had instructions on the best way to utilize the fabric and to construct the garment, as well as guidance on suitable materials. However, amateur dressmakers, unconcerned about the longevity of the garment and keen to make an impact, tended to disregard these. A piece of curtain fabric from a street market was just as likely to be used for a dress in this anarchic approach to clothes-making.

In a new move, just as patterns designed by well-known names such as Mary Quant were now becoming available to the home dressmaker, it was also possible to buy fabrics that were formerly exclusive to couture, through the agency of the London store, Liberty. For the first time, fabrics accessible only to designers were available to the home dressmaker to buy by the yard.

Bernard Neville, later professor of textiles at the Royal College of Art was invited by Arthur Stuart Liberty to be the store's design director, where he

became known as the "Prince of Prints". His designs sold to all the major couturiers of the time: Yves Saint Laurent, Chloe, Kenzo, Sonia Rykiel, and Jean Cacharel, as well as to home dressmakers. His influences were broad based and eclectic, and his radical use of colour involved combinations that were previously unseen. Bernard Neville is gifted with the rare perceptual characteristic of synaesthesia, in which the stimulation of one sense provokes a secondary impression in a different sense. "When I am working with colour I listen with my eyes. I actually 'hear' the colour."

Neville also tapped into the desire to mix different prints in one garment. Yves Saint Laurent purchased one of the earliest Liberty ethnic prints, "Macedonia", for the first maxi skirt to appear on the catwalk. To his consternation, the store Fenwick had also bought the fabric and produced similar skirts. Despite this, the couturier told Bernard Neville that it was his "most successful print ever", and the skirt achieved instant iconic status.

left Bernard Neville, who in his role as design director of the London store Liberty, and later as professor of textiles at the Royal College of Art, was the first to reappraise artistic movements such as art deco and vorticism and place them in the context of sixties culture.

right The Tango collection designed by Bernard Neville in 1967 for Liberty broke down the barriers between the categories of fabrics used for fashion and those used for interiors.

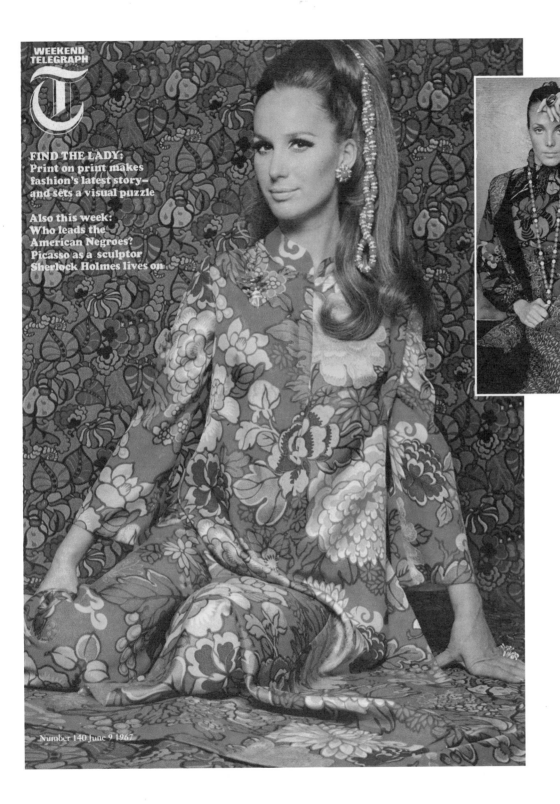

WEEKEND
TELEGRAPH

FIND THE LADY:
Print on print makes
fashion's latest story—
and sets a visual puzzle

Also this week:
Who leads the
American Negroes?
Picasso as a sculptor
Sherlock Holmes lives on

Number 140 June 9 1967

above The "Renaissance"
collection, by Bernard
Neville in 1970 consisted
of multiple prints designed
to go together. The design
reflects the hippy propensity
for patchwork layering of
colour and pattern.

right & overleaf Bobby
Hillson worked as a fashion
illustrator for Vogue.
"Fashion drawing was much
freer in the forties and fifties,
and I was very influenced by
the work of the American,
Kenneth Paul Block in
Women's Wear Daily; he
had such a freedom of style...
However illustration became
much more stylized in the
sixties, one never knew how
much space would be
allocated... sometimes it
would be reproduced as a
much smaller image so it
was safer to do a stylized
illustration in which the
details were clear... The
clothes became much more
stylized, very simple little
shapes. At the end of the
sixties photography
replaced the work of fashion
illustrators, generally people
wouldn't buy from a
drawing, and illustration
wasn't used at all in
magazines'.

right & overleaf Pages from
the sketchbook of designer
Bob Manning showing the
working drawings for a
range of garments for
independent retailers. The
mass-production fashion
industry began to employ
young designers in response
to the demands and desires
of a newly aware High Street
customer. Designers were at
last acknowledged as an
important element in the
marketing and manufacturing
of young "cool" clothes.

CLASSIC SUIT
CUTS A NEW
LINE IN
SCATTERED POLO"
SEAMED &
FITTED
ROUNDED
COLLAR & REVER
ZIP POCKETS

PLEATED SKIRT

MARYGOLD PINPOINT
FOR SUN FRESH DRESS.
NEAT AND SLIGHTLY
FITTED.
ZIP FRONTED,
EMPHASIS ON
TRIMS I.E.
LEATHER CONTRAST
TASSELS.

ZIP FRONTED
TROUSER SUIT
IN 'ECRU PINPOINT
LONG & LEAN
SCOOPED NECK
BAND IN CONTRAST,
SUPER RIPPED
PATCH POCKETS WITH
LEATHER TASSELS
TROUSERS IN PRUNE

FEATURE POCKET
SET IN SIDE SEAM

NEAT SPRING SUIT
IN SKONI
COLLARLESS AND
BUTTON THROUGH.
DRAPED SHOULDER SEAM.
LONG FITTED SEAMS
WITH FEATURE ZIP
INSETS.
SKIRT WITH
C/FRONT PLEAT.

CASUAL
TROUSER SUIT
IN BONE PINPOINT
PEWTER CONTRAST.

POCKET FEATURE
ELONGATED WITH
ZIP FEATURE +
LEATHER TASSEL.

X

Y

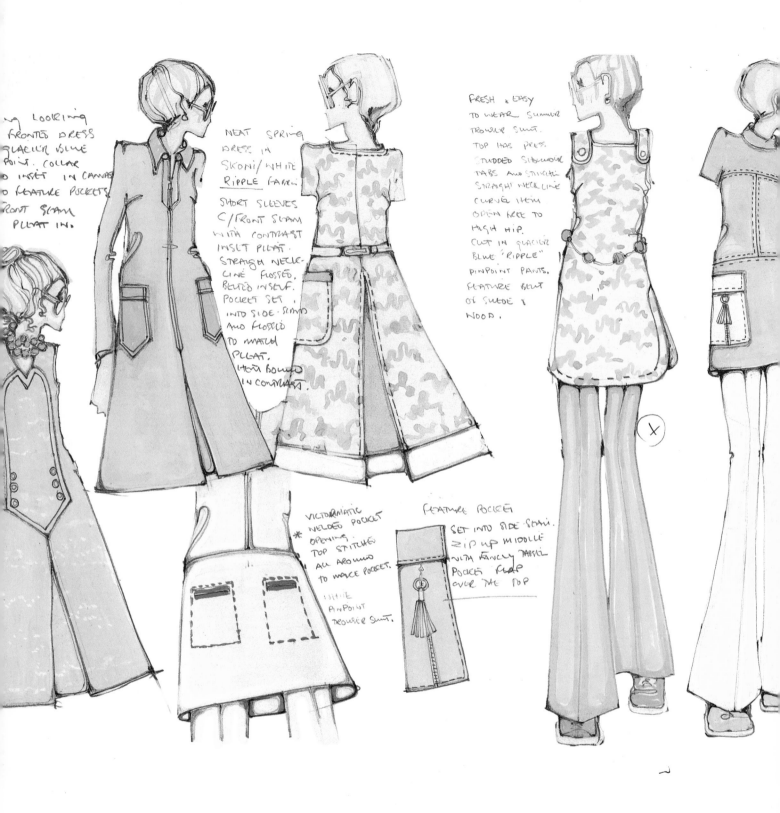

LOOKING
FRONTED DRESS
GLACIER BLUE
POINT. COLLAR
O INSET IN CANVAS
O FEATURE POCKETS
RONT SLAM
PLEAT IN.

NEAT SPRING
DRESS IN
SKONI/WHITE
RIPPLE FABRIC

SHORT SLEEVES
C/FRONT SLAM
WITH CONTRAST
INSET PLEAT.
STRAIGHT NECK-
LINE FLOSSED.
BELTED INSELF.
POCKET SET.
INTO SIDE SLAMS
AND FLOSSED
TO MATCH
PLEAT.
HEM BOUND
IN CONTRAST.

FRESH & EASY
TO WEAR SUMMER
TROUSER SUIT.
TOP HAS PRESS
STUDDED SHOULDER
TABS AND STITCHED
STRAIGHT NECKLINE
CURVED HEM
OPEN FREE TO
HIGH HIP.
CUT IN GLACIER
BLUE 'RIPPLE'
PINPOINT PANTS.
FEATURE BELT
OF SUEDE &
WOOD.

VICTORIMATIC
* WELDED POCKET
OPENING.
TOP STITCHED
ALL AROUND
TO MAKE POCKET.

WHITE
PINPOINT
TROUSER SUIT.

FEATURE POCKET
SET INTO SIDE SEAM.
ZIP UP MIDDLE
WITH FANCY TASSEL
POCKET FLAP
OVER THE TOP

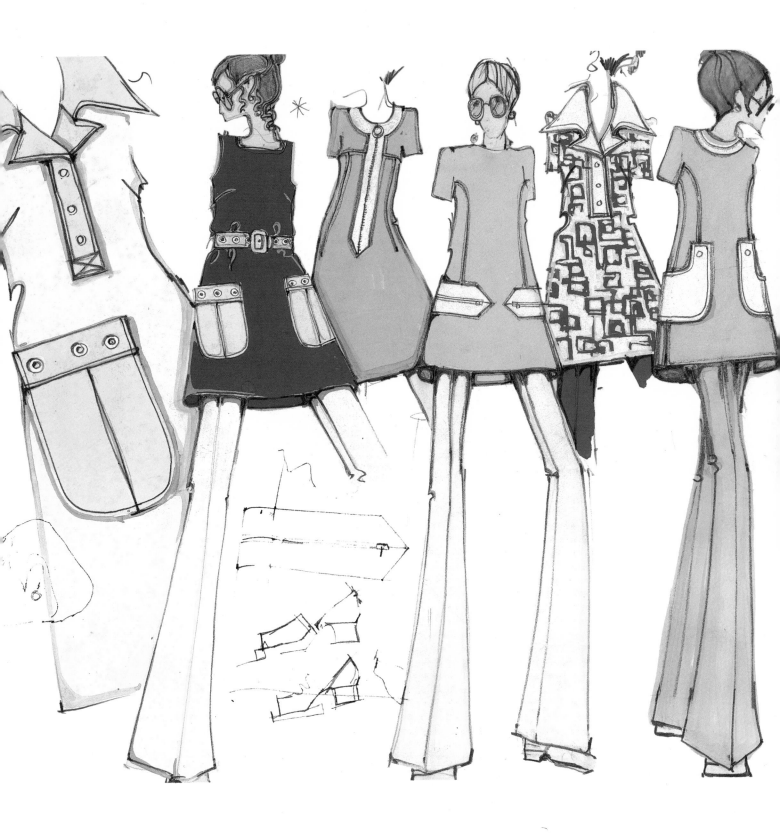

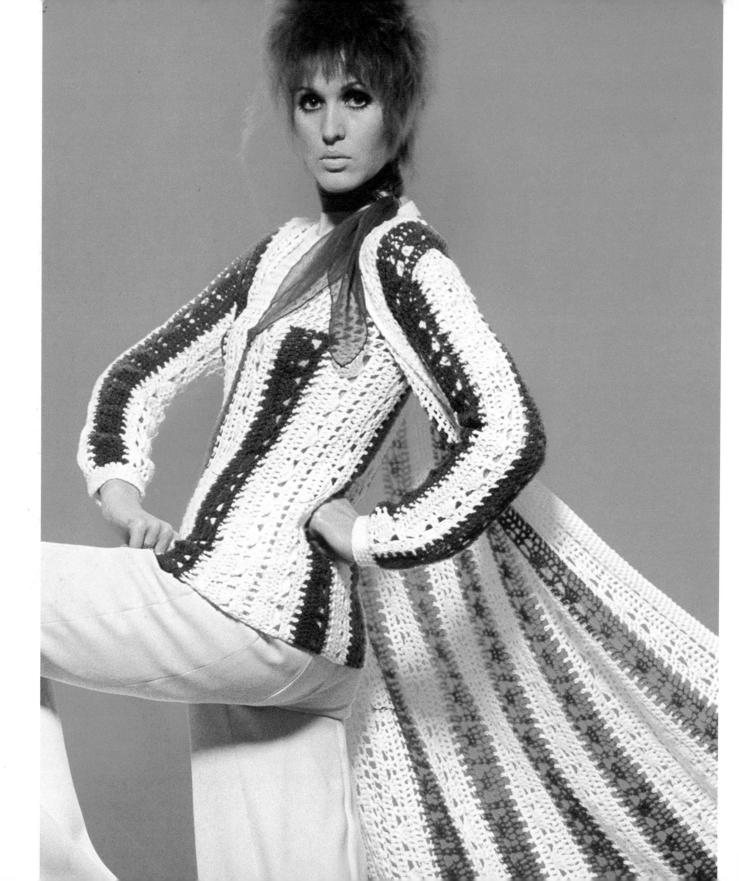

a wilderness of stoned harlequins

fashion and the counter culture

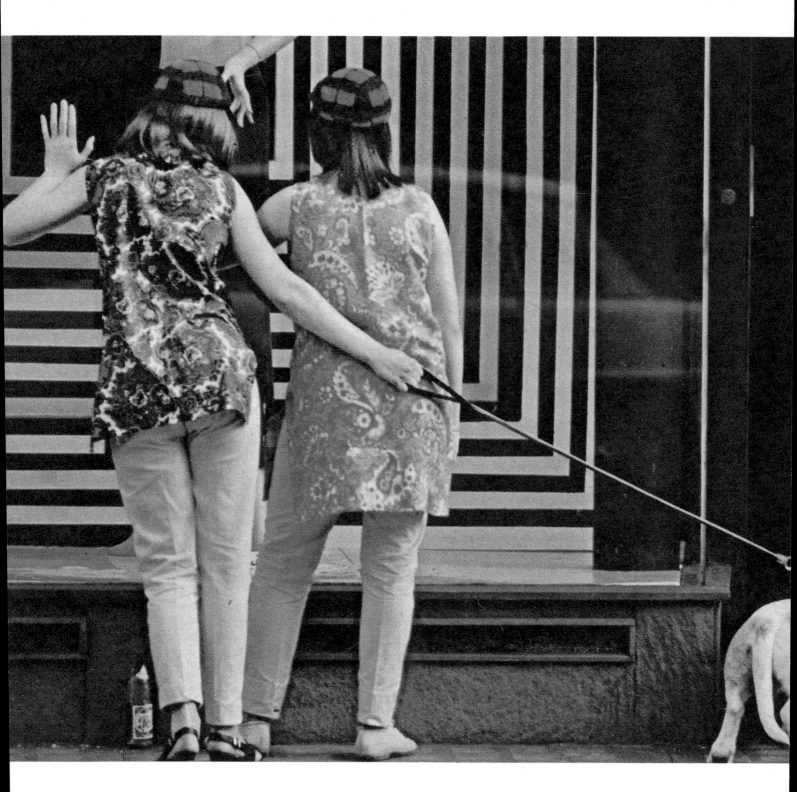

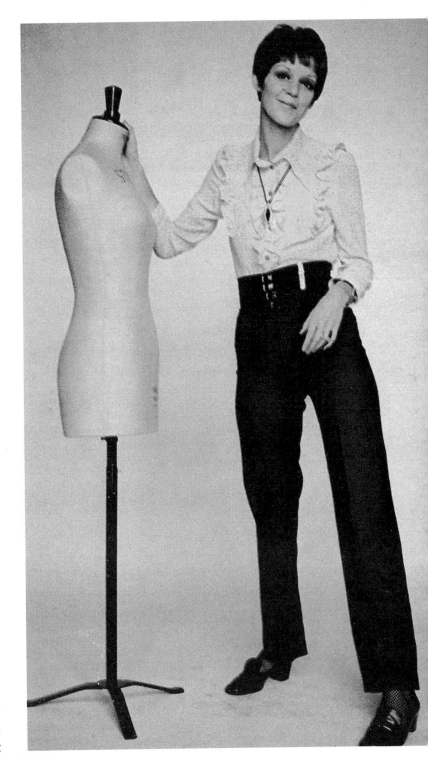

d uring the "high" sixties, boutique culture developed from a designer-driven construct offering just a single "look", to accommodate the whimsicality of a consumer undergoing the process of psychedelic enlightenment. The modernism of the early sixties soon gave way to an eclectic appropriation of the accoutrements of other cultures, and a historical revivalism, which further fuelled the desire for self-expression inherent in the burgeoning hippy movement. Hippy culture owed both its linguistic origins and its inspiration to the American beat movement. In Britain it translated into a desire to live outside the strictures of an affluent, aspirational middle class, while still benefiting from a society in which choice was seen increasingly as a necessity for all. For young people the structure of working life was changing radically. "Dropping out" while not suffering any financial deprivation could only be achieved in an affluent culture. Those driven to express themselves by dressing up were almost invariably middle class, even though they were not following the traditional patterns of employment.

The desire for self-realization and "doing your own thing" included the rejection of the commonplace or the mass-produced, and included dressing in a uniquely individual way. The denial of the modern in favour of the nostalgic was one way to express individuality, and the playfulness that is evident in the juxtaposition of references, from second-hand couture to charity-shop finds, dispensed with the need or the desire for "branded" or labelled goods. This elevation of the object from the past, allied to a desire for the special and obscure, meant that spending a lot of money was no longer vital to achieving a certain "look". "Value" was not merely fiscal but lay in distinctive and self-conscious eccentricity of clothes. There was no shop assistant to advise or recommend, it was not possible to buy the Edwardian blouse from Oxfam in a different size or in the same style but in a different

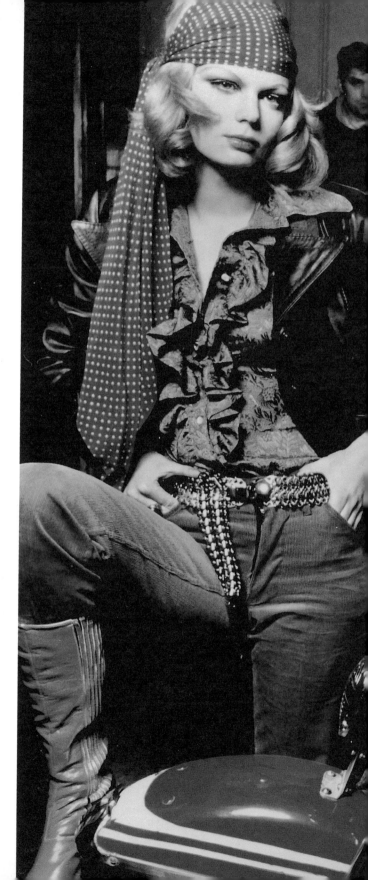

right Mike Berkofsky's
photo for Quorum evokes
the chic of the marginal.
Ruffled shirts and crutch
defining trousers signified
the sexual androgyny of
the era. Laconic attitudes
complete the air of
provocative sang-froid.

colour. It took time and effort to source garments that perpetuated the personal legend.

In her seminal work of the sixties *Loose Change,* Sara Davidson describes the reaction of her hippy boyfriend to her new dress. "I noticed he was staring at my dress, my new red-and-white Mary Quant mini-dress. He said 'There's nothing really… *special* about it.'"

Once the hippy movement gathered momentum Chelsea, and its milieu of aristocrats and rock musicians, again took centre stage. Chelsea had momentarily ceased to be the epicentre of "cool" and took a back seat as "Swinging London" became centred around Carnaby Street. However, as the era of the "dolly bird" and the pop star waned, the King's Road became once more what Richard Neville describes as "the catwalk for the demimonde." He goes on, "I traipsed behind the tripmaster, trying to blend with the Beautiful People. Men with buccaneer boots and phosphorescent faces waved from the Picasso café, looking like they took LSD with their cornflakes." Christopher Gibbs concurred, "The King's Road is a wilderness of stoned harlequins."

Connecting the hippy movement and the use of hallucinogenic drugs such as LSD was the notion that these drugs were the gateway to enlightenment and cosmic consciousness. The headquarters of the "World Psychedelic Centre" was the Belgravia flat of Michael Hollingshead. Among his associates he lists many people who were central to the artistic and cultural changes that were happening in London, including the Ormsby-Gore family. In 1966 Jane Ormsby-Gore, daughter of Lord Harlech, described by Christopher Gibbs as "a mediaeval monarch surrounded by her courtiers" was, according to Nigel Waymouth, "a marvellous figure, quintessential to the dressing-up process." Christopher Gibbs goes on to say her "detestation of all things commonplace is especially evident in her wardrobe. She does, it

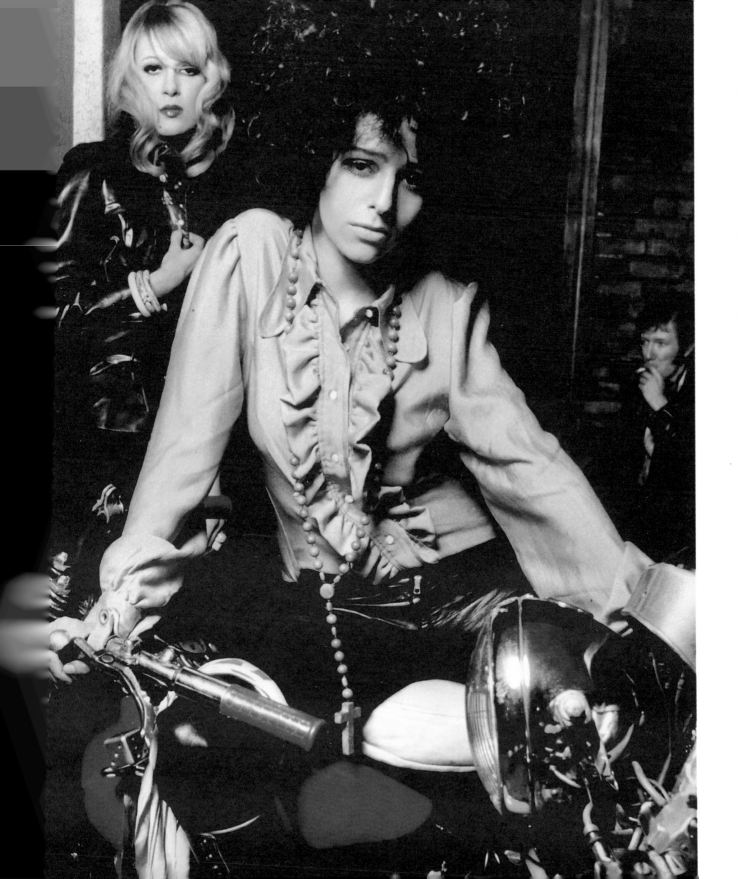

a wilderness of stoned harlequins

right The fleeting, transient nature of sixties fashion is epitomized in this wear-once- and-throw-away paper dress, designed by Ossie Clark and Celia Birtwell. It is modelled by sixties icon, actress Jane Asher.

opposite page "All the people of the earth are forced to come together now and this expresses itself even in fashion" said Simon Posthuma of boutique The Fool in 1967. Taking their name from the joker in the pack of tarot cards, this group of four, led by Dutch- born Marijke Koger, opened a boutique financed by the Beatles at 94 Baker Street. Their idealistic dream of hippy-inspired commerce plummeted under the weight of freeloaders and shoplifters. It lasted seven months.

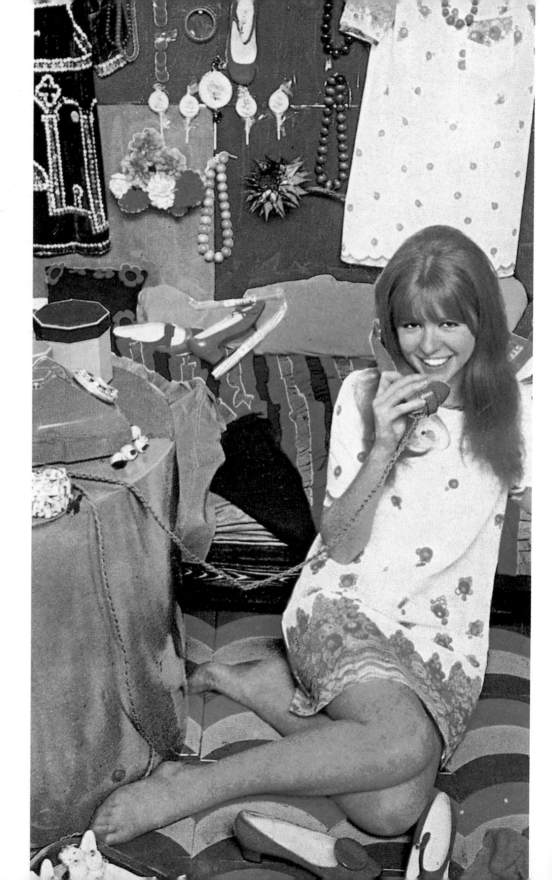

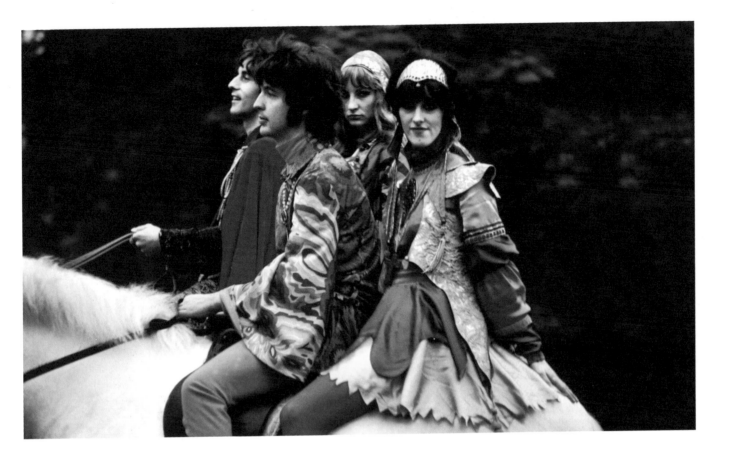

is true, buy a few clothes from boutiques like Dandy and Deliss, but under her eye they suffer a sea change. She scours the Portobello Road and the antique shops… searching for handfuls of Venetian lace, rich embroideries, and beautifully made clothes of any age and kind. She has boots of Russian leather, endless shirts of cream and white lace, embroidered velvet coats falling almost to the ankle, striped silk stockings, huge plumes of ostrich and egret tumbling from floppy 1900 hats, and above all a jewellery box stuffed with glittering treasures."

Jane Ormsby-Gore married Michael Rainey, described by Janey Ironside as a "top hippy", and the owner of Hung On You, one of the boutiques lining the King's Road. Originally sited at Chelsea Green, the move to the King's Road garnered the custom of the pop aristocracy, attracted to the exclusive tone and drug-fuelled atmosphere. Christopher Gibbs described it in *Vogue* as having "none of the taint of Carnaby Street. The strains of Bob Dylan float

up past cupboards groaning with satin stripe shirts and racks heavy with jackets and trousers in ravishing pin stripes, blue, grey, and marmalade."

The effects of hallucinogenic drugs on visual perception was to heighten and distort both colour and pattern, and the many coloured swirling fantasies of psychedelia at this time can be traced to a preoccupation with the kaleidoscopic effects of LSD. Michael Hollingshead likens the experience to an "emotional-reflective visual kaleidoscope, dissolving continuously from one pattern to another. The impressions become more intense. The vibrations turn into colours – brilliant blues, purples, and green with dashes of red and streaks of yellow orange."

Another influence on fashion was a resurgence of interest in the work of nineteenth-century designer William Morris and the art nouveau movement. Bernard Neville, head of textiles at the Royal College of Art, in a project for a fashion show encouraged his students to use Morris's wallpaper designs.

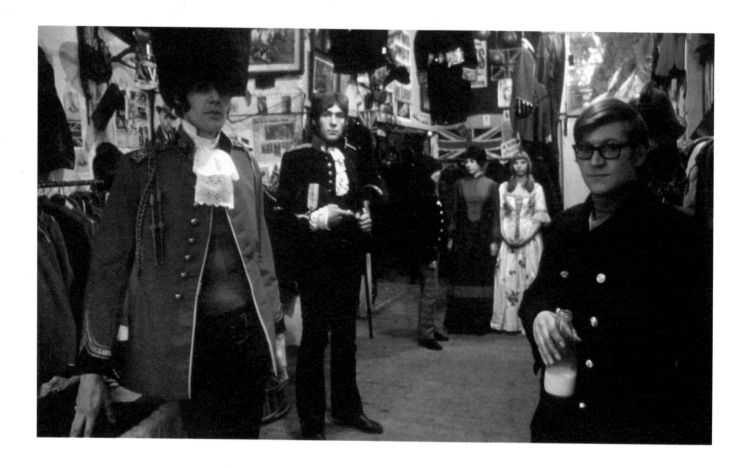

A couple of years later Barbara Hulanicki at Biba used a plum-and-navy William Morris print for the curtains in her Abingdon Road shop in 1964.

It is quite possible that the influence of all things Parisian on British style and culture in the fifties translated into an enthusiasm for the art nouveau-style of the Paris metro and architecture that then infiltrated London in the sixties. In 1966 the Victoria & Albert museum exhibited the work of Aubrey Beardsley, and together with Lautrec and Mucha he became one of the formative influences on the graphic designers of the underground movement. Poster art became the means by which multi-layered and many-coloured graphic imagery was used to express the fantasy of excess.

These ebullient, free-flowing forms were the antithesis of the geometric, architectural shapes of the "mod" look now appropriated by couturiers such as Courrèges and transmuted into catwalk fashion for the wealthy, or reproduced and imprinted with crass pop art motifs by high street

manufacturers. A new direction in fashion was necessary to sustain individualism. Modernism began to segue into the beginnings of historical revivalism and the desire for a more complex and fluid silhouette began to emerge. The dramatic and intricately cut clothes of Ossie Clark, who graduated from the Royal College of Art in 1964, exemplified this look.

Ossie Clark arrived at the Royal College of Art via a scholarship after getting his national diploma in design at the Manchester Regional College of Art. He was born in 1942 to a working-class family in Warrington, and was part of the great exodus of talent to London from the North, which included his friend and later wife and professional partner, Celia Birtwell. They had met through fellow student Mo McDermott in1959 while Celia was studying Textile Design at Salford College. "I came to London for a holiday and stayed" she remembers. She and Ossie started working together on a paper dress for Molly Parkin, then fashion editor of *Nova*, that was sold through the

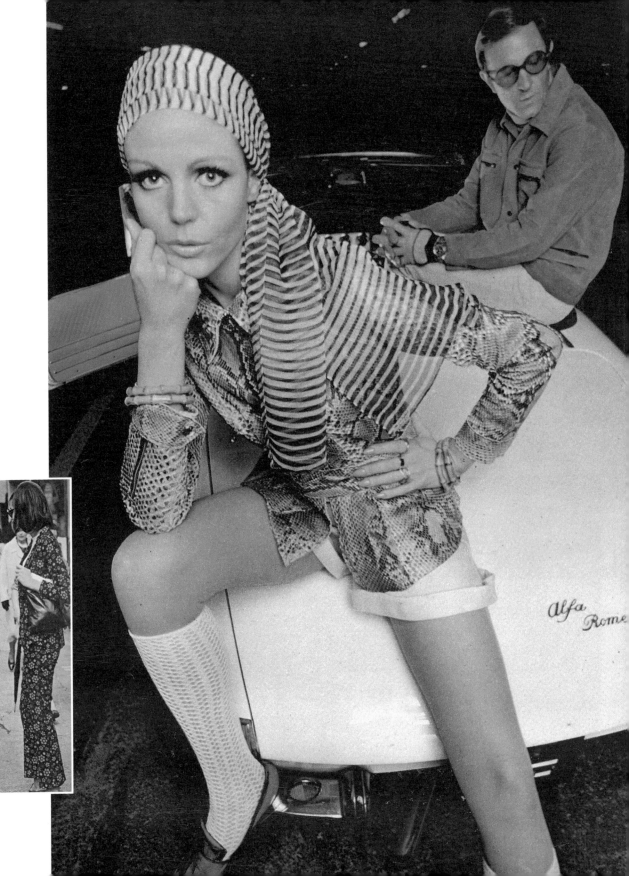

left Subverting the heroic and the spectacular. Ian Fisk, who was proprietor of I Was Lord Kitchener's Valet, the first boutique to sell period and military costume in appreciation of the Victorian aesthetic.

right Ossie Clark's signature snakeskin biker jacket, styled here with the long, narrow scarf, last seen in the thirties, and revived in a striped print by Bernard Neville.

below Saturday morning on the King's Road. In the sixties the notion of exclusivity was rejected, and to wear the same clothes was to create a bond of mutual "coolness". It was an affirmation of being in the right place at the right time.

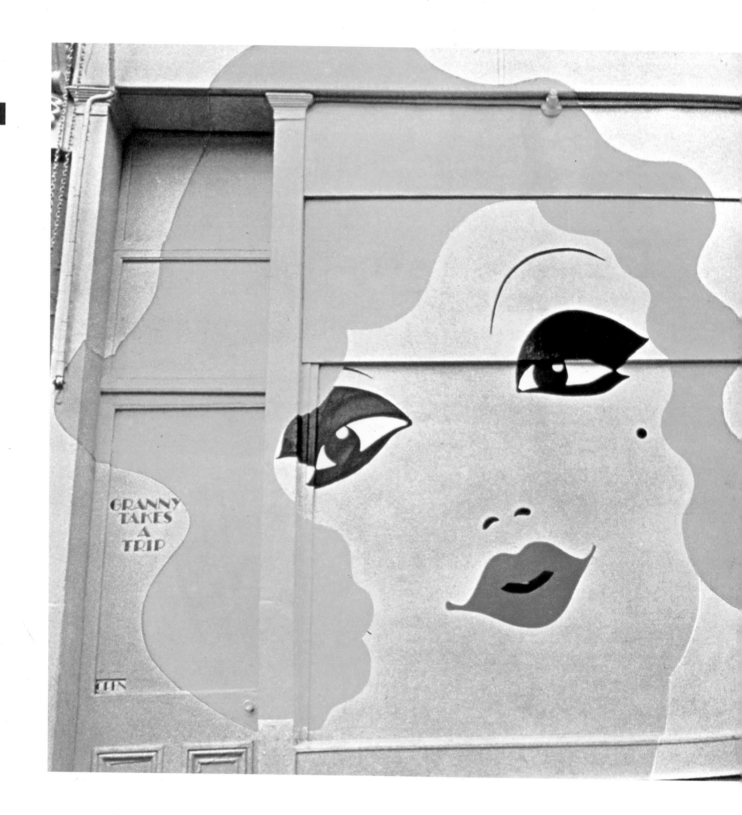

163

a wilderness of stoned harlequins

*left Boutiques such as
Granny Takes a Trip relied
on their reputation for
counter-culture mystique
to perpetuate an image of
exclusivity. As one of the
owners, Nigel Waymouth
admits, "The shop definitely
had an intimidating quality."*

magazine. While still at college Ossie visited the US with his fellow student David Hockney, and returned enthused about the use of pop and op art motifs there. His graduation show in 1964 included an architectural and complex coat of swirling op art patterns that was photographed by David Bailey and featured in *Vogue*.

On leaving college Clark and Birtwell were approached by Alice Pollock, the owner of the boutique Quorum, sited on Andsell Street in London. Alice Pollock had started her career in films, as assistant to Tony Richardson and Orson Welles. "There I was," she explained in an interview in 1971, "pregnant with a pretty house in W8. I had to do something to pay the rent."

Ossie Clarke joined her in 1966, when the shop moved to 52 Radnor Walk in Chelsea. Celia Birtwell recalls, "Alice Pollock was very supportive of me, she included just one print in the first season, a scarf with a Cubist design. She would say, 'Do what you like' and that was just what I needed. She was rather daunting for business people. She was brilliant at finding finance, and had a high-handed approach with businessmen. They never understood her, and perhaps that was her strength. She was erratic but had great passion."

The creative partnership between Ossie Clark and Celia Birtwell was the perfect synthesis of garment and fabric, structure and pattern. Birtwell explains "I always designed on the figure. Ossie would look at my drawings and just tell me to get on with it. I would try out the prints on all different types of fabric; silk-satin, flannel, chiffon, jersey, crêpe-de-chine, they were all hand-printed. I worked with Ellen Haas at Ivo Prints in Southall. She is technically brilliant, and she was the one that made things work."

Ossie Clark juxtaposed the fluidity of these printed, bias-cut dresses with the edginess of masculine tailoring. Marit Allen, editor in the early sixties of "Young Ideas" in *Vogue* recalls, "He included a motorbike jacket and a safari jacket in a collection and Yves Saint Laurent came over and bought things

from Radnor Walk and copied them in his next collection. What made Ossie very, very special indeed, and unlike anyone else around, was his sense of proportion. He knew about proportion in his bones. That's what changes fashion. The jacket and the trousers will be around forever, but it is the way they are worn; the exact width of the trouser, the exact length of the jacket in relation to the trouser. That's what he knew, that's why he was brilliant."

Prudence Glynn in *The Times* defined the clothes as having "an originality which depends for its effect on cut and construction. No one more flatters a women's body by sheer cutting than does Ossie when he sets his mind to it."

Celia Birtwell acknowledged the help Ossie received from Kathleen Coleman. "She was Ossie's absolute right hand. She and he would work out how to do something together, she had marvellous nimble fingers." Lady Henrietta Rous, editor of the *Ossie Clark Diaries*, describes Quorum at this time as a "crash pad of louche grooviness" and Ossie Clark as the "King of the King's Road." Customers such as Brian Jones, Keith Richards, Mick Jagger, Julie Christie, Sharon Tate, Marianne Faithfull, and Anita Pallenberg were drawn to clothes that celebrated eccentricity and audacity. Ossie records in his diary that 1967 was the year when, "Brian Jones and Keith took to wearing the silks and satins printed by Celia and the skin-tight, jewel-coloured trousers from a stash of pre-war corset satin AP found. I made men's shirts with frills in chiffon, in crêpe, with a one-sided collar, a leather jacket metallic with blue snake. Marianne bought a suede suit trimmed in python with a fluted peplum and never asked the price."

Ozzie Clark's customers became his models. Both Marianne Faithfull and Patti Boyd, wife of George Harrison, modelled in the fashion show that took place in the Chelsea Town Hall in 1967.

April of the same year also saw the hemline drop to midcalf as the film *Bonnie and Clyde* was released. This story, set in the time of the American

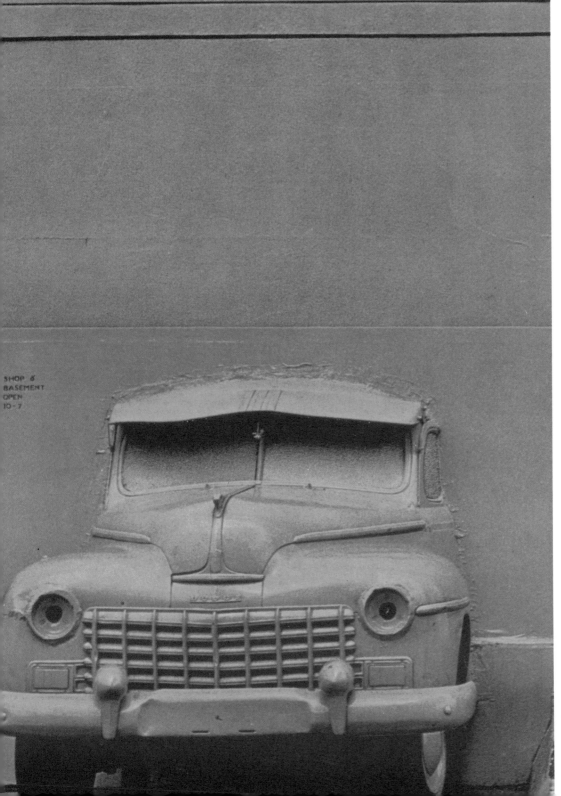

RANNY TAKES A TRIP

SHOP &
BASEMENT
OPEN
10 - 7

left The front half of a
1947 Dodge protruding
from the window of Granny
Takes a Trip onto the shop's
forecourt in 1968 provided
a benchmark of innovation
in shop window display –
but it was the last straw
for Chelsea Council.

opposite page, left Artist
Patrick Proctor wearing an
afghan coat purchased from
Granny Take a Trip. The
infamous afghan coat made
from untreated sheepskin
surrounded the wearer with
a palpable aura. "Importing
afghan coats was the
beginning of the end,"
says Nigel Weymouth.

opposite page, right
From left to right:
Christine Keeler, David
Bailey, model Penelope Tree,
and Marianne Faithfull.

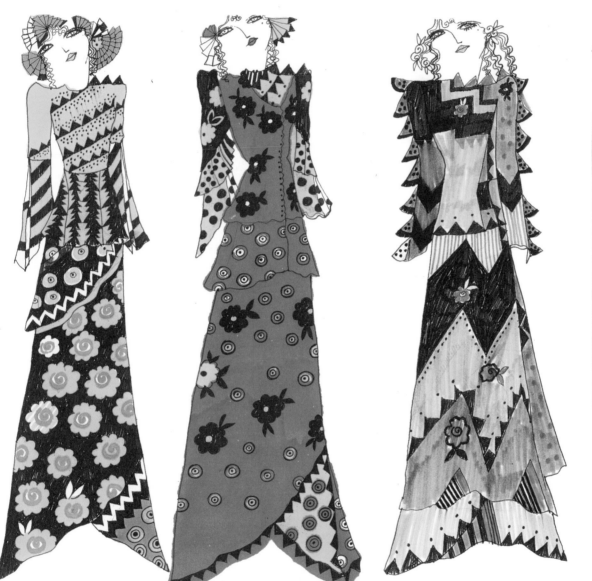
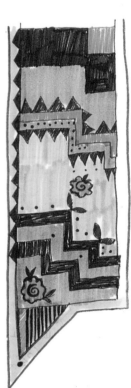

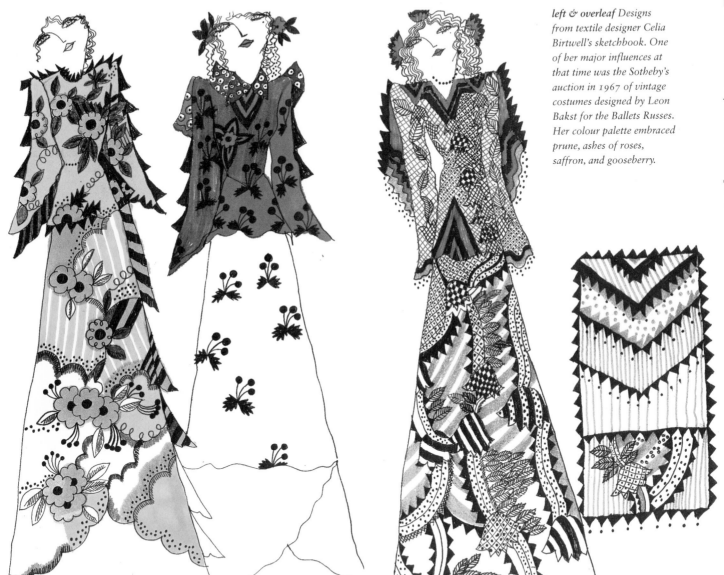

left & overleaf Designs
from textile designer Celia
Birtwell's sketchbook. One
of her major influences at
that time was the Sotheby's
auction in 1967 of vintage
costumes designed by Leon
Bakst for the Ballets Russes.
Her colour palette embraced
prune, ashes of roses,
saffron, and gooseberry.

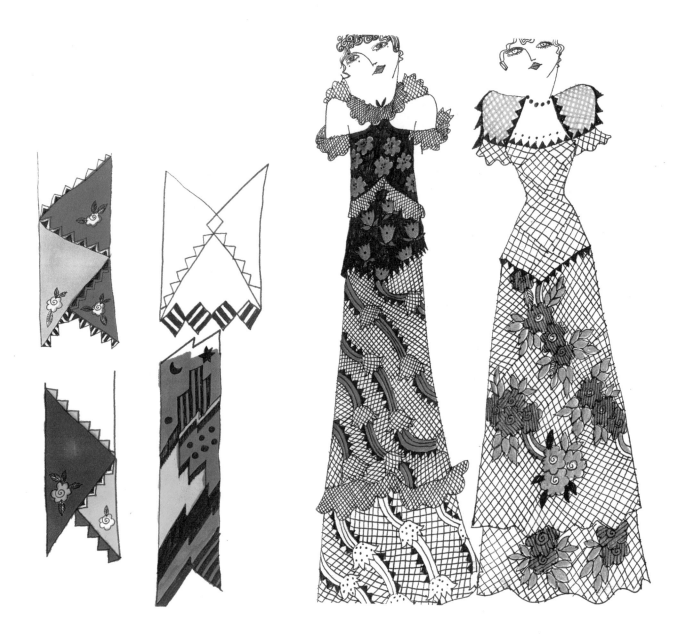

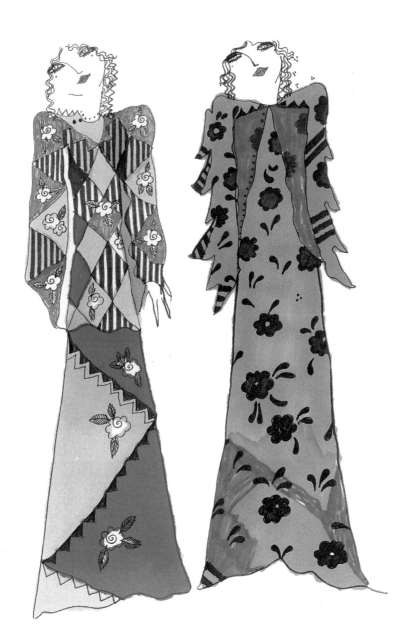

depression, featured Faye Dunaway and Warren Beatty as the two renegade outlaws, and was enormously influential in consolidating the growing interest in thirties fashions and interiors. The silhouette relaxed further into the simple shapes and long lines of that period, and fabrics were equally soft and supple. Bernard Neville had found a scrap of pre-war panne velvet, and sourced a mill in the South of France that could reproduce it. Polished on metal rollers, the one hundred percent rayon fabric reflected the signature sheen of an era. Ossie Clark used it for simple mid-calf dresses with long, pointed collars in his show at the Chelsea Town Hall.

In spite of the accolades showered on Quorum, by 1968 the boutique was in debt, and in 1969 Radley's Fashions and Textiles bought a sixty-five percent share in the two companies, Ossie Clark (London) Ltd and in Alice Pollock Ltd. Radley's provided showrooms and workrooms at Burnsall Street, and eventually a new shop on The King's Road. According to Celia Birtwell,

"Al Radley had never met anyone as glamorous as Ossie, but he didn't know how to maximize his cleverness. He couldn't make Ossie do what he wanted him to do, and Ossie became full of frustrated passion." Nevertheless it was a fruitful partnership. Ossie Clark went on to provide what Suzy Menkes recalls as "the most extraordinary moment in the history of fashion with his show at The Royal Court in 1971."

All the pop aristocracy attended the show: Alice Ormsby-Gore, Paul and Linda McCartney, and Patti Boyd. However, Ossie Clark became increasingly frustrated by the necessity to meet deadlines and work within commercial constraints, and he left the partnership. Celia Birtwell recalls that, "Once Alice had introduced Ossie to that pop star world he became difficult to pin down. He wanted a fun time. He was a very bright star that burnt itself out." The desire for self-realization, which was fuelled by the drug culture, became manifest in the playful subversion of vintage military uniforms. This

left Ossie Clark staged this scene off the Fulham Road. Model Kellie is wearing one of his intricately cut chiffon dresses. Sir Mark Palmer, who co-founded the English Boy model agency, based above the Quorum shop, is pictured second left.

right Hippie chic. Pat Booth wearing the archetypal wide-brimmed straw hat of the summer of love, decorated with flowers.

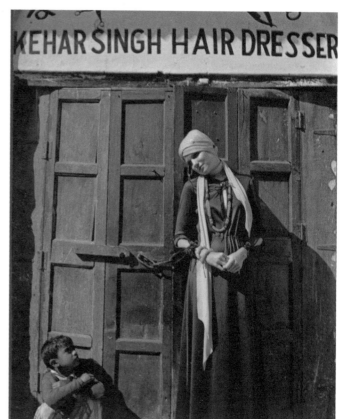

was worn with rows of medals, and second-hand clothes, beads, feathers, and sequins. The clothes were purchased from outlets such as Ian Fisk's boutique, I was Lord Kitchener's Valet, in the Portobello Road. The look transformed the sharp tailoring of the mods into the fantasy dress of the hippies. This aspiration for the heroic and the spectacular riled a middle-aged audience concerned with the clothes' provenance. In 1967 Mazin Zeki, of Muswell Hill in London was charged "that not being a person in her Majesty's military forces, he did wear part of a uniform of the Scots Guards without her Majesty's permission." His reply that "It's fashionable and smart," earned him an unconditional discharge.

The transition from the mod in fancy dress to the archetypal dandy who dressed in Granny Takes a Trip was fuelled by the traditional Saville Row background of John Pearse, who, together with Nigel Waymouth and Sheila Cohen opened up the boutique in Chelsea's World's End in November 1965.

Nigel Waymouth recalls, "John Pearse was very much a mod, there was something about our clothes that were a little bit smarter, not seedy. We abhorred all that 'I was Lord Kitchener's Valet' thing."

The popularity of period costume reached its peak in the summer of 1967, when the Sergeant Pepper sleeve featured The Beatles in their faux-military uniforms. The extent to which the look permeated popular culture was evident in the appearance of Patrick McNee as "Steed" in the prime-time cult television show, *The Avengers*. In the episode entitled, "The Superlative Seven" Steed attends a party in historical military garb. Another guest, eyeing his clothes, remarks, "Kitchener's Valet".

Originally a medical journalist, Nigel Waymouth was introduced to the fashion business through his girlfriend, Sheila Cohen, an avid collector of second-hand clothes and antique costume. They met John Pearse, who had trained in Saville Row, and formed an immediate rapport. They decided to

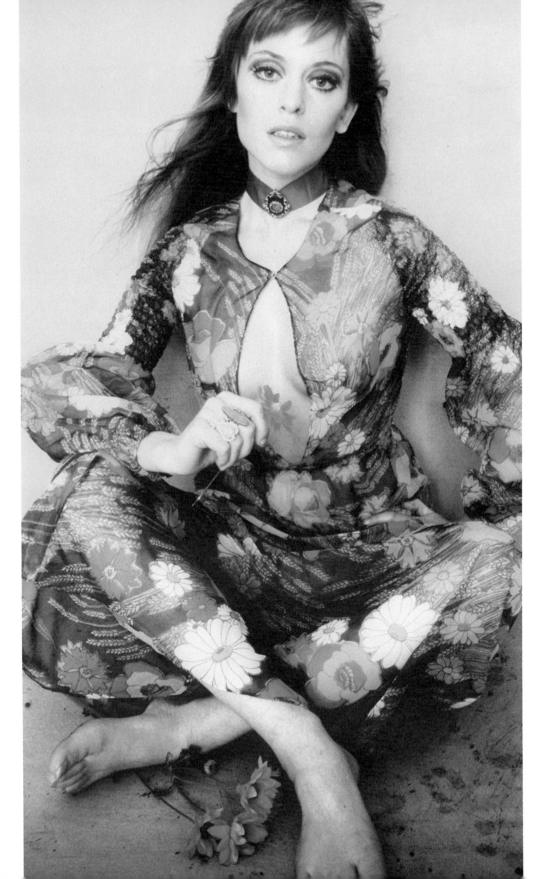

left *Edina Ronay in 1970 modelling a smocked floral dress by Georgina Linhart. New attitudes to physicality meant that transparency was increasingly acceptable in mainstream fashion. The diaphanous nature of the dress, and the use of girly details such as smocking, diffuse the overt sexuality of the nude body beneath.*

opposite page, left *The October 1969 edition of Petticoat, the influential fashion magazine for young teenage girls, featured a print top with matching bandanna designed by Georgina Linhart.*

opposite page, right *The Indian location of this fashion photograph for the cover of Honey in 1970 reflects the popularity of the hippy trail in youth culture. The outsize beads, long headscarf, and bare feet represent the desire for ethnicity in dress.*

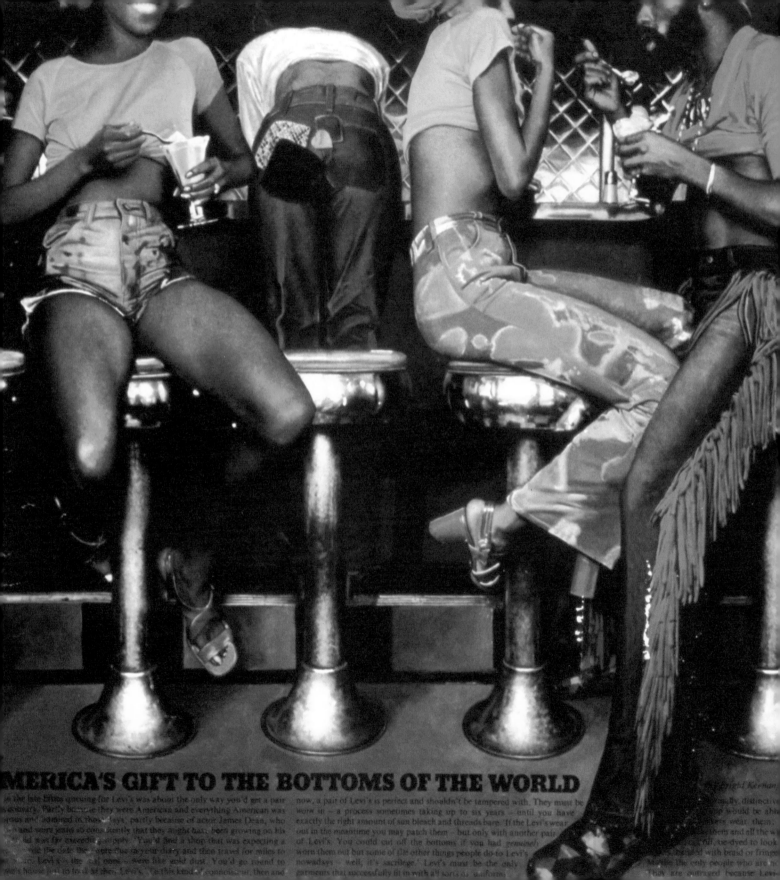

AMERICA'S GIFT TO THE BOTTOMS OF THE WORLD

Paul Goude

left *Award-winning illustration by Jeanloup Sieff for* Nova, *1970. Given the continuing and overwhelming popularity of denim jeans, the clothing industry saw the potential to turn them into yet another design commodity that was subject to the vagaries of fashion.*

pool resources, and with £200 borrowed from relatives of Pearse, rented the ground floor of the offices where Waymouth had previously worked.

Waymouth says, "The shop definitely had an intimidating quality, a mystique. It was not a friendly shop. We were spearheading a movement, not consciously in a political way, but certainly style-wise. We were trying to break away. We weren't following designer traditions. The shop was part of that, trying to establish a look for people of the underground culture. Our customers were debs, gays, pop groups, and both sexes. It was completely androgynous, we had only one changing room and the clothes were mixed on the rail."

The underground movement became the first sub-culture to fuse fashion, music, and the graphic arts. Waymouth says, "One of things that sank us was that we were too artistic, there was too much talent. We were dreadfully impatient to create and change things. I liked 'looks' and had a love of clothes, the aesthetic, the culture. We weren't designers, we had concepts way ahead of their time. I started doing graphics with Michael English, we worked under the name of 'Hapshash and the Coloured Coat.' We even made a concept album. Everyone wanted to be a pop star."

The ease with which exponents of the underground moved between the disciplines of music, graphics, and fashion only became restricted if any areas proved problematical, and with Nigel Waymouth, fashion was the first area to go. "I never liked playing shop. The initial stock of original second-hand clothes soon had to be supplemented by clothes designed by Pearse and Cohen, and it all became too much. The fashion industry has no ethics, we sent shirts to be made up in the East End, we wanted 200. When we went to collect there was a huge pile of them, far more than we had ordered. When we asked why, we were told the rest were for Cecil Gee." The appropriation of elements of other cultures and incorporating them

into the British wardrobe had enabled the rich to play at being poor. The plundering of Africa, the Americas, and Asia for decorative artefacts was part of a new aesthetic that was drawn from an increasing awareness of the value and meaning of other cultures and an attempt to take on what were perceived to be third world values.

Gerald McCann sums up the era with his recollection of seeing Charlotte Rampling walking up the King's Road on a hot summer afternoon, "She was barefoot and wearing a see-through Indian dress, eating the seeds from the head of a sunflower."

Eastern embroideries, Tibetan prayer shawls, the beads and feathers of the Native American Indian, all were worn in a narcissistic display of identification with the different, the marginal, the dramatic. To the generally felt revulsion of society, the sexes looked almost indistinguishable as the counterculture pushed the boundaries of gender roles to their limit. The

silhouette of men and women became almost identical as garments, patterns, textures, and colours were worn irrespective of gender or sexual orientation. A generation that had trekked to India, Morocco, and the Far East and appropriated the costumes of the emergent nations had no desire to fuel the revolution that was to come while wearing clothes they had bought over a counter. The student uprisings of 1968, the protests against the Vietnam War and the invasion of Czechoslovakia, politicized a youth culture that had an aversion to mainstream commercialism.

By the end of the sixties, fashion had become anti-fashion. The clothes of the American Depression now began to find favour with those who embraced an "alternative" lifestyle. Both men and women wore denim jeans and work shirts, and both the clothes and long untamed hair became a symbol of the revolution, a look that required very little in the way of money and maintenance.

REAM AND HENDRIX TOP POLL

BEAT INSTRUMENTAL

FEB. 2'6

opposite page, left Long hair for men was an important means of expressing dissatisfaction with the establishment culture, symbolizing rejection of both parental and institutional morality.

opposite page, right Paul and Linda McCartney with Dudley Moore and friends, dressing for comfort and practicality. The days of the sartorial excesses of the Sergeant Pepper album cover were over.

left Jack Bruce, Ginger Baker, and Eric Clapton.

below A look that did not require money or maintenance, scruffy jeans were evidence of the hippies' identification with poverty.

The economic exigencies of life in Britain in the 1970s inevitably had an impact on patterns of consumer spending. Beginning with the devaluation of the pound in 1967, and including an energy crisis as oil prices soared with the Yom Kippur war between Egypt and Israel six years later, Britain was facing a recession. The situation was exacerbated by the coal miners strike of 1974, resulting in a three-day week for industry. Small businesses, which had flourished in the entrepreneurial sixties, had to accept change and adapt to thrive under new financial constraints. High unemployment levels and high inflation created a society in which the marginal fell off the edge. Factories could only produce two-thirds of their output, workers were increasingly laid off, and unbelievably even the television stations closed down at ten o clock at night.

For the beleaguered boutique owner, lighting the shop with candles three days a week (the strike took place in February), it was a struggle to survive.

There was a mutual dissatisfaction between the designers and the entrepreneurs of boutique culture, and the manufacturers who sought to exploit their creativity and talent for commercial gain. The boutiques were losing money because the mass production industry was diffusing the concept of boutique shopping with cheaper High Street copies of the clothes. Barbara Hulanicki remembers that in the last days of Biba she could walk out of the store and see copies of her clothes at half the price in the shop opposite. The style fragmentation of the youth market during this period also contributed to the crisis, the customer of the sixties had moved on to embrace either the trappings of the counterculture or into mainstream fashion supplied by the multiple retailers.

This disenchantment with commercial fashion went with an appropriation of the idiosyncratic, the precious (in terms of being inaccessible) and the old Even vintage fashion, however, was not impervious to being commercially

conclusion

exploited. One designer remembers, "I was working in the mass market, and it was a really weird time. Most of the stuff we did was vintage inspired. I remember wearing an Edwardian blouse to work that I'd bought from the local Oxfam shop, and my boss immediately made me copy it for C&A in double-denier nylon. We even sourced nasty fake little cameos to put on the high neck."

Avant-garde fashion tends to revolve around the unexpected and plays on a sense of difference, accordingly the best designers and boutiques used the unexpected to shock and seduce; mass production destroyed the very creativity it wished to exploit. What started as avant garde ultimately became nothing more than a commodity.

The use of expensive retail space for recreational purposes, such an attractive feature to begin with, also turned out to be one of the reasons for the demise of boutique culture. Sylvia Ayton recalls:

"The shop was like an open house to strange people who liked sitting on the big banana seat and talking to the shop girl. The telephone bills were enormous."

"Retailing is difficult and expensive," Marit Allen affirms, "If you can't compete with the lions you have to get out of the forest."

Neither did the modern style of the shop interiors help security. Shoplifting was an overwhelming factor in the loss of profits. James Wedge admits, "It was the shoplifting which ruined us, really. People would just go shopping to steal things, and there were no such things as security tags. It was always so crowded that we couldn't control it. I displayed fur coats padlocked and chained to a rail and came back from lunch to find the chain had been cut."

Pat Booth confirms, "We had so much stolen, even though our customers were very rich upper class young girls. We lost a million in the first year.

When we sold up I made money out of the leases on the shops, rather than from the shops contents."

Booth was asked by Charles Clore, the owner of Selfridges, to oversee the running of the Top Gear and Countdown boutiques within the store, but by that time she had lost interest in fashion and moved into photography. Janet Campbell, in her boutique based in Nottingham, was wise enough to see that the womenswear market was being eroded by the High Street, and began to sell only widely sourced menswear, including labels from Europe and America.

It was a time of individualism for the few, or standardized fashion for the many. Richard Neville remembers a conversation he had with Martin Sharp in 1970, "Awful. King's Road has turned into Carnaby Street. The musicians, poets, graphic designers… all gone." Nigel Waymouth of Granny Takes a Trip recalls the efforts of Chelsea Council to clean up the road. "We were very much their prime target. The last straw for them was the 1947 Dodge car we had protruding from the shop front. The end was when the Chelsea Drug store opened, the whole road became seedy."

The geography of fashion changed as designer shops settled into Bond Street or South Molton Street. These retailers had none of the inspired amateurism that was so characteristic of sixties boutiques, being instead rather smart emporia selling international labels such as Missoni for the older, more financially established woman.

Richard Williams admits that he "more or less took ten years out from thinking about fashion. At the beginning of the seventies there was nothing original or outstanding. The Mod impulse had long gone; the brief period when Hippie fashions were O.K. had also gone. For a few years clothes weren't very important – maybe because there weren't any nice ones around. I shudder when I think about it. All those dreadful droopy rounded collars. Afghan coats

two years too late. "Take Six" velvet suits. Snakeskin boots from Angelo and Davide. Ugh. (But I never owned a pair of loon pants…)"

The designers who might have made their mark in the marketplace returned to that hotbed of creativity, the Art College. Their influence went into the students. By the time fashion was ready to run again, "boutique" was a word with derisory connotations and a tired and weary concept. It had became debased as every desperate department store, attempting to boost sales, threw a cordon around a corner of the shop that didn't contain cutlery or cushions, played loud music, and called it a boutique.

Jeff Banks concludes, "I sold out my share because I wanted to be a designer on a world stage rather than for a single shop. I had a massive wholesale business and a showroom in the West End. It was the beginnings of pret-a-porter, and I went to show in Paris as one of the four British contingent, alongside Ossie Clark and Alice Pollock at Quorum, John Marks and Stirling Cooper. The concept of the boutique continued in France, Spain, Italy, and Germany; a single shop that had a point of view through buying, merchandising or designing. Rental levels meant that it was no longer sustainable in Britain. Multiplicity came into play and forced the rentals up, and we saw the demise of individuality."

Iconoclastic designers have always inhabited the interface between the avant-garde and the commercial; throughout the following decades their arena would no longer be the boutique but the couturiers atelier.

Bobby Hillson, who went on to run the prestigious Master's Degree in Fashion at Central St. Martins summarizes the conflict between creativity and commerce"

"Fashion is enormously creative and can become great art, but it shouldn't set out to be art. It's a reflection of the times, and it is aimed at a market. It's a business."

Barnes, Richard (compiler), *Mods!* Eel Pie publishing Ltd, 1979.

Bender, Marilyn, *The Beautiful People*, Coward-McCann, Inc., 1967.

Bowlby, Rachel, *Carried Away*, Faber & Faber, 2000.

Cohn, Nik, *Today There are No Gentlemen*, Weidenfeld, 1971.

Cole, Shaun, *Don We Now Our Gay Apparel: Gay men's dress in the 20th Century*, Berg, 2000.

Cox, Caroline, *Good Hair Days*, Quartet Books, 1999.

Davidson, Sarah, *Loose Change*, William Collins and Sons & Co Ltd, 1977.

Faithfull, Marianne, *Faithfull*, Michael Joseph, 1994.

Ferguson, Marjorie, *Forever Feminine: Womens Magazines and the Cult of Feminity*, London 1983.

Firth, Simon and Horne, Howard, *Art Into Pop*, 1987.

Green, Jonathon, *Days in the Life. Voices from the English Underground, 1961–1971*. Heinemann London, 1988.

Gosling, Ray, *Personal Copy. A memoir of the Sixties, Faber & Faber*, 1980.

Hillman, David and Peccinotti, Harry (compilers), and Gibbs, David (ed.), *Nova – The Style Bible of the '60s and '70s*. Pavilion, 1993.

bibliography

Hollingshead, *The Man Who Turned on the World*, Acidmagic.com/books/turned_on-06html

Hulanicki, Barbara, *From A to Biba*. Barbara Hulanicki, Hutchinson, 1983.

Ironside, Janey, *Janey*, Michael Joseph, 1973.

Lobenthal, Joel, *Radical Rags*, Abbeville, 1990.

Marwick, Arthur, *The Sixties*, Oxford University Press, 1998.

Melly, George, *Revolt Into Style. Pop Art in the 50s and 60s*. Oxford University Press, 1970.

Neville, Richard, *Hippie Hippie Shake*. Bloomsbury, 1995.

Quant, Mary, *Quant by Quant*, Cassell & Co Ltd., 1966.

Rous, Lady Henrietta (ed.), *The Ossie Clark Diaries*, Bloomsbury, 1998.

Sasoon, Vidal, *Sorry I Kept You Waiting, Madam*, Cassell & Co. Ltd, 1968.

Scott-James, Anne, *In The Mink*. Michael Joseph, 1952.

Shields, Rob (ed.), *Lifestyle Shopping*, Routledge, 1992.

Twiggy, *Twiggy in Black and White*, Simon Schuster UK Ltd, 1997.

Page numbers in *italic* refer to the illustrations and captions

index

Front cover: Rex Features; back cover Hulton Archive; spine: Mike Berkofsky. 2 John Frost Newspaper Archive/Photo by Bill King; 4–5 Photo by David Hurn; 6 Hulton Archive; 9 Camera Press/Peter Mitchell; 11 Bobby Hillson; 12 Jo Dingemans; 15 Getty Images/Hulton Archive; 16 Courtesy of Vanessa Denza/Photo by Martin Chaffer; 18 Courtesy of Mary Quant; 20–21 Advertising Archives; 22–25 Courtesy of Mary Quant; 26 Getty Images/Hulton Archive; 27 left Courtesy of Mary Quant; 27 right Magnum Photos/Ian Berry; 28 Sunday Times; 30–32 Martin Moss; 33 left (c) ADAGP, Paris and DACS, London 2002; 33 right David Montgomery; 34 Mike Berkofsky; 35 left Courtesy of Vanessa Denza/Photo by Dennis Hooker; 35 right Courtesy of Vanessa Denza/Photo by Martin Chaffer; 36 left John Bates/Terry O'Neill; 36 right John Bates/Terry O'Neill; 37 left John Bates/Lategan; 37 right John Bates; 38 left David Bailey © Vogue/Condé Nast Publications; 38 right David Bailey © Vogue/Condé Nast Publications; 39 left Sunday Times; 39 right Mirrorpix/Gordon Carter; 40–43 Sylvia Ayton; 44 left David Skinner; 44 right–45 Georgina Linhart; 46 James Wedge; 47 Pat Booth; 48–49 left Jeff Banks; 49 right Getty Images/Hulton Archive; 50–51 Photo by David Hurn; 52–53 Gerald McCann; 54 David Skinner; 56 Carole Longdon; 57 left PYMCA/Richard Braine; 57 right Carole Longdon; 58 Gerald McCann; 59 Getty Images/Hulton Archive; 60 PYMCA/Peter Francis; 61 Hilary Carter; 62–63 Gerald McCann; 64–65 Marnie Fogg; 66–67 Topham Picturepoint/Colin Jones; 68–69 Marnie Fogg; 69 top Topham Picturepoint/Colin Jones; 70 left Marnie Fogg; 71 Scope Features/Allan Ballard; 72 Courtesy of Professor Bernard Nevill/Photo by Jonathan Moor; 73 Courtesy of Professor Bernard Nevill; 74 left Greg Longdon; 74 right Ian Longdon; 75 Greg Longdon; 76 Jo Dingemans/Fred Saunders; 78–79 James Wedge; 80 left Marnie Fogg; 80 right Barbara Hulanicki; 81 left Rex Features; 81 right Barbara Hulanicki; 82 left Rex Features; 82 right Ronald Dumont; 83–84 Barbara Hulanicki; 85 Barbara Hulanicki; 85 Barbara Hulanicki; 86

credits

boutique

Marnie Fogg

First published in 2003 by
Mitchell Beazley, an imprint of Octopus Publishing Group Ltd,
2–4 Heron Quays, London E14 4JP

ISBN 1 84000 621 8

A CIP catalogue copy of this book is available from the British Library

Executive Editor Mark Fletcher
Managing Editor
 Hannah Barnes-Murphy
Design Nicky Collings
Executive Art Editor Christie Cooper
Copy Editor Penny Warren
Picture Research Jenny Faithfull
Production Controller Alix McCulloch

Set in Helvetica Neue and Sabon
Printed and bound in China by
Toppan Printing Company Limited